THE

ART

OF

PHOTOGRAPHING

NATURE

THE
ART
OF
PHOTOGRAPHING
NATURE

TEXT BY

MARTHA HILL

PHOTOGRAPHS BY

ART WOLFE

CROWN TRADE PAPERBACKS
NEW YORK

For Kevin,

Near and Far

Text copyright © 1993 by Martha Hill
Photographs copyright © 1993 by Art Wolfe

Published by Crown Publishers, Inc., 201 East 50th Street, New York, New York 10022. Member of the Crown Publishing Group. Random House, Inc. New York, Toronto, London, Sydney, Auckland

Crown Trade Paperbacks™ and colophon are trademarks of Crown Publishers, Inc.

Manufactured in Hong Kong

Design by Lauren Dong

Library of Congress Cataloging-in-Publication Data
Wolfe, Art.
 The art of photographing nature / photographs by Art Wolfe;
text by Martha Hill.—1st ed.
 p. cm.
 Includes bibliographical references and index.
 1. Nature photography. I. Hill, Martha. II. Title
TR721.W65 1993
778.9'3—dc20
92-22806
CIP
ISBN 0-517-88034-2
10 9 8 7 6 5 4

CONTENTS

ACKNOWLEDGMENTS

THE IDEA FOR THIS BOOK was conceived several years ago, while I was still picture editor at *Audubon* magazine. Sadly, the staff I worked with for fourteen years is no longer there, scattered to the four winds in a managerial thrust to find new directions for the magazine. The camaraderie of a small, dedicated staff, their high standards of excellence and professionalism, will be missed. It was a pleasure to be part of that team.

To the many fine photographers I worked with over the years, I would also like to express my gratitude. Theirs was a dedication born out of love and concern for their subjects, which, more often than not, meant sacrificing creature and material comforts in pursuit of their craft. Because of, or in spite of, these qualities, they came up with the outstanding images with which we could work.

There are a couple of photographers who have, perhaps indirectly, inspired this book. First, the late Ernst Haas, whose artistry was my standard by which to measure others, and whose articulate genius inspired me to want to help others "see." If I have any professional regrets, it is that we never were able to publish his photography in *Audubon*. Not for lack of willingness—he was as keen as I—but unfortunately we did not have the budget to fund what he wanted to do, which was to return to Iceland for a month of photography.

Secondly, I want to thank Boyd Norton, who first invited me to teach workshops with him in 1979. Teaching forced me to articulate for others what I had learned from my art training and day-to-day experience as a working picture editor. The workshops were fun, as well as being informative to both teacher and student.

In any project such as this, certain key people play a more active role, albeit behind the scenes. To these colleagues and friends, I would like to give special thanks and individual mention. To Guy Tudor, bird artist and naturalist, and to my father, Oscar Mertz, a retired art professor, for their careful vetting of the artistic concepts contained in the manuscript. To photographer and writer Susan Gibler, for her thoughtful comments and insights. To picture editors Karen Zakrison and Kay Zakariasen for their comments. To Michelle Le Marchant for introducing me to the magical "Afrika" cookies, which kept me going through the most critical times. To photographer Richard Frank for graciously allowing me to use the photo he took of me at my light table at *Audubon.*

To my coauthor, Art Wolfe, I want to express not only my deep appreciation for his beautiful imagery, but for his enthusiasm and flexibility, and for bearing the major burden of bridging the distance between coasts. To our editor at Crown, Brandt Aymar, our sincerest gratitude for supporting the idea of a two-voiced collaboration, and for shepherding the project through all its various phases.

And finally, to my husband, Kevin Schafer, an apology. He gave up Seattle for New York, understanding that it would be for one year, only to have this book project lengthen his imprisonment by another year. He has generously supported me and the project, both financially and emotionally, and given invaluable criticism and advice. This book belongs, in part, to him.

Martha Hill

FOREWORD

IN WRITING THIS BOOK, we, the authors, made several assumptions that we would like to explain beforehand.

The first assumption is that the 35mm single-lens reflex camera is the most widely used format by amateur and professional photographers today. Because it is so portable, and so many lens options are available, most published illustrations are taken with it. So we have ignored $2^{1}/_{4}$ x $2^{1}/_{4}$, 4 x 5, 8 x 10 and other larger-format cameras. We have thus based our discussions of composition on the rectangular format provided by 35mm cameras.

The second assumption is that technical information about cameras, lenses, tripods, shutter speeds, apertures, and exposure can be derived from two sources: first, from one's own personal experience and familiarity with the cameras themselves, and secondly, from some very good books on technique as it relates specifically to nature photography. Those are listed in the bibliography in the back of the book for further reference.

The third assumption is related to the second. We wanted to discuss the concepts of composition in a nontechnical way. The principles of good composition derive from art and are therefore widely applicable to any of the graphic media, photography being just one of them. These concepts are so basic that, even though we are illustrating them here using nature subjects, they actually relate to all other photographic specialties, such as still life, studio, architecture, people, and commercial photography.

The last assumption is that our readers will forgive us for using the pronoun *he* to indicate "the photographer." Sadly, no one has come up with a satisfactory solution to gender. "It" just doesn't work. Each year, there are more talented women entering the field of nature photography, which is refreshing, and we applaud this trend. For years, the profession has been dominated by men, probably largely due to the physical demands of carrying heavy equipment in the field. We by no means wish to appear sexist, but we felt it would be jarring to constantly use the "he/she" option throughout the book.

Finally, we hope everyone will find something of value, whether they are beginning photographers or serious amateurs.

THE ART OF PHOTOGRAPHING NATURE

INTRODUCTION

SEEING

If I had to summarize this book in one word, I would have to say it is about seeing. Seeing is something we all do unconsciously, like breathing. In one sense, we all see alike. We possess two eyes, retinas, rods, cones, a visual cortex in the brain. We stand within a foot or so of the same height, with our feet on the ground, looking out from that perspective at the rest of the world.

But in another sense, no two of us truly see alike. Even standing side by side, we see not only through our eyes, but with our minds. We *interpret* and *select*. Everything we look at is filtered through our experiences, emotional responses, our prejudices and preferences. So while you and I might look at the same scene, we *see* different pictures within that scene.

To visualize a photograph, that is, to isolate a piece of the landscape in your mind, you must focus your senses. Your mind must become the viewfinder, scanning and framing the scene, checking for elements that will make a strong composition.

Former *Life* photographer Andreas Feininger wrote, "No matter how violently photographers may disagree in regard to specific aspects of composition, they all agree on one point: A well-composed photograph is more effective and makes a stronger impression than a badly composed one...the purpose of composition is to heighten the effect of the picture."

Using Art Wolfe's photographs, we have set up comparisons of similar photographs to show why one is a stronger composition than the other. Without being too technical, we will discuss them from two different points of view. Art, as the photographer, will explain the creative decisions he makes when taking a picture. Having been the picture editor at *Audubon* magazine from 1978 to 1990, as well as an art critic and teacher of photographic workshops, I will discuss my view of the artistic merit of each picture and what it might communicate to a larger audience.

We hope it will be fun and provocative. There is no "best way" to photograph a subject. We may have different opinions as to what works and why, and you may disagree with both of us. But we hope our discussions will help you evaluate your own and other people's work, then inspire you to look through your viewfinder in new ways.

THE COMPELLING IMAGE

Audubon magazine was the one publication in the field of nature to really showcase photography. Because of this, we were deluged with submissions, and for thirteen years I looked at every one. I never knew when I was going to discover something new and wonderful, one of the great delights of the job. Over the years, I must have scrutinized several million images, but less than one-quarter of one percent ever made it to publication.

I was often asked, "What do you look for in a picture?" Aside from the obvious technical considerations of sharpness, color saturation, and good composition, I hoped to find an additional quality of artistry—a unique point of view that compelled me to look at the image again.

The artist James McNeill Whistler once wrote: "We look at a painting to know the painter; it's his company we are after, not his skill." Photography is no different. When we look at a picture, we like to imagine ourselves in the photographer's shoes. We want to feel what he felt, see what he saw, and come away a little richer for the experience.

Twenty people can look at the same landscape and create twenty different images. Some of those images will inevitably be more compelling. But while there is no best way to photograph a particular subject, there are definite ways to express it more artistically.

Art Wolfe first came to see me in the fall of 1979. I had become picture editor in May of 1978. He brought a portfolio of his work in the Pacific Northwest, and a book of his photographs of Indian baskets that had just been published. He had both an extraordinary eye for composition and a feeling for light.

I was always on the lookout for photo-story packages. We liked to run one in each issue, if there was room in the editorial well. These portfolios, along with our covers, were the most difficult items to find. Art's Olympic Peninsula photos were definitely portfolio material. We scheduled it for the very next issue, which at the time was actually July 1980, because we worked six months to a year ahead. We called it "The Wildest Beach." It was the beginning of a long and fruitful working relationship.

The most rewarding part of being a picture editor was discovering new talent. Since most of the job was conducted on the telephone, you might have years of telephone relationships with hundreds of people and never meet them. Over the years, I got to know personally only a small percentage of the more than three hundred photographers we dealt with.

Art and I shared a background in the fine arts. Before getting into photography professionally, he had been an art teacher and painter. I was trained in printmaking and wrote and lectured about wildlife art. Both of us taught nature photography in workshops. Each of us felt that composition was the most overlooked essential in picture-making, and we decided in 1989 to collaborate on this book together.

MAKING ORDER OUT OF CHAOS

The elements that go into making a good image are basically the same for photography as for art, with one significant difference. An artist is faced with a blank piece of paper or canvas and has to construct a whole image by putting together the design elements—line, color, form, space, perspective—all of which he must create for himself. A photographer is given all these same elements in his viewfinder and basically subtracts the material he finds distracting and unessential to his statement.

Good photography is decision-making. It is not a passive process. The eye must learn to detect the essential and make it into a meaningful arrangement. Initially, nature appears random and chaotic. Our mind needs to make order out of chaos, to create relationships between things in order to understand them. When we look at something, we subconsciously focus our attention on some aspects and ignore others; we filter everything through our experience and our emotions.

The camera makes no such distinctions or evaluations. It records everything it sees. It is, therefore, the photographer's responsibility to edit the camera's view and select those elements to be captured on film. Understanding what goes into making a strong composition can improve a photographer's personal statement. Freeman Patterson stated it beautifully when he wrote: "The camera always points both ways. In expressing the subject, you also express yourself."

In a good composition, one has the distinct impression that nothing could be added to or subtracted from the picture. This sense of completeness—of balance—is the key. Balance does not, however, imply symmetry. Asymmetrical compositions can be balanced. We will explore these concepts as we move from chapter to chapter, discussing where to place the subject, how to make it stand out, how it relates to the other elements within the frame, and what creative options you have to work with in making a stronger photographic statement. There are some guidelines that can be followed, but none of them are so absolute they should be adhered to constantly.

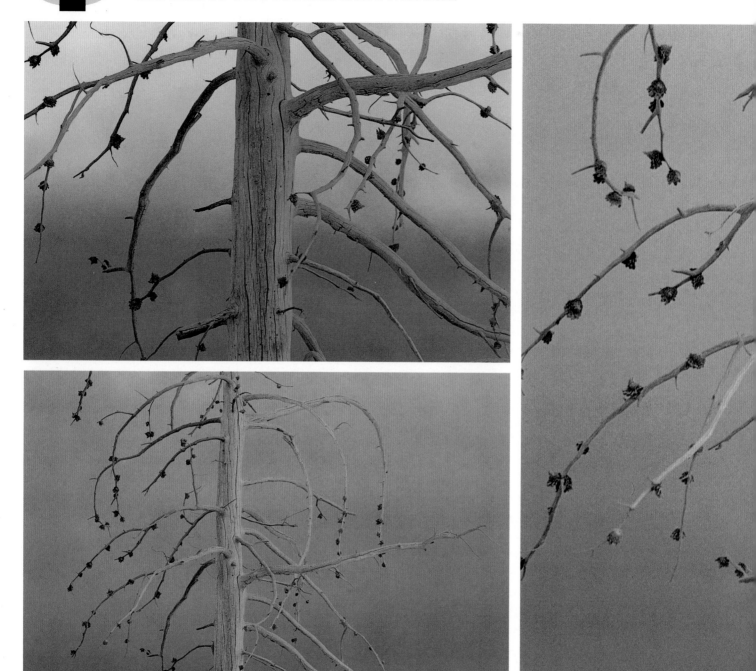

ABOVE AND BELOW: DEAD PINE TREE, YELLOWSTONE NATIONAL PARK, WYOMING. 200–400mm zoom lens (in 400mm range), f/11 at 1/15 second, Fujichrome 50.

ABOVE RIGHT: DEAD PINE TREE, YELLOWSTONE NATIONAL PARK, WYOMING. 200–400mm zoom lens (in 400mm range), f/11 at 1/15 second, Fujichrome 50.

AW In the first image, the tree is silhouetted against a much lighter pink sky. In the second, it is against a part of the cloud closer in value to that of the tree, but the composition is still not quite there. In the third, the cloud is now in complete balance with the value of the dead tree, and I have recomposed the tree to fill out all four corners of the composition. To my eye, it is a more harmonious image.

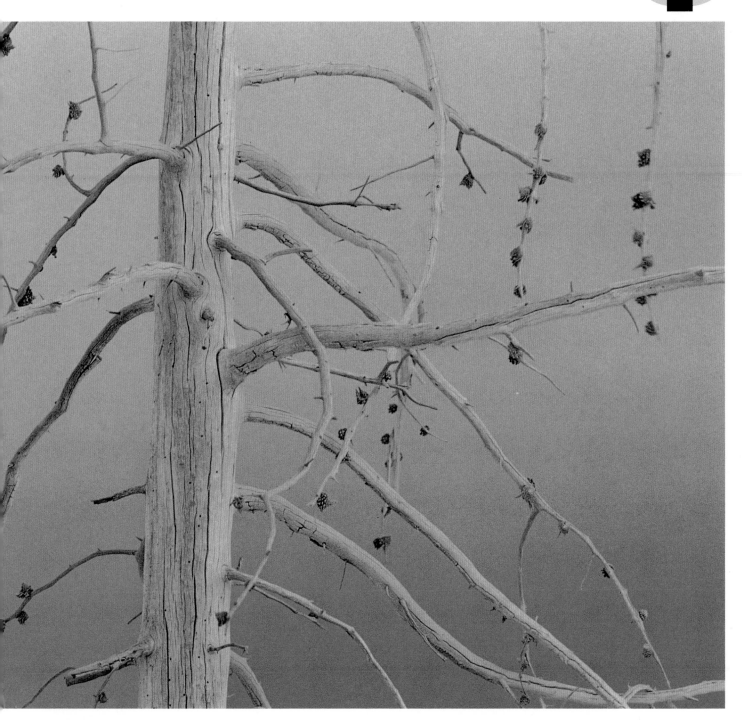

MH We are talking about very subtle distinctions here. Many people will like the first image over the third because of the luminous quality of the pink background. And it is clearly a matter of personal taste.

What makes the third photograph so appealing to me is the ethereal quality of the light. The background colors gradate very subtly from pink to lavender to blue in an even tonality, giving a sense of serene harmony and balance. The linear design of the tree branches is weighted slightly off-center, thus creating a delicate imbalance.

The spatial depth in the picture is also ethereal. Like an Oriental painting, the sense of three-dimensional space is ever so subtly there, as the lighter tone of the tree brings it forward from the background. The branches reach to the edges of the frame, also bringing the tree to the frontal plane of the picture space. To me, this third version is *shibui*, which in Japanese describes something of an understated, highly refined elegance.

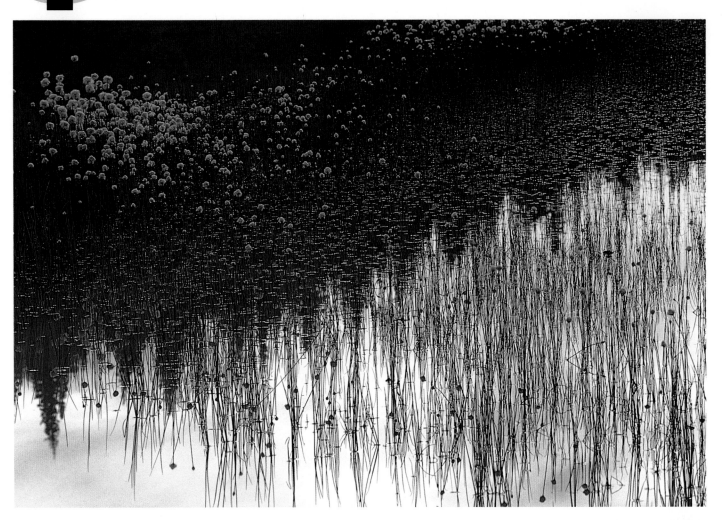

REFLECTION,
COTTON GRASS
AT LAKE EDGE,
DENALI NATIONAL
PARK, ALASKA.
80–200mm zoom
lens (in 80mm
range), f/16
at 1/2 second,
Fujichrome
Velvia.

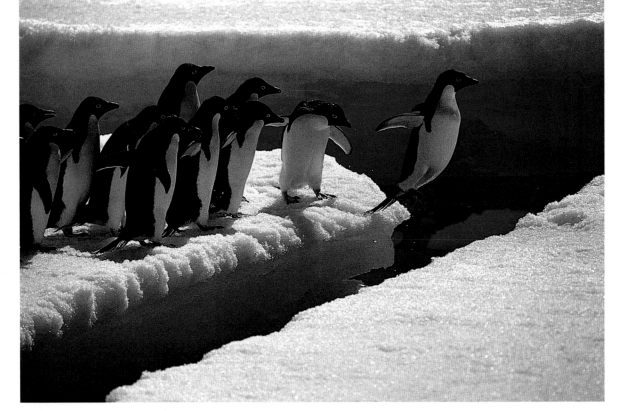

LEAPING ADÉLIE
PENGUINS,
ANTARCTIC
PENINSULA.
300mm 2.8 lens,
f/8 at 1/250
second,
Kodachrome 64.

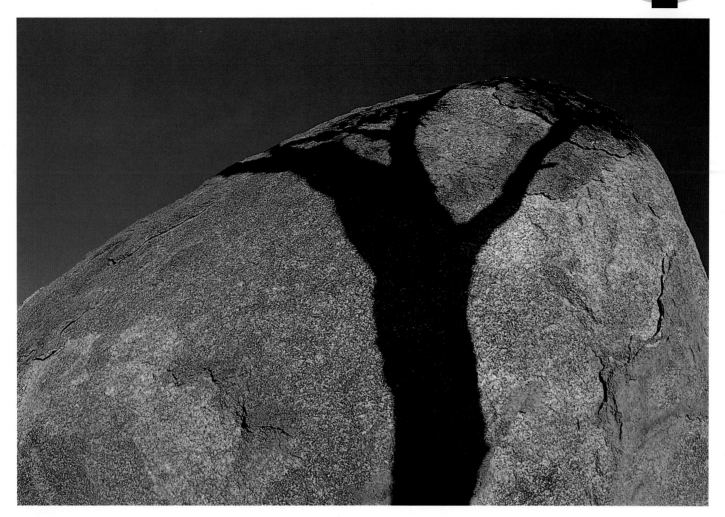

AW In this portfolio of three images, you see first the picture of cotton grass in Alaska. I wanted to make a complete composition that filled out the four corners of the frame. Snow reflects lots of light, and I was able to shoot the Adélie penguins at 1/500, which stopped the action of the leaping bird. In the third image, your eye follows the tree shadow as it spreads out on the rock, again filling out the picture space within the frame.

MH What Art describes as filling out the four corners is working within the space dictated by the rectangle of the viewfinder.

In the cotton grass image, the strong diagonal line of the shadow gives the picture its dynamism. Otherwise, it is quiet and subtle, a balance on the one side of soft, white puffs of grass, and on the other by the pastel cloud reflections. The interplay of light, line, texture, and color are reminiscent of an impressionist canvas. This is another image I would qualify as *shibui*.

The penguin shot is one of my all-time favorites. It has humor, composition, a sense of place, and drama. The strong, dark diagonal takes us immediately to the most important penguin. Suspended in midleap, he provokes us to think not only about what he is doing, but more empathetically, about the hazards he has to face on a daily basis. The fact that he looks like a comical little man makes us chuckle, but we find ourselves hoping that he will safely reach the other side.

The last image, of the tree shadow on the boulder, is brilliant in its idea—we have the tree without having the tree. I like this visual ambiguity, where illusion and reality cross over. The shadow is a bold presence, more bold than the real tree, and looks almost like a deep crevice in the rock. Everything about this picture is bold, from its concept to its design and intense complementary colors of orange and blue.

SHADOW ON MONOLITH, DEVIL'S MARBLES, NORTHERN TERRITORY, AUSTRALIA. 20mm lens, f/16 at 1/15 second, Fujichrome 50.

1 ISOLATING THE SUBJECT

The first decision to make is what you want to photograph. The best place to start is with what appeals to you. When I used to review portfolios, I could always tell what subjects the photographers really enjoyed shooting. It was invariably their best work.

If finding subject matter to photograph is easy, making it stand out is harder. Our first impulse, when something catches our eye, is to point the camera, center the subject, and shoot the picture. When the processed film comes back, all too often we are disappointed and ask ourselves, "Why did I take that picture?"

As a rule, simplicity is the clearest way to make a statement. The novelist and critic Henry James wrote, "In art economy is always beauty." At *Audubon* magazine, we used to tell our writers and photographers in jest that we editors had the attention spans of five-year-olds. The message was: be bold and up-front with the communication. If you couldn't grab our interest quickly, then how could we expect our readers to be interested? Visual and verbal communication had to be direct.

In his book *Principles of Composition in Photography*, Andreas Feininger describes the process as "isolating" the subject. The camera is completely objective and will record everything in the viewfinder. A great many images are disappointing because too much is going on in them visually.

When Art is out in the field, looking for subjects to shoot, his eyes are like scanning radar. But once he locates something of interest, the creative decisions take over. Where do I stand? How long a focal length lens do I want? How large do I want the subject to be in the frame? Where is the light coming from? What is in the background? What is in the foreground?

In a landscape, a lot of things are usually going on in the viewfinder. Artists who sketch in the field will often take a piece of cardboard with a rectangle cut from the middle. By holding it up to frame various sections in the landscape, they can isolate what has potential as a strong composition.

This can also be a valuable aid for photographers who have trouble visualizing the potential field of view of different focal length lenses. The closer you hold the hole in the board to your eye, the more it approximates the field of view of a wide-angle lens. The farther away you hold it, the more it resembles what a telephoto lens might see.

Isolating the subject is the first step in making a stronger composition. This can be achieved in a number of ways—coming in close, backing up, looking down, looking up, changing the direction of the light on the subject, waiting for another time of day, blurring the action or stopping the action, using selective focus to blur unwanted elements, putting a light subject against a dark background—all these are potential creative solutions. We will deal with them in later chapters.

Isolating your emotional responses to the subject may be more complicated and take time and practice, but it is an important step for an artist. If you can analyze why you feel drawn to make the picture, and work to express the feeling clearly, chances are someone looking at it will also respond with more than passing interest.

USING LENSES

AW One of the most important decisions that confronts a photographer in the field is how to record photographically what he deems an interesting subject. Often it is a matter of what lens to use or what angle to use to capture the subject. As I was walking through a field of boulders high in the Canadian Rockies, I noticed the beautiful corallike patterns of lichen on a granite rock. I set up my 55mm macro on a tripod, twenty-four inches from the rock, and began taking pictures. As you look at this image, you can see how the lichen at the center of the composition is overwhelmed by all the other lichens, as well as by the out-of-focus rock in the background. These serve to confuse the eye.

What I liked were the actual patterns of lichen in the center. In the second shot, I moved in a little closer, to about twelve inches away. Now the lichen takes on the shape of coral and becomes more prominent in the composition. Yet I still felt I wanted to try it as a complete abstract.

In the last frame, I moved in to within a couple of inches and reframed the shot to make a very strong pattern. Now it becomes not so much a "lichen on a rock" image as an abstract composition of rolling hills or anything else you want it to be. It's very two-dimensional and, more important, regardless of whether the viewer likes this type of imagery, there can be little question as to what my original intent was in this last frame.

MH Here, subject isolation is complete. Macro lenses open up whole new worlds and allow us to experience the familiar and ordinary in an unfamiliar way. Edward Weston did this years ago in his close-up studies of vegetables in black-and-white. They were sensuous—reminiscent of the lines, curves, and forms of the nude human body. Likewise, Imogen Cunningham's close-up photographs of calla lilies seem extraordinarily sexual, much like Georgia O'Keeffe's paintings of flower parts.

The macro lens involves us intimately with the subject. When it is looked at closely, the subject becomes an abstract, freed from its former identity. Whether we see the coral shapes that Art did isn't necessary. We can free-associate within our own experience.

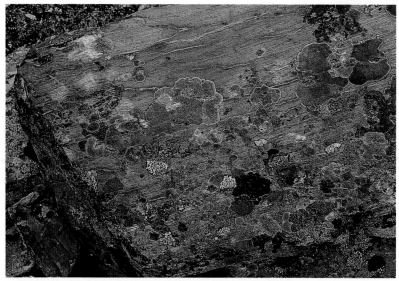

LICHEN ON ROCK, JASPER NATIONAL PARK, ALBERTA, CANADA. 55mm macro lens, f/16 at 1 second, Fujichrome Velvia.

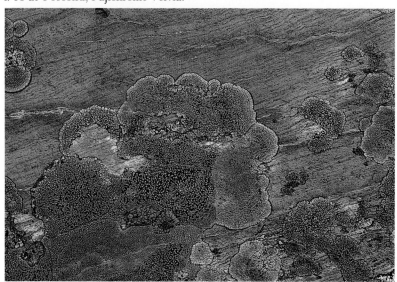

LICHEN ON ROCK, JASPER NATIONAL PARK, ALBERTA, CANADA. 55mm macro lens (focusing in closer), f/16 at 1 second, Fujichrome Velvia.

LICHEN ON ROCK, JASPER NATIONAL PARK, ALBERTA, CANADA. 55mm macro lens (focused at the closest setting), f/16 at 1 second, Fujichrome Velvia.

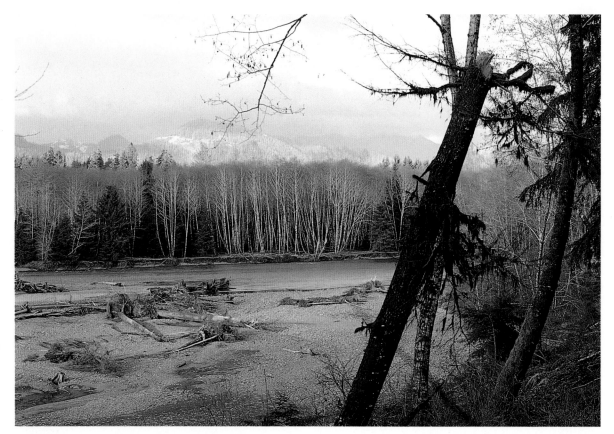

ALDER TREES,
ELWHA RIVER,
OLYMPIC NATIONAL
PARK, WASHINGTON.
80mm lens,
f/16 at 1/8
second,
Fujichrome
Velvia.

AW In this sequence, we see a progressively tighter series of compositions. The first was a record of what I saw as I drove up a road in the western Olympic Mountains. What caught my eye was the white alder trees in the early spring. I used my 80mm lens to record the scene. The composition is loose; there is too much detail being incorporated. Very distracting elements are the light sky, the trees on the right, and the shoreline in the foreground strewn with logs. All these serve to weaken what I initially saw.

The second image was taken at 200mm focal length, and while some of the distracting elements are removed, I still haven't achieved the statement of trees that I want. The last image was taken with a 400mm lens. I am now tight on the tree trunks, and there is nothing to compete with the delicate lines of the trunks and branches. The fine detail could not have been achieved on a bright, sunny day, however. The even, soft, overcast light created a uniform condition, without bright highlights and dark shadows. Had I photographed this scene under sunny, midday light, the trunks would have cast shadows on each other, and the image would have broken up into dark and light patches, making it too hard for the film to read. (We will cover film sensitivity in the chapter on light).

MH This is a classic landscape dilemma most photographers are faced with, and a perfect example of making order out of chaos. If you don't have the luxury of moving to a new vantage point from which to photograph, then you have to think of an alternate way to make the image say what you want. By zooming in on the tree trunks, as Art has done, you end up with an image that makes a statement about the trees, without the confusion of the surroundings.

We used an image very similar to this of Art's aspen trees as a cover of *Audubon* in March 1985. It was a subtle study of line and tone, again taken under soft-light conditions. Trees have character. With aspens, one tends to think of leaves—"the quaking aspen." But what made the cover image so unusual was just having the straight, narrow, white trunks of the trees closely massed together.

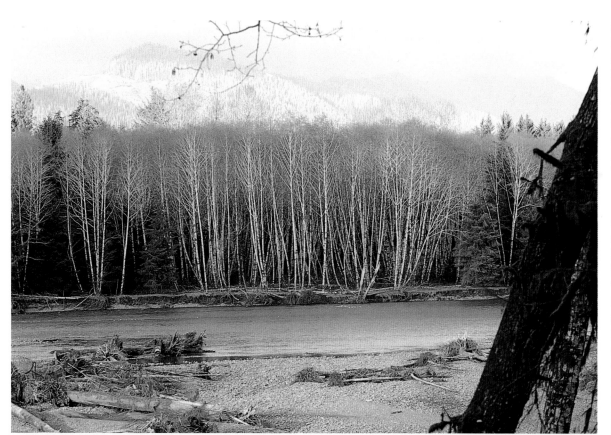

LEFT: ALDER TREES, ELWHA RIVER, OLYMPIC NATIONAL PARK, WASHINGTON. 80–200mm zoom lens (in 200mm range), f/16 at 1/15 second, Fujichrome Velvia.

BELOW: ALDER TREES, ELWHA RIVER, OLYMPIC NATIONAL PARK, WASHINGTON. 560mm lens arrangement (200–400mm zoom lens in 400mm range with 1.4 extender, *400 x 1.4 = 560*), f/16 at 1/8 second, Fujichrome Velvia.

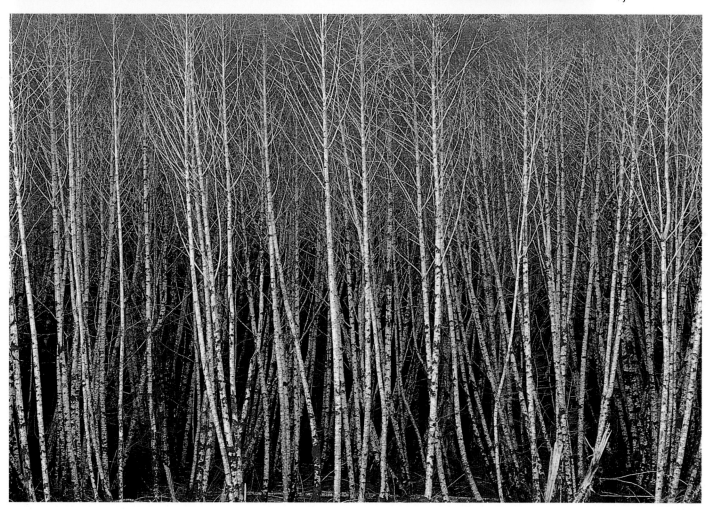

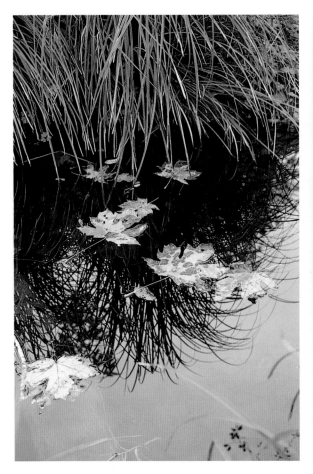

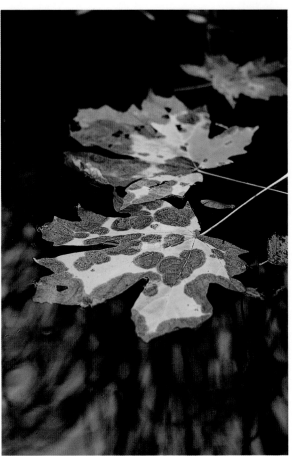

RIGHT: MAPLE LEAVES IN POND, OLYMPIC NATIONAL FOREST, WASHINGTON. 50mm lens, f/5.6 at 1/30 second, Kodachrome 64.

FAR RIGHT: MAPLE LEAVES IN POND, OLYMPIC NATIONAL FOREST, WASHINGTON. 135mm 2.8 lens, f/5.6 at 1/30 second, Kodachrome 64.

ELIMINATING CLUTTER

AW In this third set of images, I am photographing maple leaves I found floating on a small pond on the Olympic Peninsula. In the first image, shot with a 50mm lens, there are a lot of elements that confuse the eye—the out-of-focus blades of grass in the foreground, the leaves below the surface, and the tangle of reeds at the top of the frame. You may look at this slide and say, "What was Art trying to photograph?"

In the second frame, I've gone to 135mm, and I'm narrowing down my subject matter. My interest is clearly the floating leaves, but there is still a lot of clutter here. Some leaves are out of focus, and my eye is still wandering throughout, trying to make some kind of order.

In the third image, I've simplified it to a single leaf floating on the surface. To give it a sense of place, I've left a suggestion of the reeds in the reflection. The final image still has the same elements as the first, but the statement is clearer and stronger.

MH While I do like the composition of the middle image, because of the shallow depth of field, I would have to reject it for publication. If the front edge of the biggest leaf were sharp, it would be publishable, and I'd also crop the light spots at the top edges.

The final version is definitely the best, partly because of its simplicity, but also because there is a subtle play of elements going on in the picture. There is no question, visually, that the leaf is floating on the water. As a light subject, it comes forward of the darker background. Art has also placed it high in the picture, so it floats within the vertical space. But it is firmly held down, in the picture space, by the strong dark space at the top. From the bottom, the soft curves of the reflected reeds hold the leaf up and in the frame.

The reflection of the grasses implies a swirling movement to remind us the leaf is not really frozen. It is subject to the flow of water and the blowing wind. Without this, the picture would be static. The dark shadow line of the grass gently divides the picture across a diagonal line, which adds a dynamism to the image, reinforcing the illusion of motion.

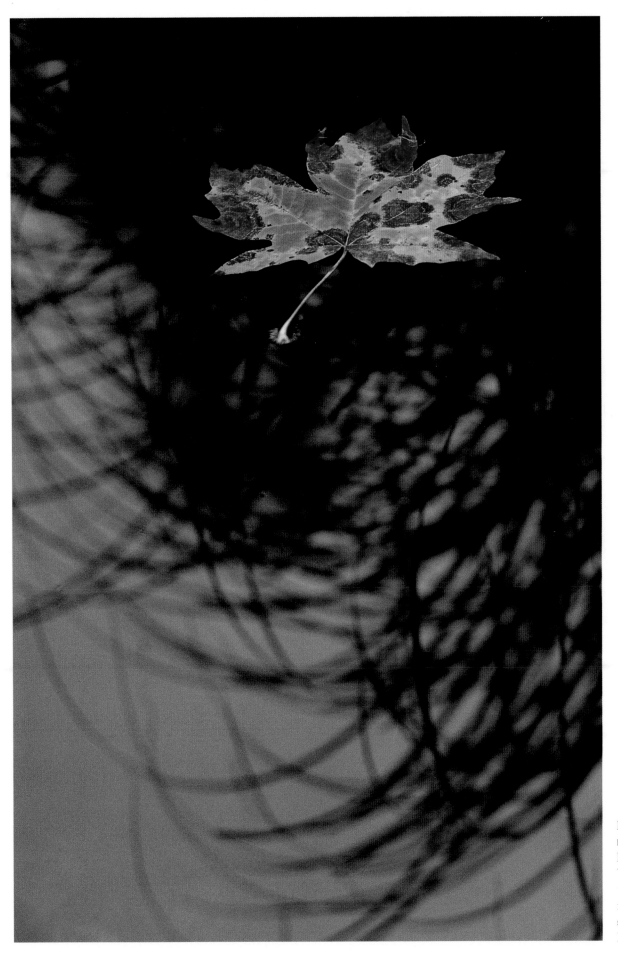

MAPLE LEAF IN
POND, OLYMPIC
NATIONAL FOREST,
WASHINGTON.
135mm 2.8 lens,
f/5.6 at 1/30
second,
Kodachrome 64.

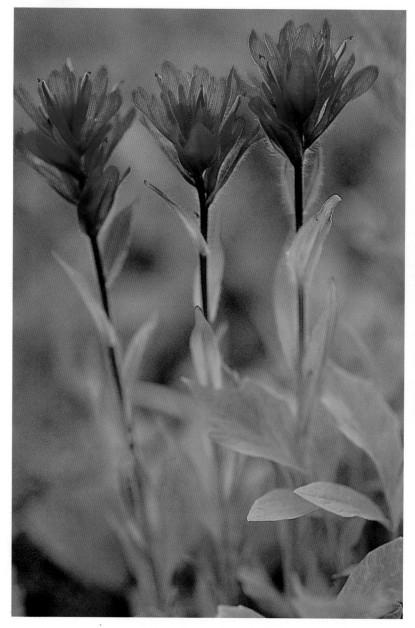

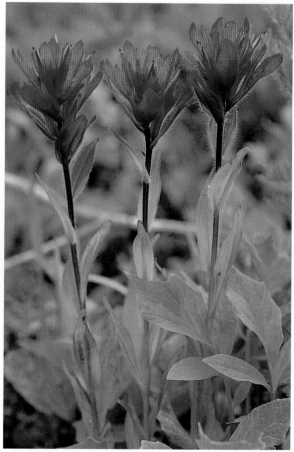

ABOVE LEFT: INDIAN PAINTBRUSH, BANFF NATIONAL PARK, ALBERTA, CANADA. 55mm macro lens, f/5.6 at 1/60 second, Fujichrome Velvia.

ABOVE RIGHT: INDIAN PAINTBRUSH, BANFF NATIONAL PARK, ALBERTA, CANADA. 55mm macro lens, f/11 at 1/15 second, Fujichrome Velvia.

AW Here we have a comparison of two Indian paintbrush in the Canadian Rockies. In the photo on the right, I was distracted from the soft greens of the plants by the hard, white line of a dead branch immediately behind them. Often when photographing, it is easy to be intent on the subject and not see distracting elements that weaken the composition and should be eliminated. Simply by my removing the dead branch and reshooting, you can immediately see how greatly improved the image is.

MH This is a common problem many photographers have in composition, not seeing the little details in the picture that will suddenly jump out when the image changes from a three-dimensional experience to a two-dimensional slide. One little white line can divert the eye from the real subject. As we saw with the floating leaf, light elements tend to stand out, and dark elements to recede. If a background element is lighter than the subject, it can fight with the eye and interfere with enjoyment of the picture.

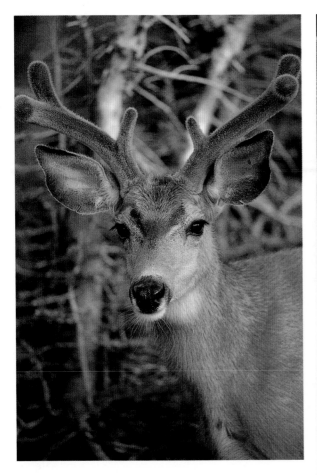

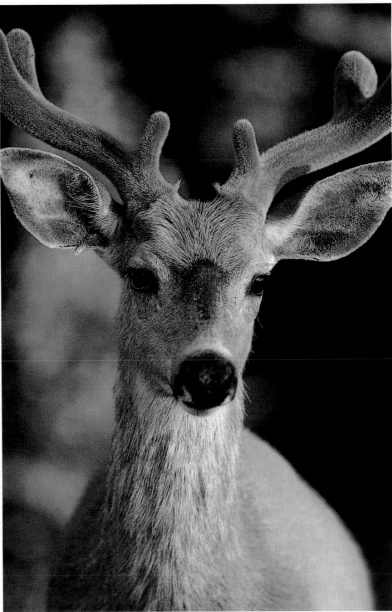

AW　Distracting elements are a frequent problem that impairs the success of an image. Often, the background interferes with the full impact of the subject. Most serious 35mm single-lens reflex cameras are equipped with a depth-of-field preview button, which many photographers either ignore or don't know how to use. It is invaluable for checking the zone of focus for each aperture setting on the lens. At f/2.8, wide open, the depth-of-field is very shallow, sometimes a matter of inches, depending on the focal length of the lens. At f/22, the aperture is tiny, and depth-of-field is deeper.

MH　In the first portrait, there are too many distracting lines in the background, making it difficult to see the antlers. If this were to be a statement of how deer are camouflaged in the forest, however, the cluttered background is necessary. But as a pure deer portrait, the second image is definitely cleaner and simpler. The deer now stands out, partly because the background is so dark, and partly because it is uncluttered.

Depth-of-field control is important to master. I had to reject a lot of photographs at the magazine because of distracting elements in the foreground or background. In publishing, there are times when the empty background is desirable, as when type needs to be superimposed on the image. Magazine covers almost always need some clean space of a solid tone (either pale or dark) in which to do just that.

MULE DEER BUCK, GLACIER NATIONAL PARK, MONTANA. 200–400mm zoom lens (in 400mm range), f/8 at 1/30 second, Fujichrome Velvia.

ABOVE LEFT: MULE DEER BUCK, GLACIER NATIONAL PARK, MONTANA. 200–400mm zoom lens (in 400mm range), f/8 at 1/30 second, Fujichrome Velvia.

2 COMPOSING THE PICTURE

H L. Mencken once wrote that "the true function of art is ...to edit nature and so make it coherent and lovely. The artist is a sort of impassioned proofreader, blue-penciling the bad spelling of God."

Composition is how we structure a picture to be coherent and lovely. Like the skeleton that is brought to life by the muscles and ligaments attached to it, composition is the unseen structure that gives strength to the photographic statement. If it is strong, lyrical, and clear, it has the power to move others. The photographer, like the brain that directs the whole synchrony of elements, is the soul breathing life into the inanimate. If he is fortunate enough to understand his motivations, he can take the documentary photograph into the realm of art.

What qualities distinguish a well-composed image from one that is not? First, there must be a center of interest. This doesn't mean the subject should be in the center. A poorly composed image may allow the eye to wander out of the picture space, or it may feel out of balance in some way. Perhaps the subject is too small to make us feel its importance, or it may be too large in relation to other elements in the frame.

In his book on composition for painters, David Friend wrote: "A good deal of the magic that transforms a painting into a work of art lies in successful unification. Pulling together the parts or elements of a painting is the crucial and most baffling problem to beginners. Perhaps the term 'integration' describes it better—integration of all the component parts of a picture into a series of *rhythmic relationships* to form an artistic whole."

For photographers, the problem is a little different. You are searching for the right combination of elements in the viewfinder. But the integration of the separate pieces into a lyrical whole is the same goal.

Where to place the subject will be our first set of considerations. Then we will tackle the subject's relationship to other elements within the picture space. Bear in mind that subject placement has ramifications for the ultimate use of the picture, too.

If you are thinking about publishing, then chances are your pictures may end up with type superimposed on them or cropped to fit a square space. Generally, it is wise to have a little leeway in composing and not crop the picture too tightly. *Audubon*'s cover format was unusual— a horizontal wraparound. I had to remind photographers to place the subject off-center, so it would not be cut in half by the spine.

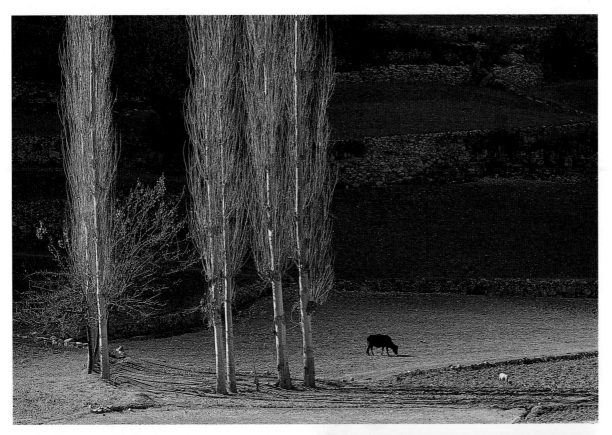

COW WITH POPLAR TREES, HUNZA VALLEY, PAKISTAN. 200–400mm zoom lens (in 400mm range), f/11 at 1/15 second, Fujichrome Velvia.

FORMAT: HORIZONTAL OR VERTICAL?

AW There are situations in which horizontal and vertical formats are equally valuable, and one should be aware of that. When I first started shooting, I shot only horizontals and effectively lost many sales as a result. Now I always pay attention and usually try to shoot both when possible. Each one is valid, but says different things. The first comparison is of poplar trees in the Hunza Valley of Pakistan. The second is a prairie falcon on a cliff, and the last a caribou.

MH In the first pair, the vertical clearly emphasizes the tall, slender quality of the trees, whereas the horizontal gives more sense of place, of light and shadow, with the animal becoming more evident, too. In the prairie falcon comparison, both are strong images. I prefer the vertical because it tells me something about how falcons live. One nearly always finds them perched atop high rocky cliffs where they

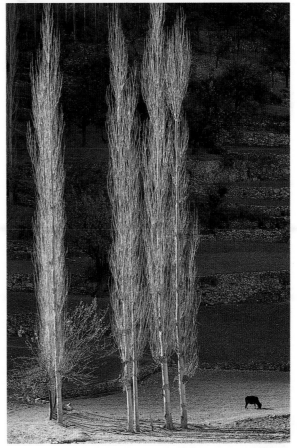

COW WITH POPLAR TREES, HUNZA VALLEY, PAKISTAN. 200–400mm zoom lens (in 400mm range), f/11 at 1/15 second, Fujichrome Velvia.

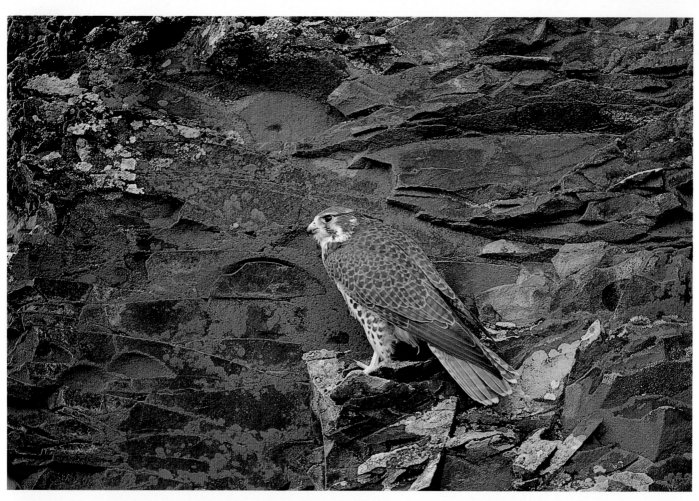
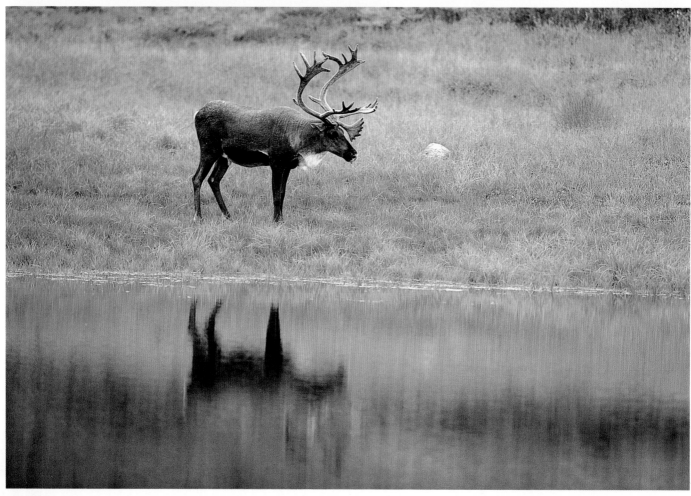

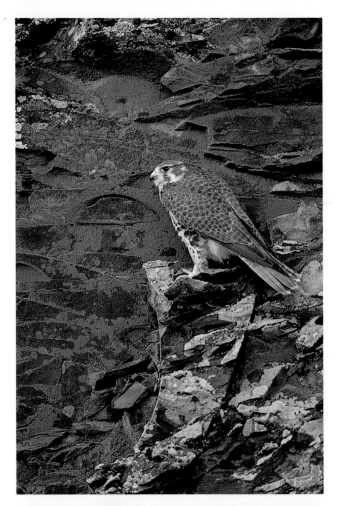

command a good view, since height is crucial to their hunting strategy. In the caribou comparison, notice how the animal's reflection suddenly becomes a more important element in the vertical version. But in all three sets of comparisons, every one is a publishable image.

Art directors always need to have room to crop when doing layouts, so it is important to have both horizontals and verticals of the same subject for maximum flexibility. Most magazine covers use verticals and usually need room at the top to drop out their title. Both formats should be submitted when sending in your photos to a magazine. Most calendars and greeting cards have predetermined formats as well.

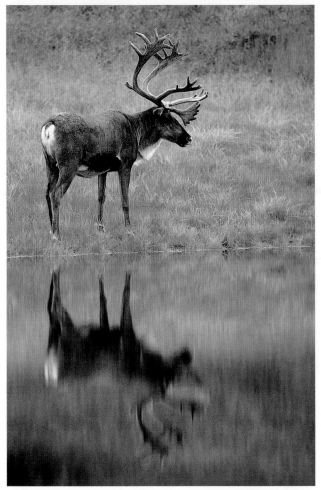

OPPOSITE ABOVE: PRAIRIE FALCON, COLUMBIA PLATEAU, WASHINGTON. 800mm 5.6 lens, f/11 at 1/15 second, Fujichrome Velvia.

ABOVE LEFT: PRAIRIE FALCON, COLUMBIA PLATEAU, WASHINGTON. 800mm 5.6 lens, f/11 at 1/15 second, Fujichrome Velvia.

OPPOSITE BELOW: CARIBOU BULL, DENALI NATIONAL PARK, ALASKA. 200–400mm zoom lens (in 200mm range), f/8 at 1/60 second, Fujichrome 100.

BELOW LEFT: CARIBOU BULL, DENALI NATIONAL PARK, ALASKA. 200–400mm zoom lens (in 400mm range), f/8 at 1/60 second, Fujichrome 100.

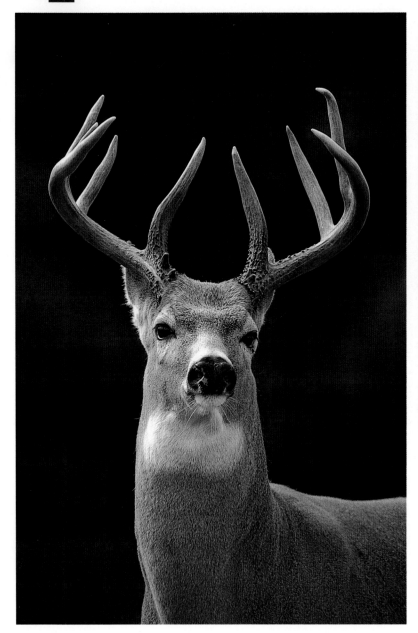

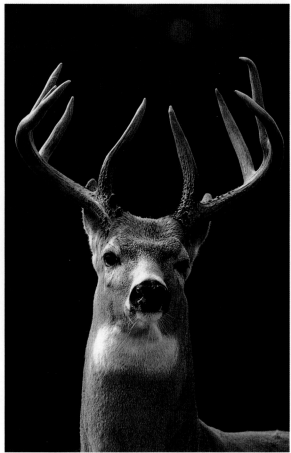

WHITETAIL BUCK, COLUMBIA RIVER VALLEY, WASHINGTON. 300mm 2.8 lens, f/8 at 1/60 second, Kodachrome 64.

WHITETAIL BUCK, COLUMBIA RIVER VALLEY, WASHINGTON. 300mm 2.8 lens, f/8 at 1/60 second, Kodachrome 64.

FRAMING—CROPPING

AW Where you crop the image in the viewfinder can make a significant difference in how the subject looks. In the picture on the right, I have created an unpleasant effect. The head of the deer almost looks like a stuffed wall mount. In the picture on the left, by lowering the viewfinder slightly and giving a little more depth to the body, I have solved the problem.

MH Looking through the viewfinder is like taking a rectangular slice out of life. By selecting certain subjects to lie within the frame, you make a statement about them and create a balance of elements. If those elements come in contact with the frame, or are intersected by it, you need to evaluate what this does to the overall balance. Sometimes, as in the small deer portrait, the cropping creates a strong sense of imbalance that is corrected, in the larger, by a slight change of proportions.

FRAMING—WHERE TO PLACE THE SUBJECT

AW A common mistake is to photograph an animal looking out of the frame. What I liked in this scene was the heron against the mangroves. I took it at the Ding Darling National Wildlife Refuge in Florida. But I prefer the balance of the second image with the bird looking

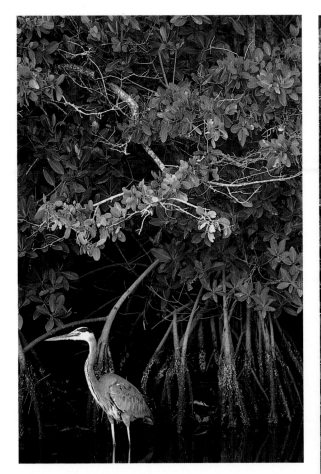

GREAT BLUE HERON, DING DARLING NATIONAL WILDLIFE
REFUGE, FLORIDA. 200–400mm zoom lens (in 400mm
range), f/11 at 1/8 second, Fujichrome Velvia.

into the picture. To my eye, in the first image, the
bird feels crowded up against the left edge of the
picture.

MH Nature photographers need to keep in
mind constantly not only how an ani-
mal relates to its habitat, but how the subject
relates to the frame. Clearly, the bird in the first
photo seems out of balance and its bill too close
to the edge. The balance is much better in the
second, and the vertical format gives a better
feeling of space and height, accentuating the fact
that herons are tall birds.

When a subject is looking out of the frame,
there is an implied line of sight. Our eye naturally
wants to look in the same direction. If this carries
you out of the picture space too emphatically,
then you are in danger of losing your viewer's
interest.

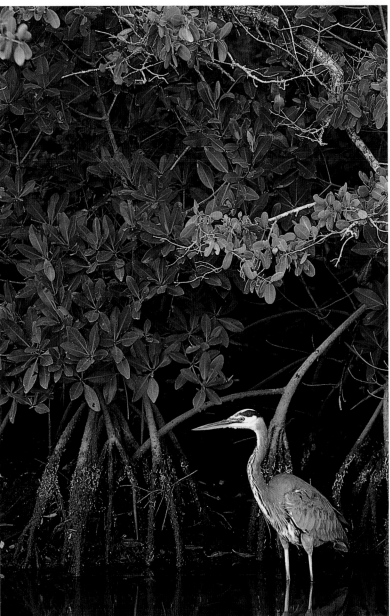

Many people feel a subject should be looking
out at the viewer. We become more interested in
what is going on in the picture precisely because
the subject is looking away from us. We are
curious about what has caught the heron's at-
tention and thus more engaged in his world.

Subjects have a visual "weight," which means
they have a certain importance or position within
the frame. This may be due to the fact that we
experience the force of gravity. We know intu-
itively that objects fall to the ground. When the
weight of the subject seems out of balance within
the frame, too high or too low or too close to the
edge, we find the effect jarring.

GREAT BLUE HERON,
DING DARLING
NATIONAL WILDLIFE
REFUGE, FLORIDA.
200–400mm zoom
lens (in 400mm
range), f/11 at 1/8
second, Fujichrome
Velvia.

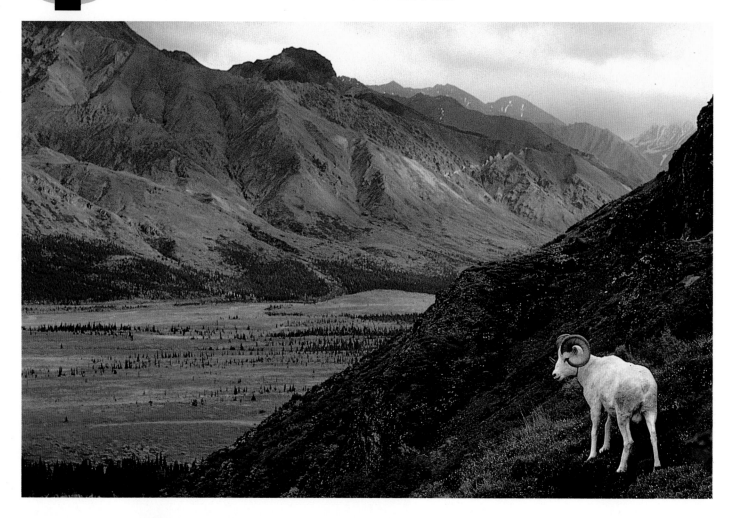

AW In the sheep picture above, the white animal stands out dramatically against the dark fall colors, so your eye goes first to him, then subsequently follows the angle of his body into the rest of the compositional space.

MH Because it looks more like a painting than a photograph, I find the sheep picture very satisfying to look at. The landscape is a rich tapestry of fall colors, and the sheep seems completely natural and unaware of the photographer's presence. He stands out against the darker mountainside, and the steep angle of the slope tells us a lot about his environment. With the sheep angled away from us, we find ourselves drawn into his world, and deeper into the picture space, into the valley beyond.

In fact, if Art had sent this to me when I was still at *Audubon* magazine, I would have pulled it for a fall cover. The off-center placement of the sheep would have been perfect for our horizontal, wraparound format.

SYMMETRY VS. ASYMMETRY

Up until the Renaissance, in the tradition of Western art, composition was dominated by symmetry. The subject was generally in the center, as in the religious paintings of Christ or the Virgin Mary, and if there were other figures in the painting, the composition was symmetrical. They extended outward, or downward, from a central figure. Today, painters predominantly use asymmetrical composition. This allows greater flexibility in giving a subject "visual weight" or emphasis.

Rudolf Arnheim, an expert on psychology in art, devoted a book to the subject of centers as the most powerful focal point in composition. Circles, in particular, because of their perfectly round shape, have tremendous visual energy. Their power is contained within their circumference. Unless they are carefully balanced with the other design elements in the picture frame, the eye will always go first to the circle.

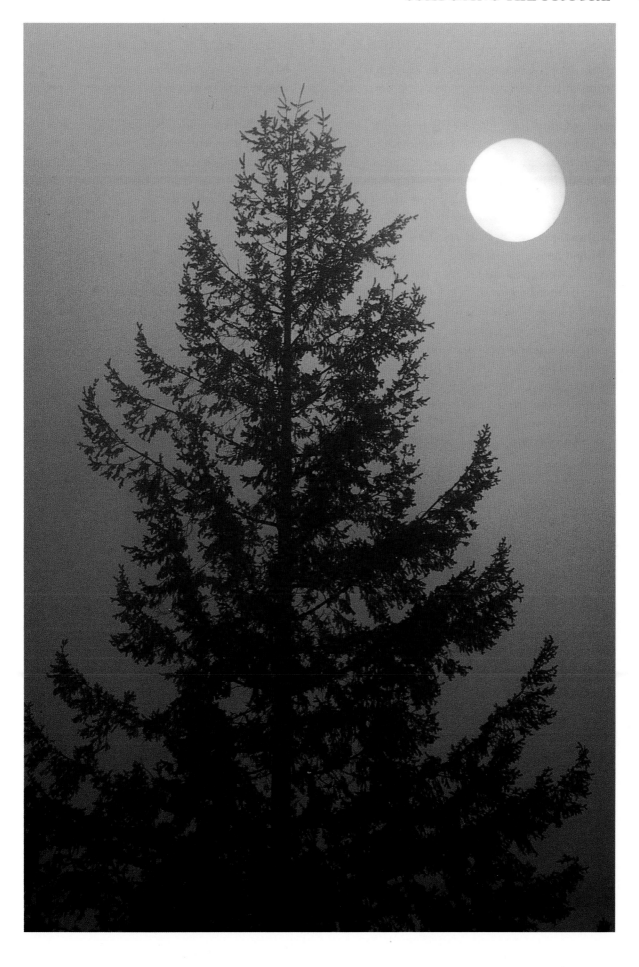

Symmetry is a form of centeredness, based on a central line. It implies a balance between the two spaces on either side of the line, an equilibrium called stasis, which gives us the word *static*. Symmetrical compositions emanate tranquillity and stability. This may be the desired effect.

If, however, you desire a more dynamic statement, asymmetrical composition is the answer. It immediately shifts the emphasis, giving more visual weight to one area over the other. This off-balance positioning creates tensions confined within the picture frame. Tensions, which can be defined as a sense of being visually tugged in a certain direction, can be disturbing, if not somehow counterbalanced to keep the eye and the mind focused on the action inside the picture space.

In Art's image of the sun and evergreen on the previous page, the sun is the first thing to attract our eye. But it is balanced by the strong pyramid shape of the tree. Neither one overpowers the other. And yet the image is far from static. Our eye travels back and forth from the sun to the tree, enjoying the comparison of dark and light, of shapes and elegant simplicity.

Asymmetry requires that a balance be restored. We seem to have an innate desire for stability. Since we ourselves experience gravity, we look at the world with a subconscious assumption that everything falls to the ground. Things that are lower in the frame appear naturally weighted toward the earth. Large areas with solidity placed too high in the picture look out of balance, either too heavy or as if they are taking off out of the top of the picture.

However, as we saw in the picture Art made of the single leaf floating high in the frame, the balance was restored by two things — the grass shadows that curved upward in the lower portion, and the large dark space at the top. These reweighted the visual elements so that they worked in a new harmony.

There are still times when putting the subject in the center makes a more powerful statement.

PATTERNS IN SAND, WHITE SANDS NATIONAL MONUMENT, NEW MEXICO. 28mm lens, f/16 at 1/15 second, Kodachrome 64.

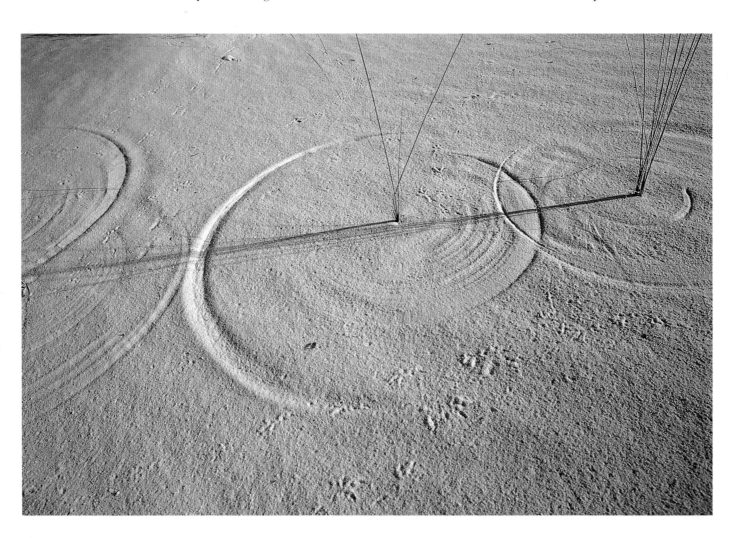

SUBJECT IN CENTER

AW In the first image, the circular pattern created by the wind is deliberately placed in the middle, but is balanced on either side by more circular patterns. In the second, with the man between two boulders, the man is placed intentionally in the middle with the two boulders of equal weight on either side. I wanted to make an abstract statement—to accentuate the balanced symmetry by making each element of equal importance. In the third, with the male lion approaching me, I wanted him in the center so all your attention would be focused on him. The last is an example of abstract design. I was intrigued by the "eye" spots on the tail feathers.

MH Like the bull's-eye of a target, a subject in the middle of the frame keeps one's gaze on the center. As long as that is the most interesting part of the picture, as in the lion image, it is entirely appropriate. The surroundings are completely secondary to the animal. We are riveted by the look in the lion's eyes as he heads toward us with the full menace of a large and dangerous predator.

In the shot of the man and boulders, the tension created by the two strong shapes on either side is held in balance by the central figure. Without him, the two shapes lose interest. They become two dark blobs.

In the image of the grasses, the circular patterns are the center of interest, and Art has put the strongest design in the middle. But because of the other circular patterns on each side, the picture is balanced, not static. The number three is an odd number and lends itself to more dynamic compositions than, say, two or four, quite possibly because the latter reinforces the rectangular frame of the composition, whereas the odd number does not.

The boldest statement of symmetry and of the riveting power of circles is the pheasant-feather image. It is hard to ignore the brilliant purple spots, as they dominate the surrounding pattern of a much smaller scale. What helps here is that they are not placed exactly in the center of the frame. The symmetry is on the vertical plane, but not the horizontal, helping the eye to move around inside the frame.

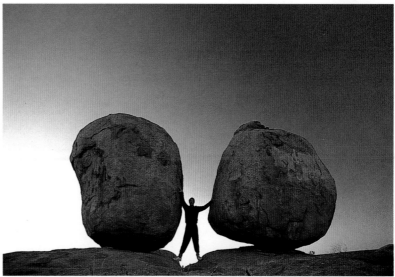

SILHOUETTE, DEVIL'S MARBLES, NORTHERN TERRITORY, AUSTRALIA. 20mm lens, f/11 at 1/30 second, Fujichrome Velvia.

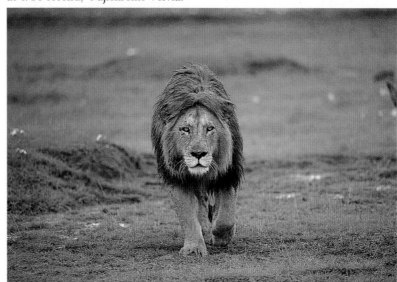

ADULT MALE LION, NGORONGORO CRATER, TANZANIA. 200–400mm zoom lens (in 400mm range), f/5.6 at 1/60 second, Fujichrome 100.

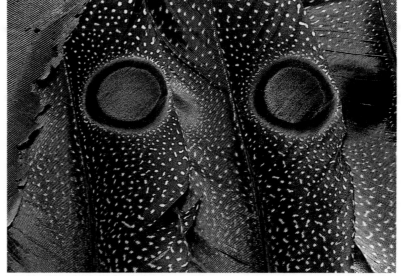

GREAT ARGUS PHEASANT FEATHERS. 55mm macro lens with flash, f/16 at 1/60 second, Fujichrome Velvia.

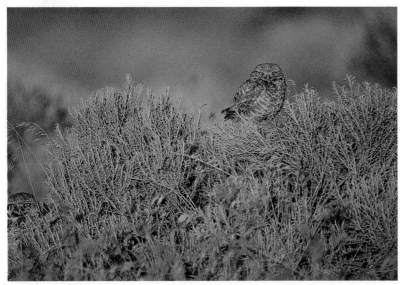

Burrowing owl, eastern Oregon. 800mm 5.6 lens, f/5.6 at 1/30 second, Fujichrome 100.

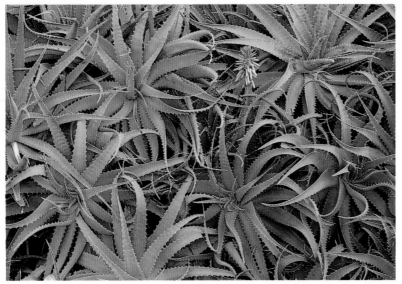

Aloe plants, Hawaii. 55mm macro lens, f/16 at 1/8 second, Fujichrome 100.

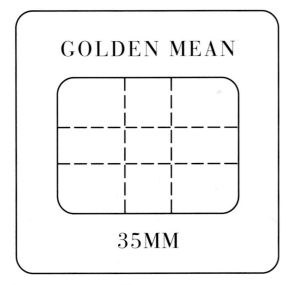

The Golden Mean Proportions for 35mm Format.
Center of interest would lie on *one* of the grid's intersections.

THE GOLDEN MEAN

AW In the next four examples, you see how the main subject has been taken out of the center to make a more dynamic composition.

MH Art composes many of his images instinctively close to the ideal ratio the Greeks called the golden mean. It was considered the perfect spatial proportion for sculpture and architecture and works out mathematically close to a ratio of 8:5. For us, using 35mm format (24mm x 36mm), it means a grid such as we have illustrated below. Accordingly, the focal point of the image should fall where these lines intersect.

Other books on photographic composition talk of the "rule of thirds." The proportions are not quite the same, but the idea is similar. The intersections of the grid lines, in either case, represent powerful "new" centers of interest.

Whether you subscribe to either formula or not, they do create the possibility for an asymmetrical composition of appealing proportions and are fun to use in analyzing compositions of your own and other people's work. Try cropping these images on your own and playing with the spatial relationships of subject to background and subject to frame. You can decide what proportions are most pleasing to your eye.

Rules, as we know, are made to be broken. Asymmetry, though, opens up more possibilities for composition than symmetry. Symmetry represents a formal, stable, static organization. Not having the visual weight in the middle opens the door for creating tensions and relationships between the pictorial elements, achieving a new balance and a more exciting dynamic composition.

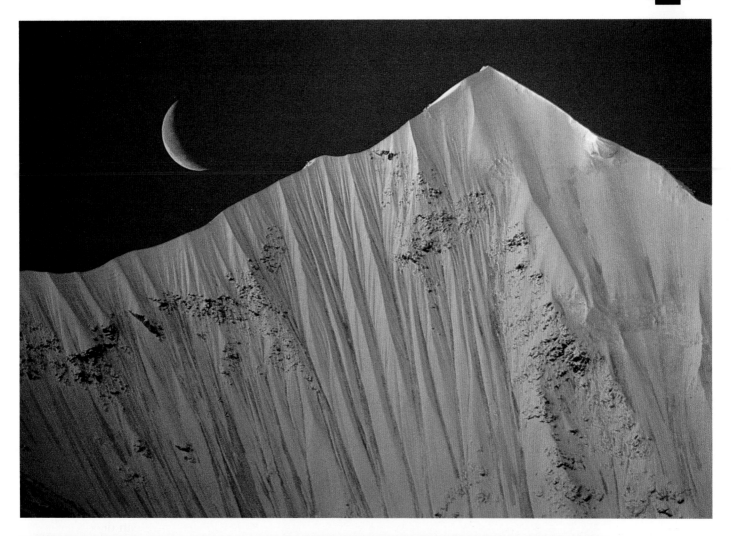

CRESCENT MOON
OVER MOUNT
LINGTRIN, TIBET.
300mm 2.8 lens,
f/5.6 at 1/8
second,
Kodachrome 64.

SOUTHERN BEECH
TREE, MOUNT
FITZROY NATIONAL
PARK, ARGENTINA.
300mm 2.8 lens,
f/11 at 1/8
second,
Fujichrome 100.

3 DEFINING YOUR PERSPECTIVE

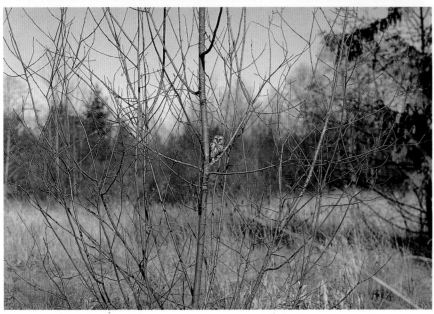

In chapter 1, we looked at isolating the subject. In chapter 2, we looked at the subject in relation to what else was going on inside the picture frame. This chapter deals with how you, as the photographer, want to make your statement. This involves your choice of lens, where you stand in relation to the subject, how different lenses alter spatial relationships within the frame, and your angle of view.

Defining your perspective as a photographer implies making an evaluation of the size of the subject in the frame, and its relation to the other pictorial elements. You have two choices for altering size: you can move closer or farther away to make it larger or smaller in the frame, or you can change lenses.

Now it becomes important to understand the relationship of your lens focal length to magnification of your image. Remember, we are talking about the 35mm format. The 50mm lens comes closest to having a magnification power of one. This lens is often described as "normal," because supposedly it comes closest to rendering what we see with the naked eye.

Doubling that focal length to a 100mm doubles the size of the subject in the frame. Taking this another step further, a 500mm lens would render a subject

ten times larger than the 50mm lens, the equivalent of a ten-power binocular.

To show how much enlargement is needed for an almost frame-filling portrait of a small subject, Art has remained thirty feet from the owl and increased his focal length from a 50mm lens to an 800mm, when the bird is now sixteen times larger in the final image.

Changing to a longer focal length is not the same as moving closer to the subject, as we will see in the next series of comparisons. Each power of lens magnification cuts your distance to the subject in half. But the spatial relationships are not the same when you move closer. Shooting with a telephoto from a great distance, with a narrow field of view, gives you a much more intimate portrait than if you get up close to it with a wide-angle lens.

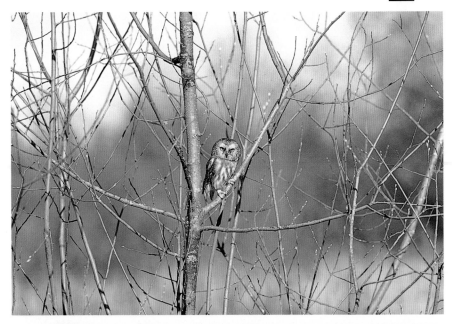

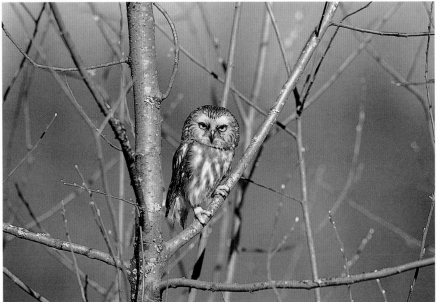

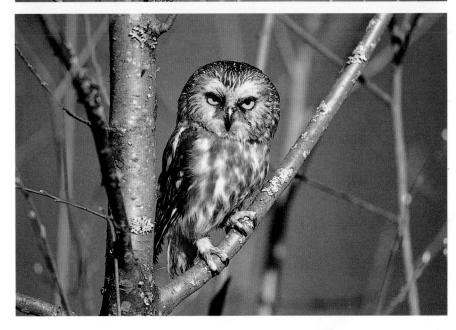

OPPOSITE TOP: SAW-WHET OWL, WASHINGTON. 50mm lens, f/8 at 1/30 second, Fujichrome Velvia.

OPPOSITE BOTTOM: SAW-WHET OWL, WASHINGTON. 80–200mm zoom lens (in 80mm range), f/8 at 1/30 second, Fujichrome Velvia.

TOP: SAW-WHET OWL, WASHINGTON. 80–200mm zoom lens (in 200mm range), f/8 at 1/30 second, Fujichrome Velvia.

MIDDLE: SAW-WHET OWL, WASHINGTON. 200–400mm zoom lens (in 400mm range), f/8 at 1/30 second, Fujichrome Velvia.

BOTTOM: SAW-WHET OWL, WASHINGTON. 800mm 5.6 lens, f/8 at 1/30 second, Fujichrome Velvia.

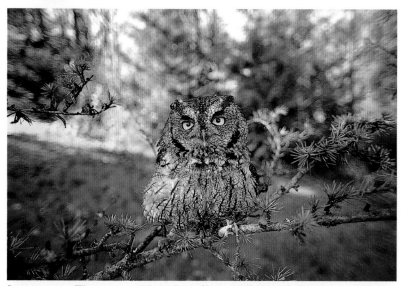

Screech owl, Washington. 20mm lens, f/4 at 1/60 second, Fujichrome Velvia.

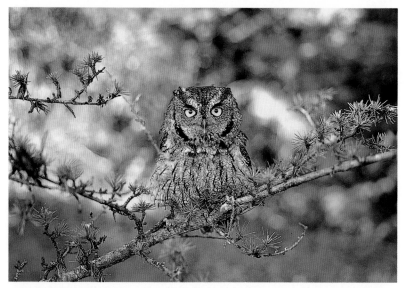

Screech owl, Washington. 50mm lens, f/4 at 1/60 second, Fujichrome Velvia.

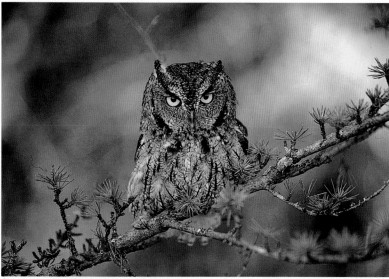

Screech owl, Washington. 80–200mm zoom lens (in 200mm range), f/4 at 1/60 second, Fujichrome Velvia.

Lenses have other features that alter normal seeing. This comparison of images of the same owl taken with different focal length lenses shows how each has a different impact on the space around the bird. The owl stays approximately the same size in the frame. Art backed away as he changed lenses from the 20mm wide-angle to the 50mm, and then to the 200mm. While none of these images is perfection as a composition, they are included to show how the relationship of subject to surroundings changes from the expanded space of the 20mm to the spatial compression of the 200mm.

Telephoto lenses not only bring the subject in close with magnification, but create a false perspective of compressed distance between objects on different planes. A telephoto shot of trees would show them looking more compactly stacked together than they would be in reality.

Wide-angle lenses do just the opposite. They expand the distance between objects on different planes. This can be very helpful when photographing a subject in a tight place. A wide-angle, with its great depth-of-field (the zone of what will be in focus), allows you to come close to the subject and still keep everything distant in sharp focus. But it pushes those other elements farther away and makes them smaller in relation to the subject.

The other aspect to consider when deciding about the size of the subject in the frame is your angle of view. Perhaps you don't want normal, eye-level human perspective. You may want to get above or below your subject, take away the horizon line, or exaggerate its size or importance in some other way.

SCALE: HOW LARGE SHOULD THE SUBJECT BE?

AW In these three shots of a spotted owl, we see how the owl changes in importance. In my opinion, one is no stronger than the other, they simply say different things. The first composition is a shot of old-growth forest that happens to have an owl as an element (80mm lens). In the second, the owl is clearly more evident and there is still enough of a forest showing through so you have a strong sense of place (200mm lens). But in the third, I've eliminated most of the forest and the owl is clearly the dominant element. It is a more rewarding view of the owl, and of the textures of the trees, which you can now fully appreciate. The sense of forest is definitely gone (400mm lens).

MH In each of these images, the owl relates to his surroundings in a different way. In the first, he is hardly visible, blending in beautifully with his surroundings. It is interesting that here, the light-colored branch, rather than being a detracting element, actually leads our eye right to the owl. The forest, with its strong vertical lines, is clearly the dominant element in the frame. If I had a story to illustrate that emphasized the need to save lots of habitat to provide for one owl, I would use this version.

In the middle frame, there is much more of a balance between the bird and the forest. The owl stands on its own, without being overpowered by the trees. This would be a classic opening shot for a story on spotted owls and old-growth forests.

In the last image, you have a portrait of the bird. Now, too, the lighter limbs of the trees actually take over as the strong linear elements in the composition. The owl's soft shape stands out against the harder lines of the tree trunks, without losing the feeling of camouflage we had in the first version. Unless I had text I wanted to drop out of the space on the left, I'd crop this to a vertical to emphasize the owl even more.

AW To tell a complete story, it is sometimes necessary to introduce an element that dramatically shows the scale of the rest of the elements in the composition. Although not always necessary, it is helpful when the sheer size

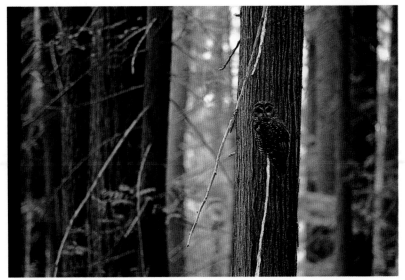

SPOTTED OWL, OLD-GROWTH FOREST, CASCADE RANGE, WASHINGTON. 80–200mm zoom lens (in 80mm range), f/4 at 1/8 second, Fujichrome Velvia.

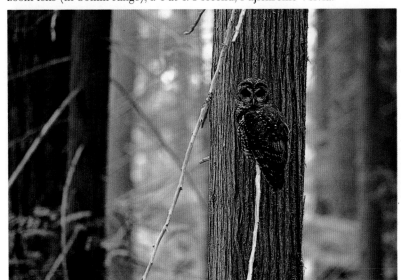

SPOTTED OWL, OLD-GROWTH FOREST, CASCADE RANGE, WASHINGTON. 80–200mm zoom lens (in 200mm range), f/4 at 1/8 second, Fujichrome Velvia.

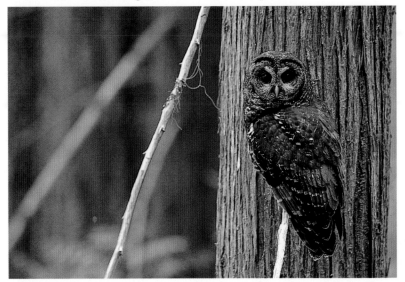

SPOTTED OWL, OLD-GROWTH FOREST, CASCADE RANGE, WASHINGTON. 200–400mm zoom lens (in 400mm range), f/4 at 1/8 second, Fujichrome Velvia.

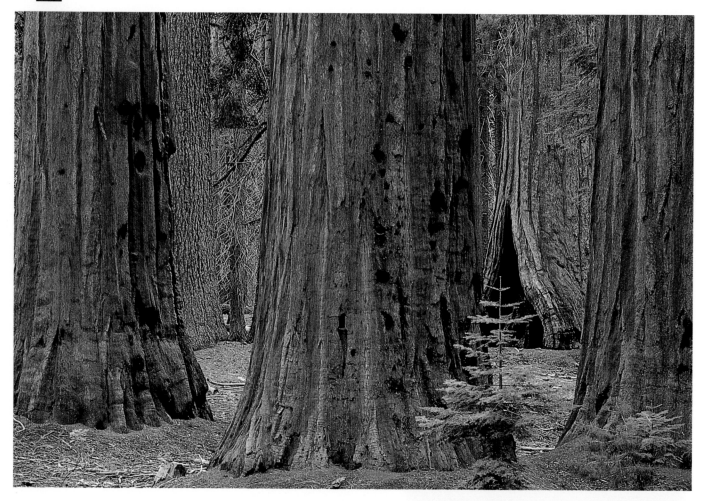

GIANT SEQUOIAS, YOSEMITE NATIONAL PARK, CALIFORNIA. 200–400mm zoom lens (in 200mm range), f/22 at 1/4 second, Fujichrome Velvia.

RIGHT: GIANT SEQUOIAS, YOSEMITE NATIONAL PARK, CALIFORNIA. 200–400mm zoom lens (in 400mm range), f/11 at 1/15 second, Fujichrome Velvia.

of the objects becomes the story itself. Then, you need to introduce something that gives viewers a point of reference. In the first, we see giant sequoias in Yosemite National Park. But without something next to them, you can't appreciate the true enormity of these trees. In the second, with a photographer standing at the base of the trees, we now have the proper sense of scale.

MH Part of our enjoyment of nature photography is being able to imagine ourselves standing in the photographer's stead. Having a person in the scene makes it all the easier. We can immediately relate to him, and thus to the proper size of the trees. Notice how the vertical format increases the sense of height of the trees. We may prefer our enjoyment of wilderness in solitude, but a landscape with the human element seems more inviting sometimes. Whether we like it or not, man is part of nature. To ignore that is to miss some of the storytelling possibilities in photography.

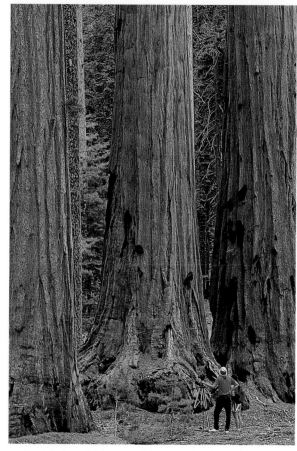

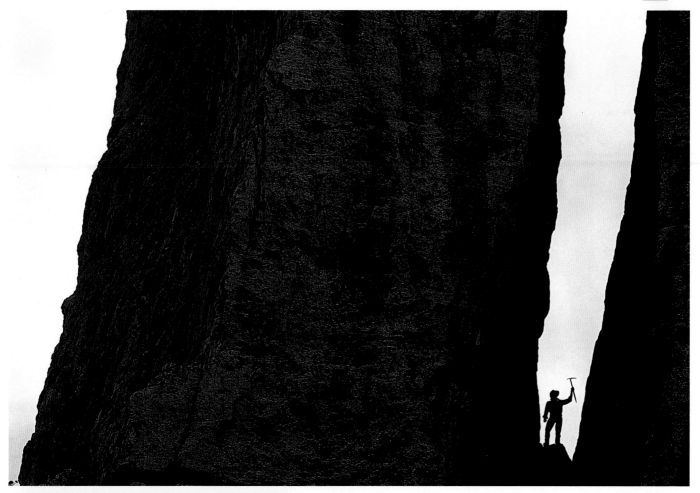

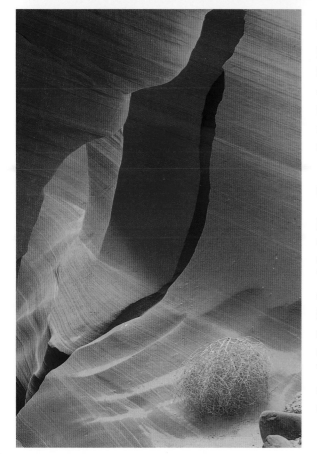

AW Without the climber, the image would be a study of black and white shapes. But with him, you have the proper sense of immensity of these columns of rock. In the case of the slot canyon in Arizona, by including the tumbleweed in this composition, the perspective and scale of the sandstone canyon walls are more clearly defined.

MH I used to receive photos at the magazine with a dime or ruler or even the tip of a person's finger to give a sense of scale. This is an academic approach, used by scientists, but hardly esthetic, especially where nature is concerned. The secret is to find something most people will easily recognize in terms of size. The small figure immediately turns the dark rocks into mountains. And the tumbleweed not only adds a sense of scale, but tells us something of the landscape. The orange color of the rock and the desiccated shrub both help evoke a strong sensation of heat and aridity.

CLIMBER. DOLOMITES, ITALY. 200–400mm zoom lens (in 400mm range), f/8 at 1/60 second, Fujichrome Velvia.

LEFT: SLOT CANYON. 20mm lens, f/16 at 2 seconds, Fujichrome Velvia.

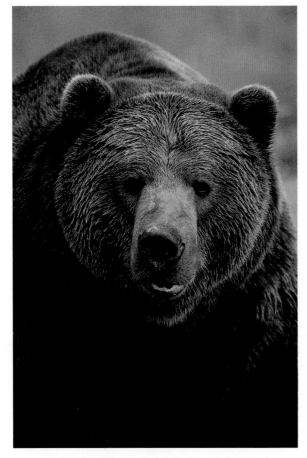

LEFT: GRIZZLY BEAR, ALASKA. 800mm 5.6 lens, f/5.6 at 1/30 second, Fujichrome 100.

BELOW RIGHT: MARTIAL EAGLE, SAMBURU NATIONAL PARK, KENYA. 800mm 5.6 lens, f/5.6 at 1/60 second, Fujichrome 100.

GETTING CLOSE WITH A TELEPHOTO LENS

AW In this book, we reiterate on numerous occasions that the cleaner and simpler the composition, the stronger the image. Telephotos are a good way to do this. Fewer distracting elements are included in the frame. With wildlife, this is especially important.

MH Long telephotos are extremely useful in wildlife photography. They bring the animal and viewer into closer contact. By providing spatial distance between the photographer and the animal, they often enable him to capture more natural behavior. When the animal's zone of comfort has not been breached, it is not thrown into a "flight or fight" response.

People still think eye contact is important to show in a portrait, such as in Da Vinci's famous *Mona Lisa,* where the eyes fix on you no matter where you may be standing. At *Audubon,* we tried to avoid the confrontational feeling of a wild animal staring at the camera. For one thing, it gives people a false experience. One would never stand so close to a grizzly in reality and have the luxury of staring into its eyes.

But as we saw with the lion photo, there is no denying the menacing look of a predator. It makes you suddenly aware you are prey, not predator. And if that is the message, then eye contact is necessary. There is no doubt that portraits such as these are compelling for that very reason.

AW Throughout this book, we talk about the challenge to the photographer to interpret what he sees in nature and capture it to make a strong statement. The actual choices one has to make in order to achieve a good composition are many and varied.

In this comparison of mountains and poplar trees taken in the Hunza Valley of Pakistan, the first shot does not really show what I saw. The poplar trees were shining in the early-morning light and were set off from the backdrop in dark shadow. The first way I composed it minimizes that effect. I've incorporated too much information and it is confusing. In the second, I've gone from 80mm to 200mm and narrowed the com-

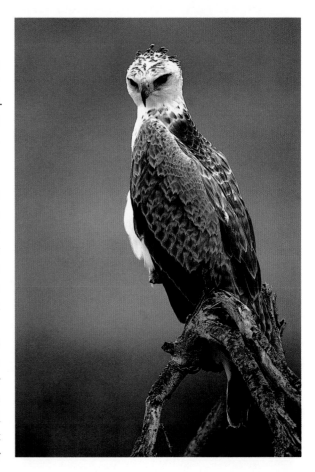

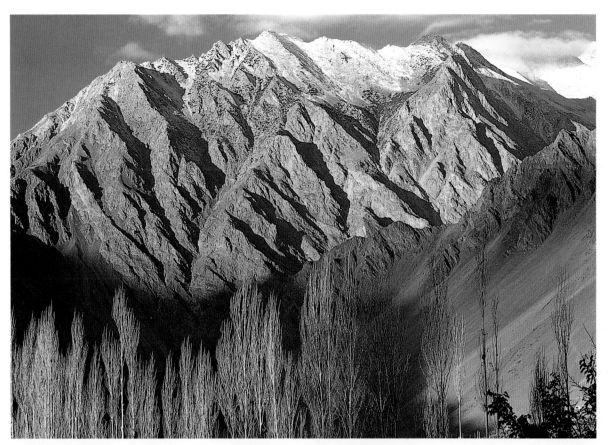

ABOVE: HUNZA VALLEY, PAKISTAN. 80–200mm zoom lens (in 80mm range), f/16 at 1/8 second, Fujichrome Velvia.

BELOW: HUNZA VALLEY, PAKISTAN. 80–200mm zoom lens (in 200mm range), f/16 at 1/8 second, Fujichrome Velvia.

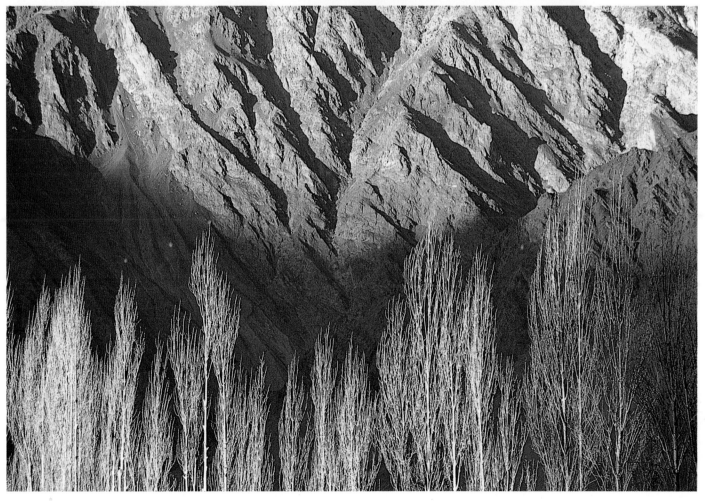

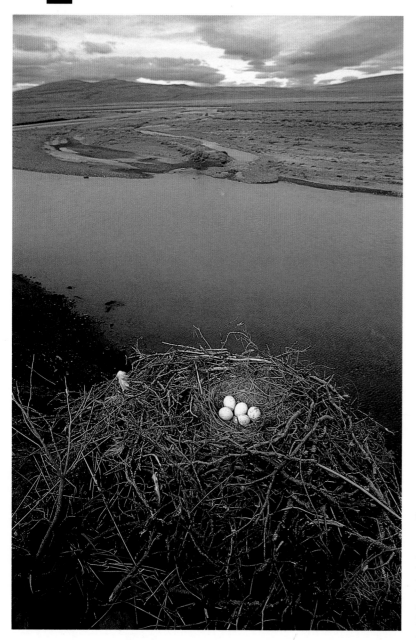

ROUGH-LEGGED
HAWK NEST,
UTUKOK RIVER
VALLEY, BROOKS
RANGE, ALASKA.
20mm lens, f/22
at 1/4 second,
Fujichrome
Velvia.

GETTING CLOSE WITH A WIDE-ANGLE LENS

AW Often students in my classes will bring work that shows an interesting subject, but without enough information to tell a complete story. One effective way of doing this is with a wide-angle lens close to the subject, so some of the backdrop is included and creates the necessary sense of place.

The first image shows the nest of a rough-legged hawk in the Brooks Range, Alaska. I chose to shoot this vertically to exaggerate the sense of space, keeping the nest as the dominant foreground element.

The whooper swans on a lake in Hokkaido have been similarly photographed—they are the dominant features of the composition, and yet the edge of the lake and distant mountains serve to give the birds a sense of place.

The musk-ox skull I found on windswept plains of Nunivak Island in Alaska: again, I wanted to give it a sense of place. Had I stood over it and shot straight down, it would have been a less interesting image.

MH In these three images, Art has kept the horizon high in the frame to give more sense of depth to the landscape. And as we noted before, wide-angle lenses expand the space in a picture, exaggerating the distance between foreground elements and background. When you need to say it, subject and environment, all within one frame, the wide-angle is often the solution. The subjects are strong, and the landscape elements understated.

I especially like the last image of the musk-ox skull. Art has almost entirely eliminated the horizon, with a very interesting consequence. The space appears more open and endless. By not putting a finite limit on the background, he has created a sense of timelessness, which enhances the solitude of the skull and seems to evoke the prehistoric ancestry of the musk-ox. The wavy lines of the wind-sculpted snow carry the eye back into the picture space as they get closer together, reinforcing the sense of space retreating in the distance.

position down to the very elements that attracted my attention. Whether you prefer the first or the second, there can be little doubt as to what I'm trying to say with the elements in the second composition.

MH This is a satisfying image on many levels. Contrast, color, and line are neatly played off against each other. The warm, gold poplars are set off against the cool, purplish blue shadows of the mountain. The diagonal lines of the mountain slope juxtaposed with the feathery lines of the trees create a nice tension of texture and line.

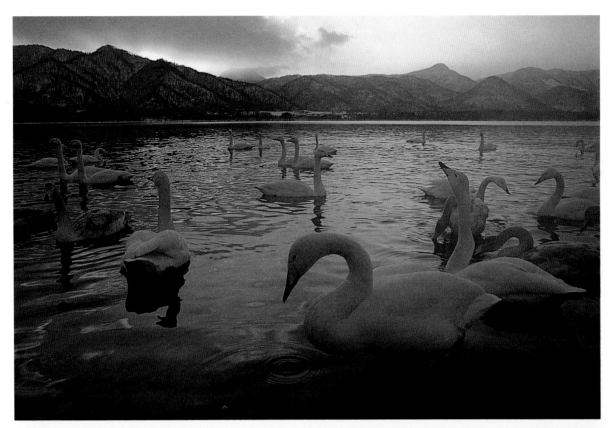

WHOOPER SWANS ON LAKE, HOKKAIDO, JAPAN. 20mm lens, f/11 at 1/30 second, Fujichrome Velvia.

MUSK-OX SKULL, NUNIVAK ISLAND, ALASKA. 20mm lens, f/22 at 1/2 second, Fujichrome 100.

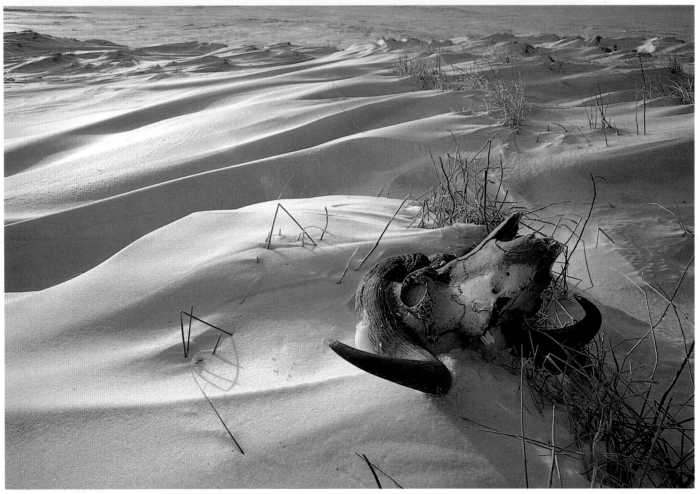

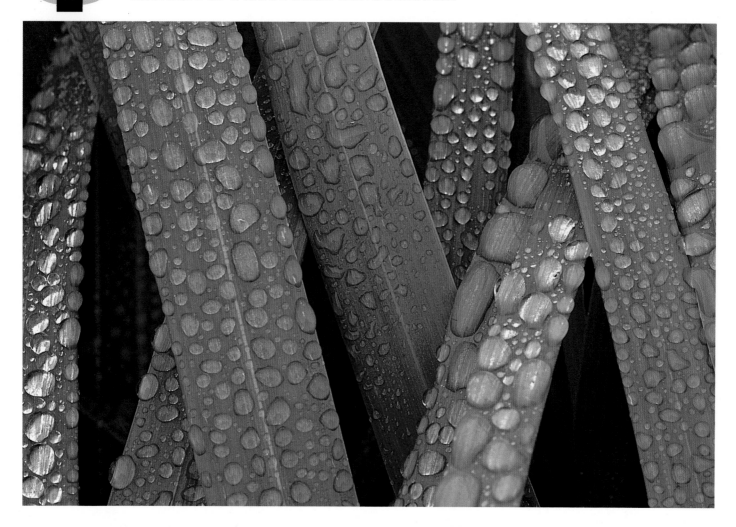

RAINDROPS ON
GRASS, UNALASKA
ISLAND, ALASKA.
55mm macro
lens, f/16 at
1 second,
Fujichrome 100.

OPPOSITE: FROST
CRYSTAL,
WASHINGTON.
55mm macro lens,
f/16 at 1/4
second,
Kodachrome 64.

GETTING CLOSE WITH A MACRO LENS

AW Here, by utilizing the 55mm macro, I've zoomed in on a clump of grass along the shoreline in the Aleutian Islands. I can focus in close on the raindrops that have accumulated during the light drizzle. Each drop contributes to the greater whole of a pattern of drops. The angle of the blades on which they sit changes the amount of light each reflects.

The second shot is of a single frost crystal. Again, I've moved in close with a 55mm macro and extension tube, to within a couple of inches, and positioned the camera so that the crystal is backed by a piece of the light, overcast sky to make it translucent. Without it, I couldn't show the very delicate lines within the crystal itself.

MH As we discussed in the lichen comparisons, the ability of macro lenses to create an abstract way of seeing helps the photographer explore his creativity. In so doing, he can open up other people's eyes to things they might not see on their own.

The soft overcast lighting lets us enjoy the nuances of the blades of grass, straight and angular, with the luminous globes of rain creating a pattern reminiscent of squid tentacles. This shot would not have been possible under sunny conditions. Gray, rainy days can work to one's advantage.

The ice crystal is elegantly isolated by light. It stands out hard-edged and clear, like a gem, from its fuzzier, unlit cousins. What I like is its cold purity, and the fact that the light source is so subtle.

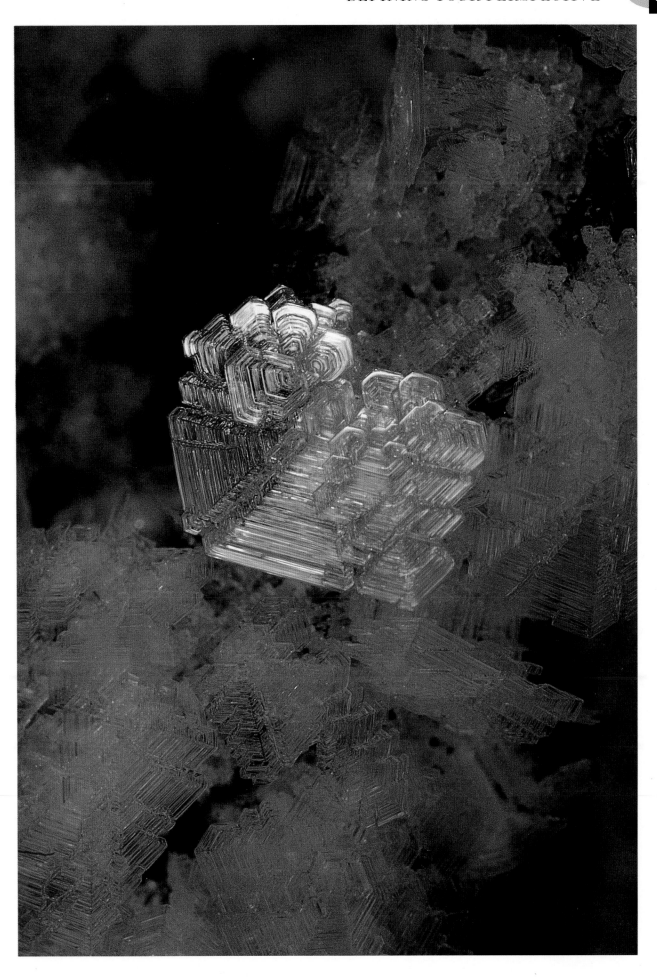

FLATHEAD VALLEY, MONTANA. 50mm lens, f/16 at 1/15 second, Fujichrome 100.

FLATHEAD VALLEY, MONTANA. 200–400mm zoom lens (in 300mm range), f/16 at 1/15 second, Fujichrome 100.

COMPRESSING SPATIAL RELATIONSHIPS: TELEPHOTO LENSES

AW As I was driving down the Flathead Valley in the Montana Rockies, I noticed this homestead against the mountains. The first was shot with a 50mm and most closely resembles what I saw from the car as I drove by. I recognized the possibilities, but this clearly was not it. It incorporated too much sky, too much foreground, and the dark furrow of earth leads your eye away from what is important to me in the composition.

In the second shot, I knew this was what I wanted—the farm with the backdrop of the mountains. By zooming in with a 300mm lens, I am creating a telescopic effect, bringing the mountains in closer relation to the farm. I placed the farm in the bottom and cropped so only mountains were above it, creating a sense of dramatic vertical rise. The last is even closer (a 400mm with a 1.4 tele-converter resulting in 560mm focal length), and now a vertical to emphasize the rise of the mountains, and using a polarizer to create a little more drama. The last is the strongest image for my money.

MH Here again is a good example of what the camera can do that the eye cannot. The only way we could approximate this image would be to hike a long way to get very close to the farm. But even then you would not have the same perspective, with the farm and the mountains so strongly juxtaposed. This sense of drama is created by the compression of distance only achieved by using a powerful telephoto lens.

AW This same effect is clearly shown in this shot of two climbers in front of Ama Dablam in the Nepalese Himalayas. They appear to be just below the summit of the mountain, but this is the result of the telescopic illusion. In reality, these climbers are a long way from the mountain, but by positioning them on a rise, and using a long telephoto, I created the sense of proximity to the peak. I was standing about two-hundred feet from the climbers.

FLATHEAD VALLEY, MONTANA. 560mm lens arrangement (200–400mm zoom lens in 400mm range with 1.4 extender, *400 x 1.4 = 560*), f/16 at 1/15 second, Fujichrome 100.

CLIMBERS SILHOUETTED AGAINST AMA DABLAM, HIMALAYA RANGE, NEPAL. 560mm lens arrangement (200–400mm zoom lens in 400mm range with 1.4 extender, *400 x 1.4 = 560*), f/22 at 1 second, Fujichrome 100.

MH Long telephoto lenses have such a narrow field of view that they often eliminate the foreground completely. In this shot of the climbers, the drama of man against seemingly overwhelming mountains is created by the compression of the distance between objects in two different planes you can only get from such long lenses.

EXPANDING SPATIAL RELATIONSHIPS: WIDE-ANGLE LENSES

AW In the field, there are times when a 50mm lens is inadequate to capture the subject as you would like to portray it. Often, I will put on a 28mm wide-angle, or even a 20mm wide-angle, to create more interesting angles and more dynamic compositions. With the koa tree, I wanted to accentuate the twisted forms of the branches. For the fun of it, I climbed up into the tree and shot down with a 17mm wide-angle.

MH The camera's ability to alter perspective can be used to create a more dynamic image, but it needs to be used carefully. Tilting a wide-angle up or down creates converging or diverging lines out of ones that are parallel. If the distortion suits your statement, you should experiment with it.

Art's second shot from inside the tree is fun, and I like the provocative vantage point. But more often than not, the curved or converging lines of wide-angle distortion are disturbing to the eye, and especially unflattering in people photography. Most publications would probably avoid using them, unless the outlandish view was the intent.

CHANGING CAMERA ANGLE TO IMPROVE COMPOSITION

AW In this first comparison, we are seeing how simply moving the camera can enhance the composition. The first shot of a columbine was taken with a bright sky behind it. As we have already noted, white areas attract your eye, dark areas recede. With this pale flower

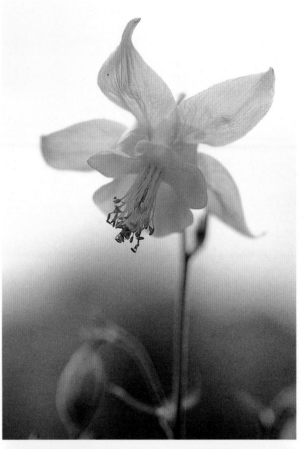

COLUMBINE, BANFF NATIONAL PARK, ALBERTA, CANADA. 55mm macro lens, f/5.6 at 1/125 second, Fujichrome Velvia.

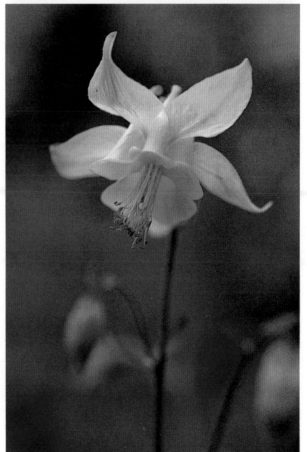

COLUMBINE, BANFF NATIONAL PARK, ALBERTA, CANADA. 55mm macro lens, f/5.6 at 1/125 second, Fujichrome Velvia.

OPPOSITE ABOVE:
ACACIA KOA TREE, VOLCANOES NATIONAL PARK, HAWAII. 50mm lens, f/16 at 1/8 second, Fujichrome Velvia.

OPPOSITE BELOW:
ACACIA KOA TREE, VOLCANOES NATIONAL PARK, HAWAII. 17mm lens, f/16 at 1/8 second, Fujichrome Velvia.

being virtually silhouetted against an even brighter sky, the subtleties of delicate yellow pastels are lost. The backdrop completely overwhelms the subject. By moving the camera up about eight inches, I've eliminated the bright background and allowed the soft colors to stand out and to dominate the frame.

MH I have seen many pictures over the years ruined by the presence of a light, featureless sky. Whether it is a solid blue expanse or pale gray, it can overwhelm whatever else is in the frame. Often, just a slight shift in position, as in the example of the columbine on page 43, is enough to solve the problem. The delicate pastel colors of the flower are lost against the light sky. Set off against a darker background, the colors, and the form, appear stronger. Wildflower photography requires great patience and care. Simpler is, more often than not, better. The delicate colors and shapes of wildflowers are shown to better advantage against clean, dark backgrounds, and under softly diffused, overcast lighting conditions.

AW In the next two sets of pictures, I have used a wide-angle lens, but the dynamism of the subject matter isn't quite fulfilled. So what I did was move from the first location trying to find a more pleasing way of stating the subject. In the second frame, I've created more tension between the rock and the tree and balanced out the composition more effectively. In the first, the trees and rocks seem to sit there without creating much eye movement throughout the composition. Now in the second, I've placed the second and third boulders in the composition so that they balance out what is going on in the left-hand corner.

ABOVE: JEFFREY PINE, OLMSTED POINT, YOSEMITE NATIONAL PARK, CALIFORNIA. 20mm lens, f/16 at 1/15 second, Fujichrome 50.

BELOW: PORTAGE LAKE, KENAI PENINSULA, ALASKA. 20mm lens, f/11 at 1 second, Fujichrome 50.

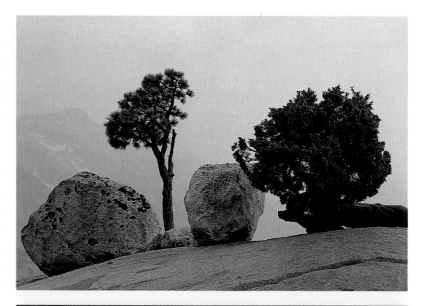

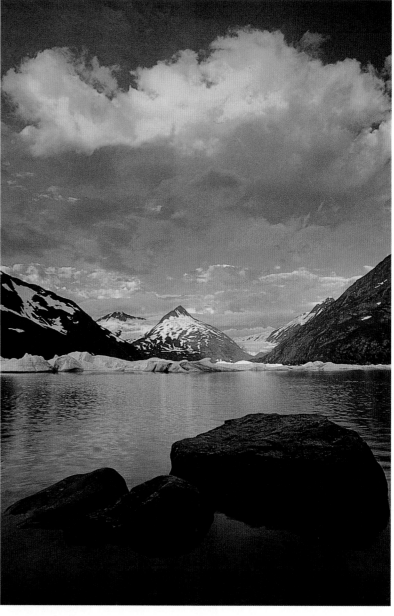

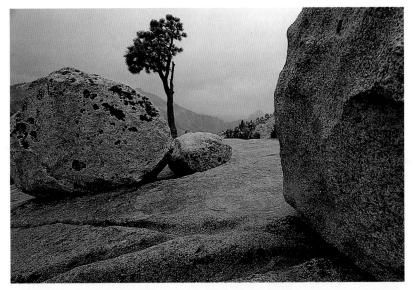

MH Here I have to disagree with Art, not about composition, but about content. The second image of the pine does have diagonal lines that lead the eye to the tree, and compositionally, it is beautifully balanced and organized. But it has a real feeling of solidity, which the first image doesn't and which I happen to like.

In the first image, the horizon is low, and right in front of us, giving us a sense of being near the edge of a precipice. Precipice is what this image is about. The boulders seem momentarily perched on the crest. The trees have been lucky to find a foothold. The second image has gained visual interest, but lost some emotional impact.

AW In the left-hand shot of Portage Lake in Alaska, I liked the composition, but thought the dark rocks in the foreground were a little out of balance, making the bottom too dark, and the top too light. By getting lower and slightly changing the camera angle, I recomposed to incorporate the pink cloud's reflection in the bottom, and to evenly distribute the light elements in the picture space.

MH Both images are definitely publishable, but I do prefer the composition of the second one, partly for the reasons Art stated above, but also because the sense of depth is enhanced with the higher horizon, and by moving back the dark rocks from the bottom of the picture space. In the first version, they feel like a barrier to entering the space. In the second, as if they were stepping-stones, we can move with ease from stone to stone into the picture. Also, the mountain in the background is less dominated by the foreground in the second version.

ABOVE: JEFFREY PINE, OLMSTED POINT, YOSEMITE NATIONAL PARK, CALIFORNIA. 20mm lens, f/16 at 1/15 second, Fujichrome 50.

BELOW: PORTAGE LAKE, KENAI PENINSULA, ALASKA. 20mm lens, f/11 at 1 second, Fujichrome 50.

THE POWER OF COLOR

Color is perhaps the most powerful tool used in visual communication. It has a direct link to our emotions. It can even affect our behavior. Experiments by psychologists have demonstrated the subconscious power of color. When violent children were put in rooms painted pink, they relaxed, stopped yelling, and some even fell asleep in ten minutes. Pink inhibits the secretion of adrenaline.

Even animals respond subliminally to color. Racehorses, after a thorough working out, were put in stalls painted either red or blue. Those in the blue stalls cooled down much faster than those in the red. Many restaurants use red in their decor because it supposedly stimulates our brains and our appetite and increases table turnover.

Color is a phenomenon of light, as Sir Isaac Newton discovered in 1676 when he refracted sunlight through a prism. White light is made up of seven basic colors of differing wavelengths from the violet (the shortest) to red (the longest). When we look at an object, what we actually see is light reflected back from its surface. For example, a red apple absorbs all the light wavelengths except those in the red part of the spectrum. The apple appears red because our eye is receiving the red light waves reflected back from the apple's surface.

All of us have color biases. Some of us prefer cooler shades of green, blue, and purple over the warmer colors of red, orange, and yellow, and someday scientists may prove that these preferences have a neurological basis. The field of photobiology is devoted to the study of the effects of different-colored wavelengths on the brain chemicals we produce. In Sweden, they have discovered that by using interior lighting with an

ultraviolet component, they can counter the depression that afflicts many Swedes during the long, dark, light-starved winter months. No doubt this also accounts for the fact that so many Scandinavians love to decorate their interiors with bright, bold primary colors.

Colors are not just a visual phenomenon. Like words and symbols, they have connotations and associations and carry psychological implications that affect our emotions. Red, for example, symbolizes love, danger, fear, and heat, to name a few. It is the color of blood, of life and death. The heart symbol used to connote love is red.

Stop signs are red to warn us and catch our attention. Bulls are thought to be angered by the red cape of the matador. Whether you love the color red or not, it is hard to deny that the sight of a bright red cardinal in a bleak winter landscape is cheering.

Yellow is warm, friendly, catches our attention, too, and so is used for high-visibility items, such as road signs, foul-weather gear, and taxicabs. Children use yellow for the color of sunshine when they paint. Yellow evokes the warmth of the sun when we look at it, even though it is not the true color.

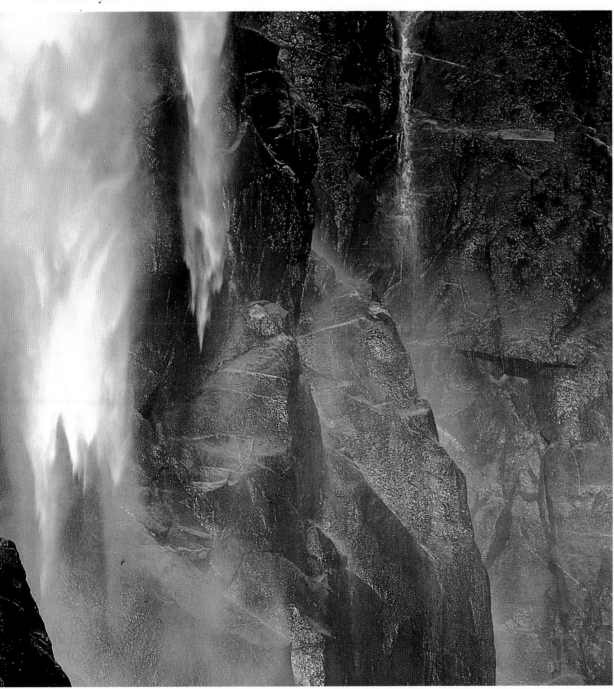

BRIDAL VEIL FALLS, YOSEMITE NATIONAL PARK, CALIFORNIA. 200–400mm zoom lens (in 400mm range), f/16 at 1/25 second, Fujichrome 50.

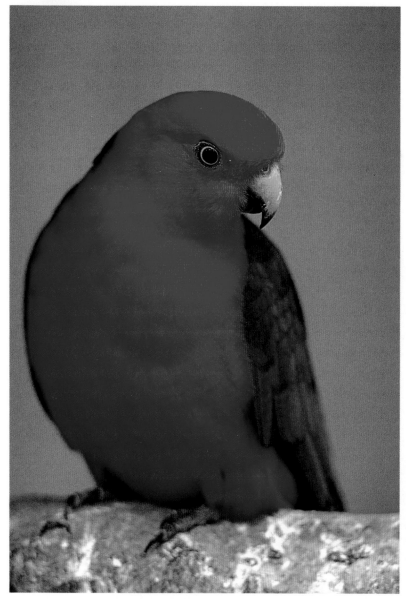

A color also changes character when it is placed next to other colors. Red, when surrounded by a field of blue, looks hot. When placed in a field of bright yellow, however, the same shade of red looks cool by comparison.

Cool colors tend to recede, and warm colors to advance. Saturated colors appear closer than pastel versions of the same hue. Landscape painters learn to use warm colors to depict foreground subjects and cool colors for distant ones. Art schools teach artists to use color carefully and deliberately, always keeping in mind its impact on the viewer. Photographers using color films also need to be aware of the power of color.

Have you noticed that magazines rarely publish black-and-white photographs anymore? This is because color is exciting, and editors know, in this day and age of television and video, that readers must be enticed. Pages of text by themselves are intimidating. Designers use color images interspersed with text blocks to enliven a page and cajole us into reading.

KING PARROT, AUSTRALIA. 200–400mm zoom lens (in 200mm range) f/4 at 1/60 second, Fujichrome Velvia.

PARSON'S CHAMELEON, MADAGASCAR. 55mm macro lens, f/8 at 1/60 second, Fujichrome Velvia.

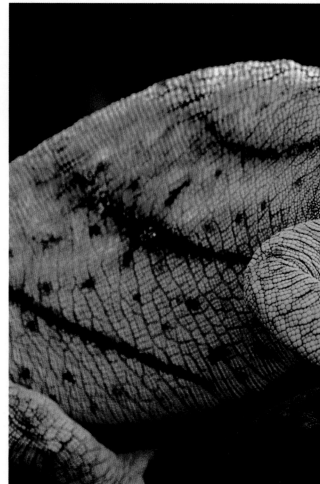

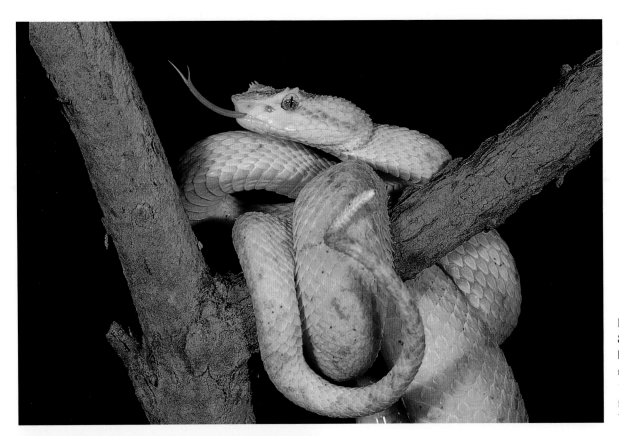

EYELASH VIPER.
80–200mm zoom
lens (in 200mm
range), f/11 at
1/60 second with
flash, Fujichrome
Velvia.

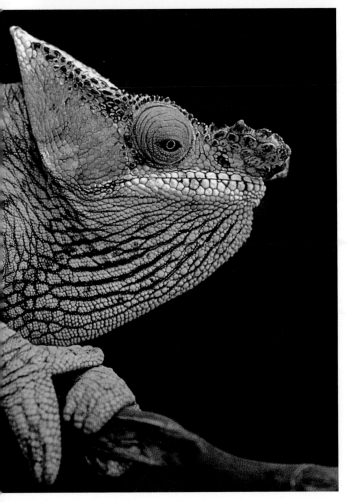

PRIMARY COLORS

In 1982, we pioneered, in *Audubon*, a series of essays of "color in nature," starting with red because it is a favorite eye-catching color for editorial and advertising use. Thirty-six images were selected from the several thousand submitted. The "Reds" essay proved so popular that we decided to follow it with a blue (September '84), and then a yellow (July '86), completing the three primary colors.

I believe the popularity of these essays was due to the delight readers had in discovering new sources of color, or color in everyday things they had overlooked or taken for granted. Some of the examples we chose were the obvious—red maples in fall, a bluebird, a yellow daisy. But most were much less familiar—the red mouths of baby cuckoos, the yellow cere on the face of a Harris's hawk, the turquoise eyes of a baby cougar. When you think about it, life without color would be dull indeed. So much of the pleasure we experience in our surroundings is tied to the sensation of color.

SCARLET IBISES,
TRINIDAD. 800mm
5.6 lens, f/5.6
at 1 second,
Fujichrome 100.

TEMMINCK'S
TRAGOPAN PHEASANT,
SOUTHEASTERN
TIBET.
200–400mm zoom
lens (in 400mm
range), f/4 at
1/30 second,
Fujichrome Velvia.

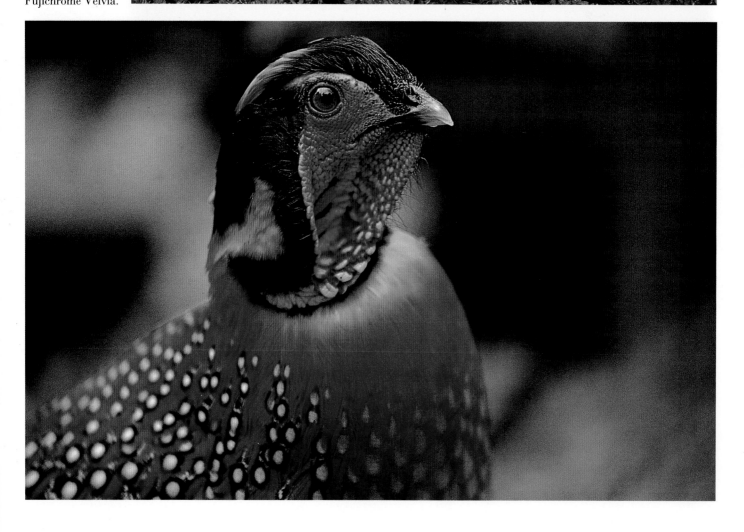

PORTFOLIO OF COMPLEMENTARY COLORS

Artists learn to use colors based on certain key color relationships. These are the primary, secondary, and complementary colors. The primary colors—red, yellow, and blue—have the most visual impact because they are considered pure. All other colors can be mixed from them. Mixing all three together yields a dark gray. The more you mix colors together, the more subtle they become, and the less visual punch they have.

The secondary colors are those made up of equal parts of two primaries, i.e., green, orange, purple. On the color wheel of primary and secondary colors, those opposite each other are called complementary—red-green, orange-blue, yellow-purple—because they have an unusual optical effect on us. When used next to each other, each hue vibrates more intensely. The French impressionists were the first painters to exploit this phenomenon. It is no different for photography. An orange bristlecone pine will look much better against a blue sky than against a white cloud.

FORGET-ME-NOTS, BLUE RIDGE PARKWAY, VIRGINIA. 55mm macro lens, f/16 at 1 second, Fujichrome 100.

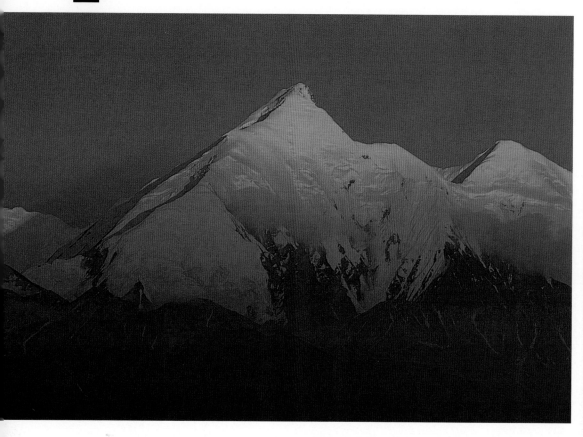

ALASKA RANGE,
DENALI NATIONAL
PARK, ALASKA.
200–400mm zoom
lens (in 400mm
range), f/8 at 1/15
second, Fujichrome
Velvia.

PORTFOLIO OF RELATED OR HARMONIOUS COLORS

Harmonious colors are those that are related in hue—yellow, green, blue, for example, or pink, orange, yellow. Because of this, they tend to make a different kind of statement, less bold than complements side by side, yet very appealing to look at. Certain seasons are characterized by harmonious colors, such as fall, with its reds, browns, oranges, and yellows. We used to take colors into consideration when selecting our magazine covers. Our best-selling cover was a fairly somber fall foliage shot of a gray-phase screech owl. What made the picture were the tiny orange berries left on a vine. As images to frame and hang on the wall, harmonious color schemes are soothing and wear better over time when they have to be looked at and lived with every day.

BAT STARS, QUEEN CHARLOTTE ISLANDS, BRITISH COLUMBIA, CANADA. 50mm macro lens, f/11 at 1/8 second, Fujichrome 100.

RIGHT: CYPRESS AND MEDITERRANEAN PINES, TUSCANY, ITALY. 200–400mm zoom lens (in 400mm range), f/8 at 1/15 second, Fujichrome 50.

BELOW: HILLSIDE OF SPRING FLOWERS, CENTRAL CALIFORNIA. 200–400mm zoom lens (in 400mm range), f/16 at 1 second, Fujichrome Velvia.

PORTFOLIO OF PASTEL COLORS

Pastel colors can be thought of as simply muted versions of the primary and secondary colors, with the same relationships still applying. The image of green trees in Italy is definitely more lively with the reddish trunks of the trees. And the pale warmth of the sand is set off by the cool, pale blue of the shadows. It reminds me of one of our January covers, which were generally pastels in the cool shades of winter. We ran a photograph of dunes in White Sands National Monument that looked like snow. We hoped our readers would enjoy the visual pun.

Spring is generally associated with the pastel colors of pink, lavender, pale yellow, and yellow-green, the colors of emerging buds and vegetation. Like harmonious colors, pastels are emotionally pleasing and have quieter impact, making them also easy to live with.

Sand dunes, Death Valley, California. 200–400mm zoom lens (in 400mm range), f/16 at 1/2 second, Fujichrome Velvia.

Arctic fox, Ellesmere Island, Canada. 300mm 2.8 lens, f/5.6 at 1/60 second, Kodachrome 64.

UNIFORMITY OF COLOR

The use of one tone, or monochrome, makes the most subtle statement of all. As in black-and-white photography, the eye is not seduced or distracted by competing colors. Instead, monochromatic images give other elements in the picture a chance to come forward—elements you might otherwise not notice. In the polar bear photograph, there is a nice play of triangular forms, in the shape of the bear's head, and the black triangle of nose and two eyes. We are drawn to the bear's expressive eyes.

The image of the lilies is elegant simplicity—a study of curved lines and shapes. The pebbles are a study of nuance—subtle variations of texture, shape, and tone. The overall green color in the pine trees leaves us, again, free to contemplate the rhythm of texture and arched shapes. Bold color in any of these images would be a jarring, discordant note.

OPPOSITE FAR LEFT: POLAR BEAR, CHURCHILL, MANITOBA, CANADA. 200–400mm zoom lens (in 400mm range), f/11 at 1/15 second, Fujichrome Velvia.

CENTER: WORN ROCKS ON BEACH, ICY BAY, ALASKA. 55mm macro lens, f/16 at 1/15 second, Fujichrome Velvia.

ABOVE RIGHT: LILY PADS, CHICHAGOF ISLAND, ALASKA. 200–400mm zoom lens (in 400mm range), f/11 at 1/30 second, Fujichrome 50.

LEFT: MEDITERRANEAN PINES, CHIANTI REGION, TUSCANY, ITALY. 200–400mm zoom lens (in 400mm range), f/11 at 1/8 second, Fujichrome Velvia.

5 THE ELEMENTS OF DESIGN

Nature is not really chaos. It is replete with rhythms, patterns, functional designs and structures. The more you observe and explore, the more you will discover them. The lovely spiral growth pattern of the chambered nautilus shell is the most famous example used to illustrate nature's extraordinary engineering. Spiderwebs, hummingbird nests, honeycombs, peacock feathers, the baleen plates of whales, maple seeds, and an ear of wheat are just a few examples of natural engineering, where form derives from function.

Along with color, the elements of design are the visual building blocks every artist or photographer has to work with in making his statement. Line, form, texture, and pattern all need to be taken into careful consideration when looking through the viewfinder.

In nature photography, except for the horizon, perfectly straight lines are rare. They appear man-made and architectural and call attention to themselves as being "unnatural." Lines and shapes, like colors, have psychological character. Bold shapes create bold images. Angular shapes are more dynamic and attention getting than rounded, smooth shapes, probably because of our mental associations of sharpness and steepness.

Wavy, sinuous lines and shapes suggest sensuality and fluidity. Diagonals are more exciting to us than horizontal lines or vertical lines. They intersect the frame and seem to want to take us somewhere—away, up, down—out of the picture space. They imply movement and something out of balance.

Sometimes, the relationship of one object to another is perceived on a subliminal level, as when the great blue heron, in chapter 2, was looking out of the frame. His line of sight created a line that took us to something outside the picture frame. In the portrait of the resting polar bear, the three dark points of his eyes and nose gave us a subtle triangular form. We know that two points can be connected by a line. Even if it is not visible, we make the connection mentally.

THE POWER OF LINE

If colors have the power to move our emotions, lines have the power to move our eye in the picture's space. When you look at the two images of Art's of the weed in the pond in the Hunza Valley on page 59, the shoreline fights with the weed for dominance. It wants to take the eye away from the weed. When the shoreline is absent, we are free to contemplate the quiet illusions in this deceptively simple, Zen-like image.

Even though the circular weed is a strong shape by itself, in the first image the line fights it for supremacy, and, I think, wins. It takes the eye out of the picture frame and ends up being disturbing. In the second image, harmony is restored. We can savor the texture of the weed against the smooth, cool surface of the water, and the interplay of reality and reflection, of two-dimensional surface and three-dimensional space. The sky's reflection in the surface of the water gives it an unsurfacelike quality.

The artistic tradition of our culture is rectilinear. We live in a world defined by verticals and horizontals. The pictures (and buildings) we create usually have a rectangular frame. This frame automatically dictates two horizontals and two verticals. And we accept this parallelism on

WEED IN POND, HUNZA VALLEY, PAKISTAN. 80–200mm zoom lens (in 80mm range), f/11 at 1/25 second, Fujichrome 50.

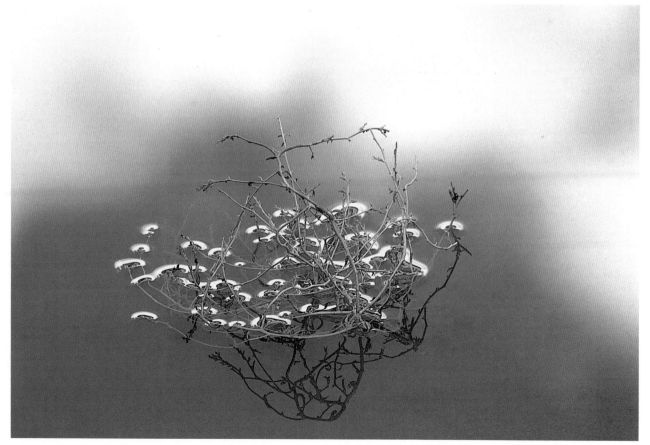

WEED IN POND, HUNZA VALLEY, PAKISTAN. 80–200mm zoom lens (in 200mm range), f/11 at 1/25 second, Fujichrome 50.

a subconscious level because it mimics our normal view of things.

Other cultures have different visual traditions. R. L. Gregory, in his clear and provocative book, *Eye and Brain*, notes that the Zulu live in round huts, plow their fields in curved lines, and have few straight lines in any of their possessions. When confronted with optical-illusion figures based on angles and lines, they simply do not see them. Tribes that live in the dense forests of Central Africa have difficulty judging distant objects, since they never get to see things far away. To them, such objects just appear to be miniature versions of what they know.

For those of us raised in the cultural tradition of Western art, lines are the most important way

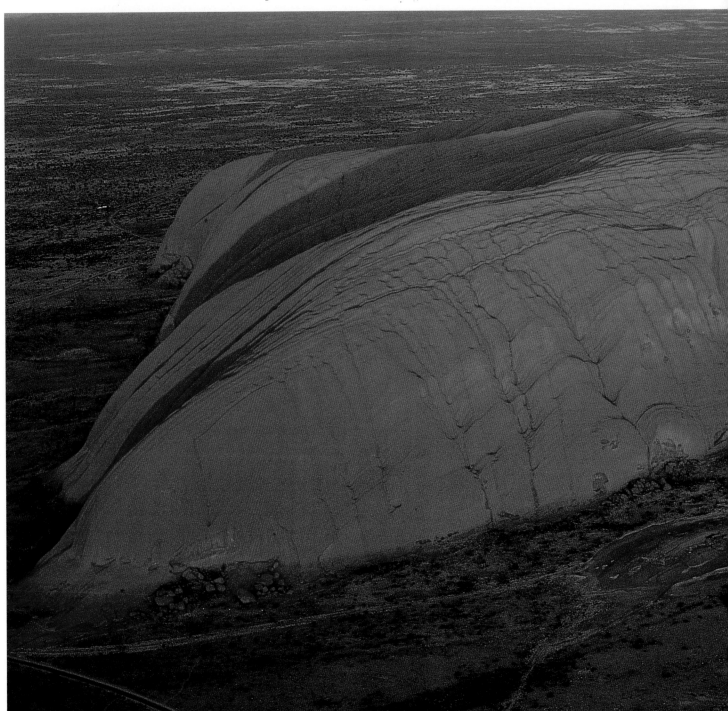

to indicate distance, or receding space, in a picture. Linear perspective, using the device of the "vanishing point" to re-create three-dimensional space, was discovered in the Renaissance. Leonardo da Vinci (1452–1519) described it as the "bridle and rudder of painting." Before then, spatial depth had been created by relationships of objects in size and scale to each other. A bigger

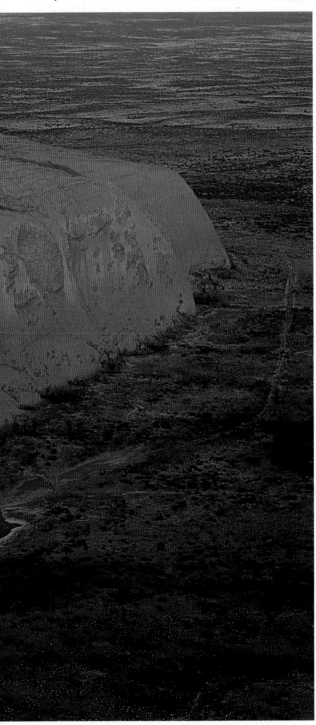

figure was perceived as standing in front of a smaller figure.

In Oriental art, however, which did not use "vanishing point" perspective, spatial depth is indicated in a different way. When you look at an Oriental painting (from before the twentieth century), it is as if you were a bird hovering just above the scene and looking down, more like what we see in this aerial of Ayers Rock. In Oriental perspective, lines run parallel, instead of converging. Depth is indicated, as in the photo of Ayers Rock, by an oblique positioning of the subject. Walls, figures, and objects often remain the same size relative to each other. There is usually no horizon line at all, although there may be an occasional reference to a distant piece of shoreline or mountain.

Three-dimensional space is also suggested by emptiness. There may be a few objects in the foreground, and then only a hint of background. The unfilled areas of the picture space are used to create an illusion of intervening space, or third dimension.

Space, as we know and experience it in our everyday lives, is three-dimensional. A photograph or a painting is a flat surface, and yet, in most cases, we can look at that photograph and put ourselves in the photographer's shoes, as it were. We immediately step into his vision as if it were our own, such is the veracity of what the camera records.

The camera sees the same perspective illusions as we do. Vertical and horizontal lines that recede become shorter and appear to converge. Think of railroad ties, or fence posts along a road. Likewise, forms that recede can also become paler, as the atmosphere in between interferes with our ability to see them clearly. Think of mountain ranges layered one behind the other. Our experience tells us to interpret these illusions as spatial depth.

The horizon is, of course, the strongest horizontal we confront on a daily basis. And since we accept that we are rooted to the earth's surface by gravity and thus are perpendicular to the horizon, we tend to accept other upright beings and things as perpendicular, too.

AYERS ROCK, NORTHERN TERRITORY, AUSTRALIA. 55mm macro lens, f/2.8 at 1/60 second, Fujichrome 50.

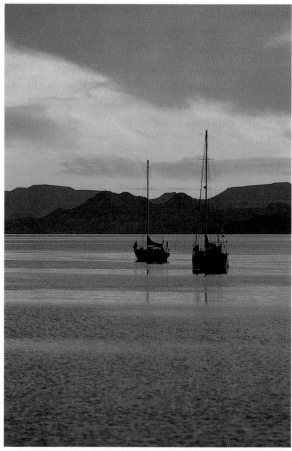

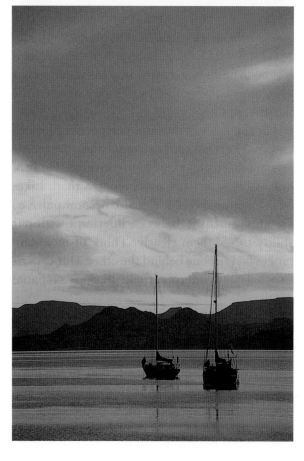

ABOVE LEFT:
SAILBOATS AT
SUNSET, SEA OF
CORTÉS, MEXICO.
200–400mm
zoom (400mm
setting), f/8 at
1/8 second,
Fujichrome
Velvia.

ABOVE RIGHT:
SAILBOATS AT
SUNSET, SEA OF
CORTÉS, MEXICO.
200–400mm
zoom (400mm
setting), f/8 at
1/8 second,
Fujichrome
Velvia.

RIGHT: SAILBOATS
AT SUNSET, SEA OF
CORTÉS, MEXICO.
200–400mm
setting), f/8 at
1/8 second,
Fujichrome
Velvia.

HORIZON PLACEMENT: HOW IT AFFECTS DEPTH

AW In these three photographs, we see sailboats in Baja California. I deliberately shot these comparisons so we could show what happens when the horizon is moved out of the middle. I have no preference for one over another.

MH Actually, every one of these images is publishable, and each conveys a slightly different statement. Even though the boats are the same size in all three pictures, in the first they feel more distant because of the empty foreground and high horizon line, which draw our eye into the picture space. But I feel the out-of-focus foreground has too little visual interest and the masts of the boats crowd too close to the top of the frame, creating an unstable balance of elements.

The horizon in the middle produces a very appealing scene, serene and a little static, which

might be just the mood you want to convey—everything in balance, everything at peace.

In the third version, the sky becomes the dominant part of the picture space, adding some drama and texture. There is a nice play of linear pattern in the bands of color in the water, sky, and mountains. Without the empty foreground, the two sailboats actually appear closer than in the first version. I prefer the weighting of picture elements here more than in the other versions.

The horizon line, because it is so straight, cuts the picture space into definite sections and has to be factored into what you want to emphasize.

AW If I have two elements that create an equal balance, then I may decide to put the horizon in the middle, or place the vertical dividing line in the middle to flatten it out. In the shot of flamingos, taken in the Galápagos Islands, I have given equal weight to the birds and to their reflection.

MH The important center line here is not the actual horizon line, or shoreline, but the line dividing the birds and reflection. As in a Rorschach ink blot, Art has made a symmetrical composition by putting the mirror-image reflection in the middle.

What keeps this image from being completely static is the two uneven groupings of birds. This off-balance tension creates the visual interest in this picture.

Generally, the horizon line has the character of strength and stability. It dominates the composition and demands to be straight. Tilting is disconcerting to the eye. I used to reject a lot of pictures in which the horizon was slightly tilted.

AMERICAN FLAMINGOS IN POOL, GALÁPAGOS ISLANDS, ECUADOR. 280mm 2.8 lens, f/11 at 1/30 second, Kodachrome 64.

ABOVE AND OPPOSITE:
THE PUNCHBOWL,
COLUMBIA RIVER
GORGE, OREGON.
28mm lens, f/16
at 1 second,
Kodachrome 64.

HORIZON: OFF CENTER

AW Once you remove the horizon from the middle, you start to create a greater sense of depth and dynamics. This is also true when framing. If you put the subject directly in the middle, you can effectively flatten out the image and make an abstract statement. This is not often the desired effect. If you take the example of the Punchbowl in the Columbia River Gorge in Oregon, in the middle it appears flattened. In the second image, it is placed in the upper third of the composition, and your eye has to travel now from the bottom of the frame to the waterfall.

MH The placement of the waterfall higher in the frame creates a sense of depth by drawing the viewer into the picture space. Because the eye travels deep into the picture space to the waterfall, it is as if we are re-creating the experience of finding this scene on our own. The version with the lower placement may be the more normal perspective or vantage point, but it lacks the enhanced sense of discovery of the second composition.

The horizon is, by nature, horizontal. Enclosed by a horizontal frame, its energy seems to spread sideways. When a landscape with a horizon is photographed vertically, interesting possibilities arise. The eye's attention is more easily drawn to the upper or lower portion, depending on where the horizon is placed. Certain tall vertical elements such as trees often demand to be photographed vertically in order to create the proper impression of height or majesty.

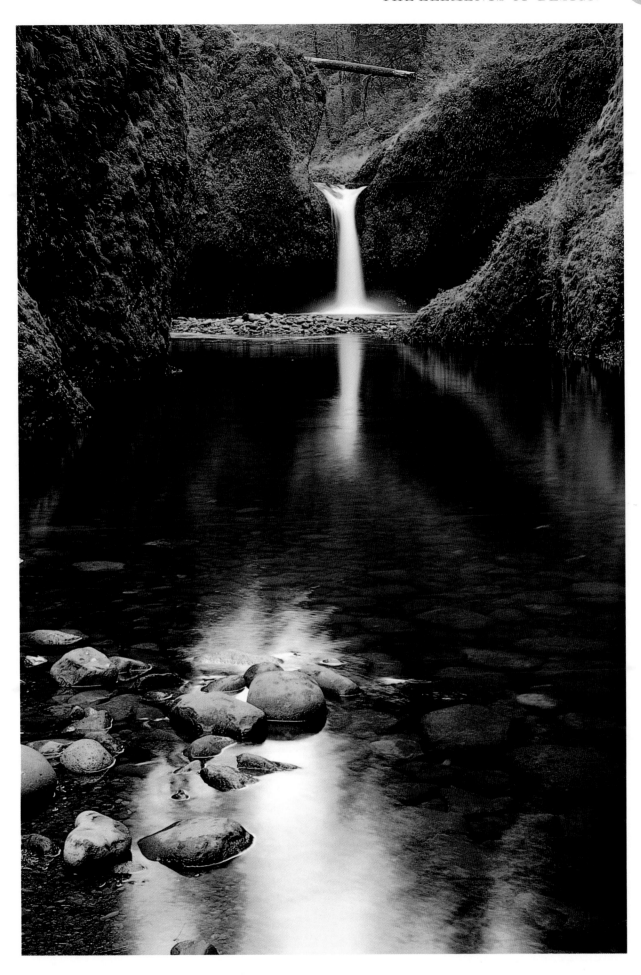

TABULAR ICEBERG, COMMONWEALTH BAY, ANTARCTICA. 560mm lens arrangement (200–400mm zoom lens in the 400mm range with 1.4 extender, *400 x 1.4 = 560*), f/5.6 at 1/25 second, Fujichrome 50.

AW In composing this picture of the iceberg low in the frame, I was deliberately trying to draw attention to the light and to the immensity of the iceberg itself.

MH Everything about this image is dramatic—the light, the extremely low placement of the horizon, the clean, stark planes of flat color. The only texture in the picture is on the brilliantly lit iceberg. We have no clues as to scale, except for Art's low placement, which gives more importance to the sky as a large monochromatic void. This heightens the feeling of emptiness and vastness and is another example of how the photographer can give visual weight to the elements in the picture. The sea is a thin, dark strip at the bottom. Even though the iceberg is distant, we don't travel deep into the picture space to confront it. It jumps out at us.

NO HORIZON: AERIAL PERSPECTIVE

AW Often the most successful images I have shot have been from the air. Elements of nature that we see every day from ground level we take for granted. When we look at them from the air, they take on a new point of view, and this can create a more dynamic composition. All, when seen from the ground, would be more commonplace. But from the air, they take on a new look. Suddenly they are patterns, as in the elk image, or shapes, as in the picture of Ayers Rock.

FAR LEFT: AYERS
ROCK, NORTHERN
TERRITORY,
AUSTRALIA. 55mm
macro lens, f/2.8
at 1/60 second,
Fujichrome 50.

NEAR LEFT: SIX
SHOOTER PEAK,
CANYONLANDS
NATIONAL PARK,
UTAH. 135mm
2.8 lens, f/5.6 at
1/125 second,
Kodachrome 64.

ELK HERD,
NATIONAL ELK
RANGE, JACKSON,
WYOMING. 135mm
2.8 lens, f/5.6 at
1/125 second,
Fujichrome 50.

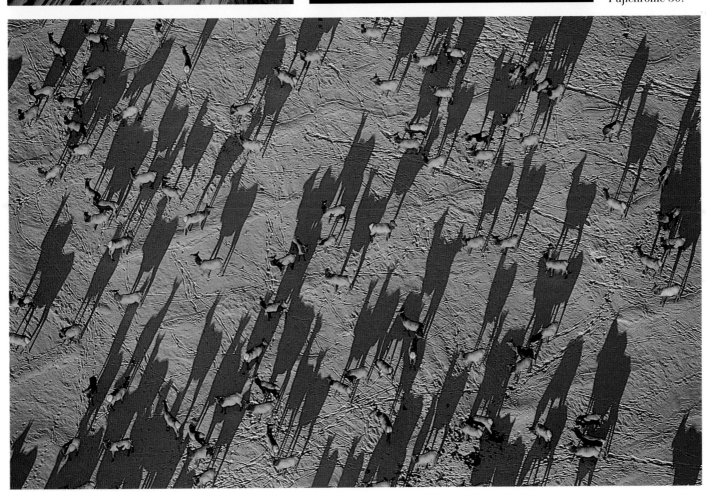

MH With no horizon line dividing the picture space and spreading energy sideways along its axis, an aerial photograph becomes a tapestry of other elements, such as light and line, texture and pattern. Space is not limited by the horizon and takes on a quality of infinity. Without a horizon by which to judge distance, we look to those other elements for depth cues.

In the shots of Ayers Rock and of Canyonlands, light creates textural relief. The lighter land forms come forward in the picture space, and darker shadows recede. The triangular shapes in the images of Ayers Rock and Canyonlands give a dynamic quality to the composition, and the diagonal lines also help to carry us back into the picture space.

The elk image is one of my favorites, and when I was at the magazine, I was holding it for a possible cover. I love the way it jars our perceptions. From the ground, our experience with shadow is that it is not substantive compared to the object casting it, and we experience it lying below, on the ground, since the light source is usually overhead.

Look what happens from the air. In the shot of the elk herd, the unusual shapes of the shadows are what draw our attention first, rather than the animals themselves. The shadows are large, dynamic, flat fields of color, and the dominant rhythmic element. Like shadow puppets, they loom larger than life, rising up above the animals, instead of lying below them.

RECEDING LINES AND SHAPES

AW In the shot of the karst mountains in Guilin, China, I wanted to emphasize their pattern. Because they are such an unusual shape, individual humps instead of long ridges, I wanted to show their character. I used my 300mm to zero in on an area that I felt made the strongest statement.

The second shot was taken a few minutes from my home in Seattle. I grew up in this neighborhood, and as a boy, I always loved this path especially, with its graceful madrone trees. I went back to photograph it twenty years later.

KARST MOUNTAINS, GUILIN, CHINA. 80–200mm zoom lens (in 200mm range), f/11 at 1/60 second, Fujichrome 50.

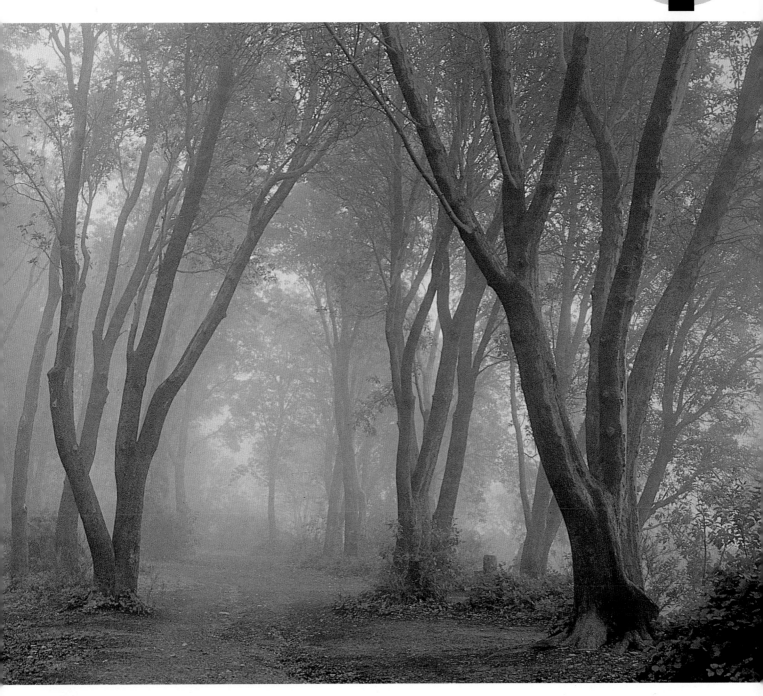

MH Spatially, light objects stand forward of dark in our normal experience of perception. When we have atmosphere such as fog, however, it is the reverse. Our experience tells us that dark is closer to us than light, as in the mountain scene. We understand this perceptually because atmospheric haze intervenes and makes the far mountains paler and less distinct. This is sometimes referred to as "atmospheric or aerial perspective."

We also understand crisp outlines as close and fuzzy ones as distant, as with the trees in the fog, which is contrary to normal perception, where we can see distant objects in focus as well. The sense of space in both these images is definitely enhanced by the fog. Forms are more noticeable without competition from intricate detail. The tree trunks stand out more without the busy clutter of foliage. Because it shrouds things from view, fog, more than any other atmospheric condition, creates mood and a sense of mystery.

MADRONES IN MIST, WASHINGTON. 50mm lens, f/16 at 1/8 second, Kodachrome 25.

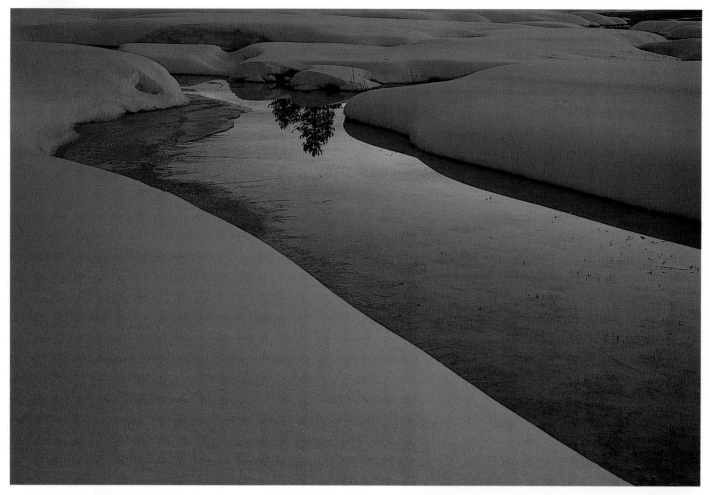

USING LINE TO CREATE DEPTH

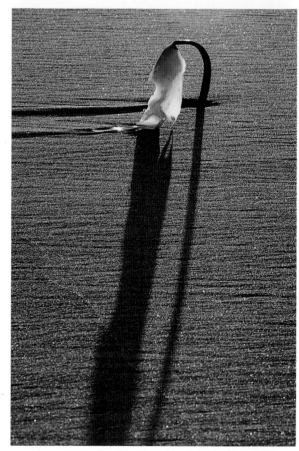

AW As with placement of horizon to create depth, you can also do this quite effectively with line. In the first composition, we see a river cutting diagonally through snow. As it gets narrower toward the back, we know it is farther away. In the second, we have a kelp frond backlit, whose shadow leads the eye back into the picture. In the third, we have a road in Tuscany. We have the lines of the road coming in from either side at the bottom of the frame and directing the eye down to the depth of the distant road. The lines of the branches arching over the road also recede in space and are used as a directional aid pointing the viewer's eye deep into the composition.

MH In the river scene, as Art has mentioned, our eye is naturally carried back by the oblique and tapering diagonal lines. It is a bolder, more sweeping scene than the road, with its classic vanishing point perspective. Notice how the central placement of the disappearing road invites us into the picture space, more so than the river scene. And the sheltering branches create a protective tunnel for travelers that evokes a feeling of quiet security and serenity. In the kelp image, the bright spot would normally jump forward. Instead, the shadow line draws us back into the picture space to the kelp, creating the sense of depth.

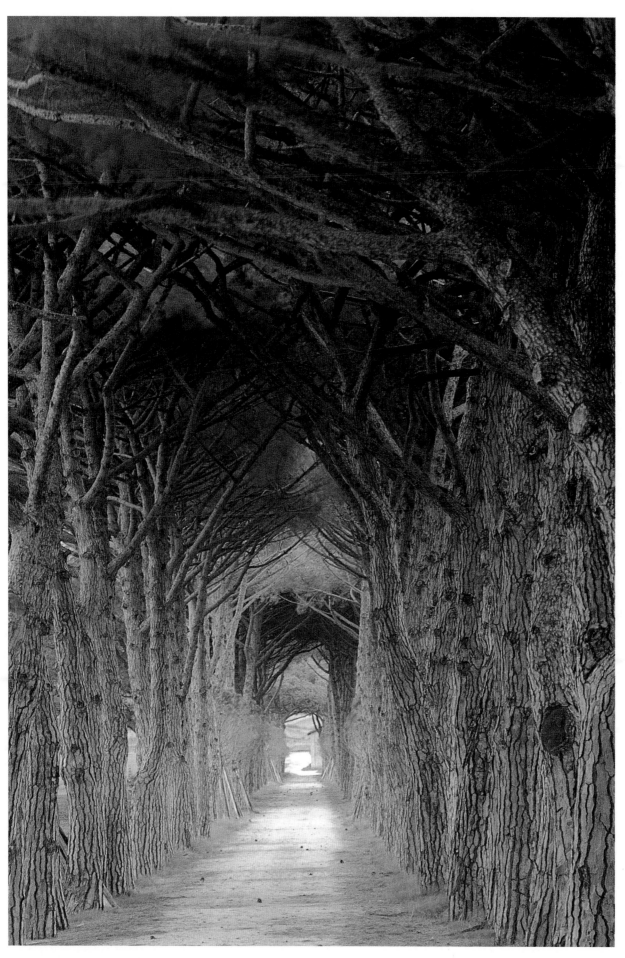

FARM ROAD
LINED WITH
MEDITERRANEAN
PINES, ITALY.
80–200mm
zoom lens
(in 200mm
range), f/22
at 1/4 second,
Fujichrome
50.

OPPOSITE ABOVE:
WINTER RIVER,
YELLOWSTONE
NATIONAL
PARK,
WYOMING.
20mm lens,
f/22 at
1 second,
Kodachrome
64.

*OPPOSITE
BELOW:* KELP
ON BEACH,
WASHINGTON
COAST. 28mm
lens, f/22 at
1/8 second,
Kodachrome
64.

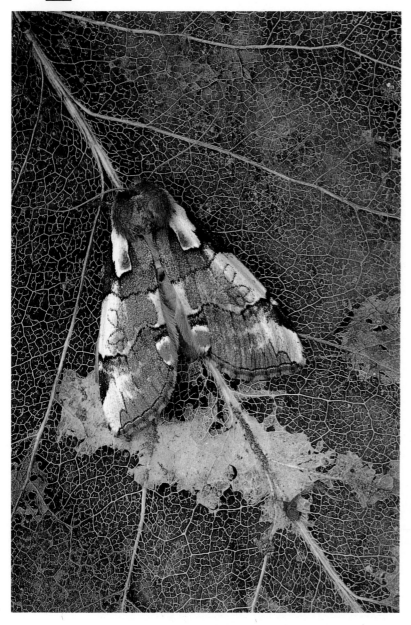

DIAGONALS USED TO CREATE DYNAMIC VISUAL INTEREST

MH Diagonals create tension, the excitement of the unexpected. And yet in nature some diagonals are very much expected, as in mountains and valleys. But because we have enclosed them inside a rectangle, their energy seems to want to escape confinement. Wavy lines, zigzag lines, radiating lines, the sort of lines we are more apt to encounter in nature, all suggest energy and motion.

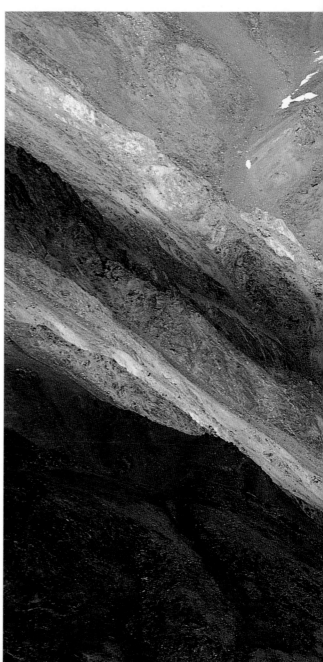

MOTH ON DEAD LEAF, WASHINGTON. 55mm macro lens, f/16 at 1/60 second with flash, Fujichrome Velvia.

BROOKS RANGE, ARCTIC NATIONAL WILDLIFE REFUGE, ALASKA. 200–400mm zoom lens (in 200mm range), f/11 at 1/15 second, Fujichrome 50.

GLACIAL CREVASSES,
SOUTHERN ALPS,
NEW ZEALAND.
300mm 2.8 lens,
f/11 at 1/15
second,
Kodachrome 64.

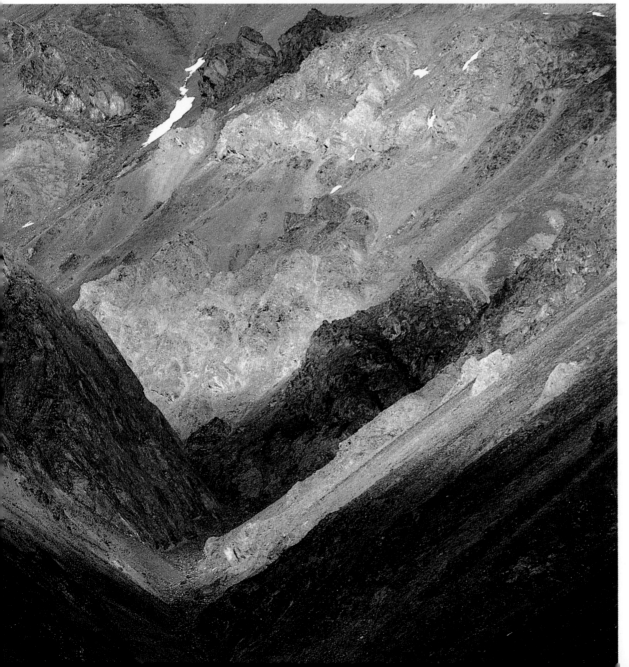

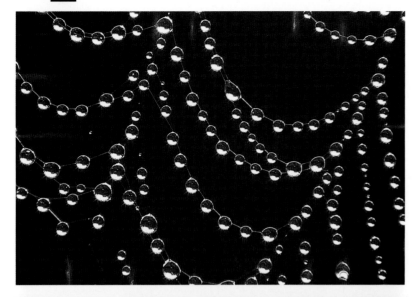

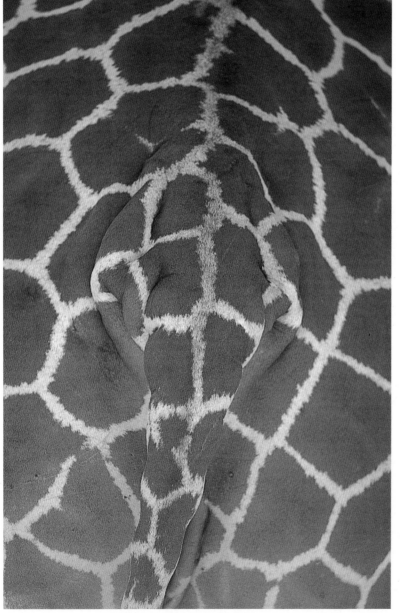

PORTFOLIO OF LINES

MH As we noted earlier, lines are really created by the contrast of dark against light, by the edges of forms and shapes differentiated by color or tonal value. Lines have character, too. They can be the main elements of pure graphic design, as in the zebras or the giraffe skin pattern, and in the cobweb strands of dewy pearls. As abstractions, they invite us literally to forget the subject and simply enjoy their rhythms.

Art's shot of the palm tree trunks in Molokai I find delightful. Normally, one can't resist including the fronds, but having left them out, he has created an intriguing image. The lines of the trunks transect the picture from top to bottom, creating a two-dimensional pattern, forcing the viewer to question what he is actually seeing. And yet, because of the variation of tonalities in the background, we have a sense of depth and space behind the trees, not unlike the very first image of the dead tree in Yellowstone we looked at in the beginning of the book.

Unlike the two-dimensional flat designs of the giraffe or the cobweb images, the zigzagging lines of the sand dunes carry us all the way back to the peak of a distant dune.

ABOVE LEFT: DEWDROPS ON SPIDERWEB, WASHINGTON. 55mm macro lens, f/16 at 1/2 second, Kodachrome 64.

GIRAFFE, SAMBURU NATIONAL PARK, KENYA. 200–400mm lens (in 400mm range), f/8 at 1/60 second, Fujichrome 100.

ROYAL PALM GROVE, MOLOKAI, HAWAII. 300mm 2.8 lens, f/8 at 1/8 second, Kodachrome 64.

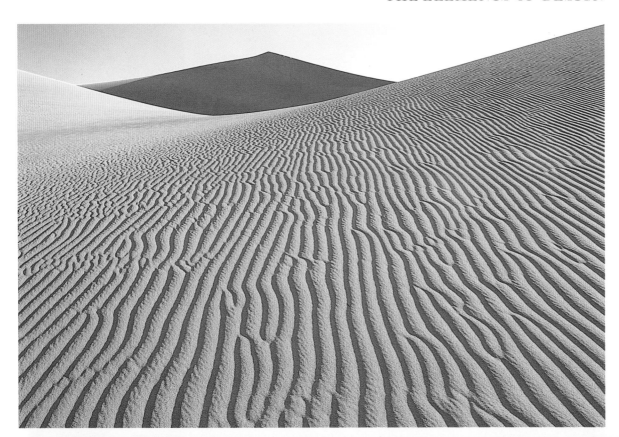

SAND DUNES,
DEATH VALLEY,
CALIFORNIA.
20mm lens,
f/22 at 1 second,
Fujichrome
Velvia.

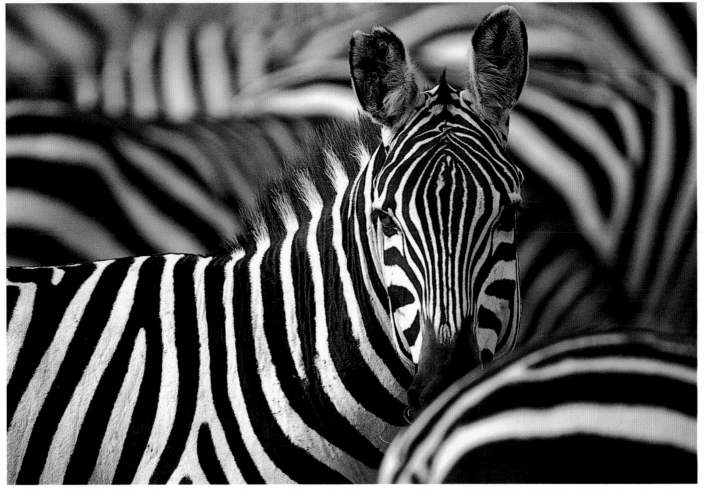

COMMON ZEBRA, SERENGETI PLAIN, KENYA. 200–400mm zoom lens (in 400mm range), f/5.6 at 1/60 second, Fujichrome 100.

NORTHERN GANNET COLONY, NEWFOUNDLAND, CANADA. 200–400mm zoom lens (in 400mm range), f/16 at 1/15 second, Fujichrome 100.

NORTHERN GANNET COLONY, NEWFOUNDLAND, CANADA. 200–400mm zoom lens (in 400mm range), f/16 at 1/15 second, Fujichrome 100.

PATTERNS AND TEXTURES

MH Patterns are repetitions of shapes that are organized in a rhythmic way. Textures are often patterns on a more minute scale, but have the added dimension of a tactile quality. In the previous sand dune image, we saw the pattern of zigzagging lines, but also, as we will see in the next chapter, the three-dimensional texture created by sidelighting. Texture alone gives images a tactile quality and allows us to experience what we are seeing with the added sense of touch. Both pattern and texture add visual variety and are abundant in nature, if only one takes the trouble to look for them.

The strongest patterns are geometric shapes, such as circles, squares, and triangles. However, these rarely occur naturally. The sun and moon are circles, and in Art's image of the sun and evergreen, we had an example of a circle balanced with the strong, triangular shape of the evergreen tree. Triangles, like diagonal lines, are dynamic, much more so than squares or rectangles. Odd numbers of things are also more dynamic in a composition. A picture of three boulders is more likely to produce dynamism than one of two or four. This is probably because evenness echoes the rectangular shape of the picture space. Oddness would therefore upset the equilibrium more.

Pattern has the ability to become abstract design. Abstract design is design for the sake of design. The subject has lost its usual connotations. This kind of pattern is most often created by macro photography. A photograph is merely a flat piece of film. It need not be a strict three-dimensional representation of the visual world.

AW When you specifically look for patterns, and you have an area, as in the first shot of gannets, that is not completely balanced, the structure is weakened. It is not filled out to all four corners. The first shot of the gannet colony shows a rather loose grouping of the birds, but there isn't a strong repetition of shapes. In the second, however, you have a strong pattern throughout. Every element is as important as the next, so it becomes an abstract design.

MH This is not abstract design in the sense that we no longer recognize the subject, but abstract because the pattern has become the subject. The ingredients of the pattern are often of secondary importance. The repetition and the rhythm created by them is what makes the image dynamic.

AW In all these photographs, I was attracted to the patterns I saw.

MH The moth and fish images are more literal examples of pattern than the frosted leaves or feather close-up, but they are still interesting designs. The jacks have a wonderful energy as they burst forward toward us in the frame. The frost-rimmed leaves are an elegant study of color, pattern, and texture, provided by the contrast of light and dark. The feather is no longer a feather, but pure two-dimensional design.

ORNATE TIGER MOTH ON GROUND COVER, ZION NATIONAL PARK, UTAH. 55mm macro lens, f/11 at 1/15 second, Kodachrome 64.

SCHOOL OF JACK FISH, CRYSTAL RIVER, FLORIDA. Nikonos with 20mm lens, f/4 at 1/30 second, Fujichrome 100.

FROSTED OREGON GRAPE, WASHINGTON. 55mm macro lens, f/16 at 1/8 second, Fujichrome 100.

PHEASANT FEATHERS. 55mm macro lens, f/16 at 1/60 second with flash, Fujichrome 100.

CAMOUFLAGE

AW One of my favorite themes is camouflaged animals whose patterns make them invisible. People delight in discovering them in the image. It is the element of surprise, and the unusualness of the subject matter, that makes them striking photos.

MH Up to now, we have been discussing visible patterns. Camouflage is nature's invisible pattern—protective coloration to conceal prey from predator, and as in the case of the serval, predator from prey. Animals either have colors or patterns that enable them to blend in with their specific habitat. Ptarmigan and arctic hare are white to conceal themselves in snow from arctic foxes, which are also white so they can't be seen. Once you have tackled the problem of exposure, a white subject on a white background should pose no problem.

Moths are night fliers, in general, and depend on mimicry of vegetation or bark to hide them from birds and other sharp-eyed predators while they rest during daylight hours. Camouflage is a perfect subject for a photo essay, and a real challenge to one's detective skills.

MOTH ON PINE TREE, HOG ISLAND, MAINE. 55mm macro lens, f/16 at 1/8 second, Fujichrome 100.

SOLOMON ISLAND LEAF FROGS. 55mm macro lens, f/11 at 1/15 second, Fujichrome Velvia.

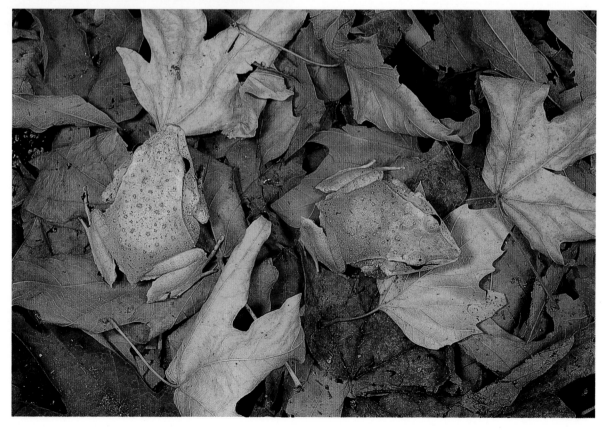

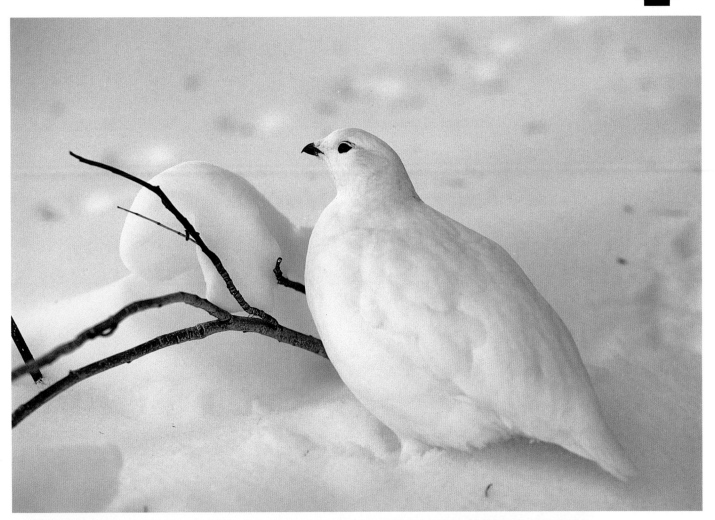

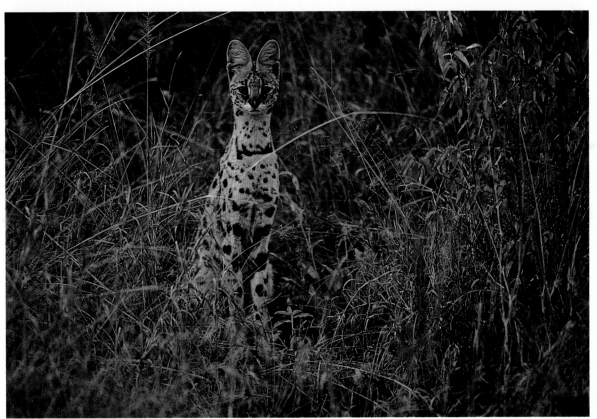

ROCK PTARMIGAN,
MOUNT RAINIER
NATIONAL PARK,
WASHINGTON.
200–400mm
zoom lens (in
200mm range),
f/5.6 at 1/30
second,
Fujichrome 100.

SERVAL, MARA
RIVER, SERENGETI
PLAIN, KENYA.
200–400mm
zoom lens (in
300mm range),
f/4 at 1/60
second,
Fujichrome 100.

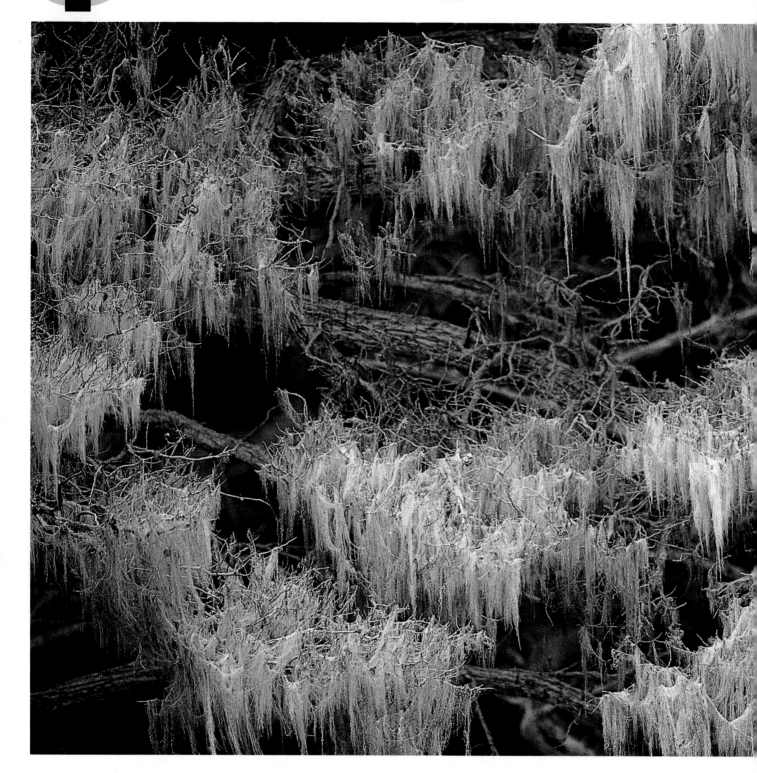

TEXTURE

AW Texture, like pattern and line, is but one element of design. Not that you would go out and say, "Today, I'm going to photograph examples of texture or shape or pattern," but I am suggesting you be aware of them. These shots of texture could also be examples of line and pattern as well. In the first, we have moss on a cypress tree on the Monterey Peninsula. The light complements the subject perfectly. Had this been a bright, sunny day, the textural character would have been reduced. I used the patterns of the moss for my design. With a 400mm lens, the strands of moss fill out the four corners of the composition. The soft lighting allows for more subtle gradations of light and shade. The kelp on the beach is a strong pattern of the smooth air bladders against the texture of the leaf. The repetition of the shapes of the bladders makes a

I shot the frozen waterfall (page 84) on a gray day in Yellowstone with a 300mm lens to make sure I excluded any branches and rocks that might detract from the pure texture of ice. Anything dark would have been a jarring note. I also didn't want any reference to scale, so that someone looking at this would be drawn immediately to the textures and forms.

MH As we will see in the next chapter on light, texture on an uneven surface is usually brought out best by sidelighting. It creates shadows in the depressions and highlights the uppermost surfaces. It is the contrast of highlight and shadow that enables us to see forms three-dimensionally. Likewise, contrast throws even very fine textures into relief.

In the case of the moss, some contrast is necessary to read the texture in this picture. In the other images, however, it is the absence of strong light that enhances the tactile qualities of what we see. In the case of the madrone curls, the colors are enriched by the soft, overcast light. The contrast is created by hue, not tone.

Because the kelp is a glossy surface, bright light would have been disastrous, causing glare

KELP ON BEACH, OLYMPIC NATIONAL PARK, WASHINGTON. 55mm macro lens, f/16 at 1 second, Fujichrome 100.

OPPOSITE: MOSS-DRAPED BRANCHES, MONTEREY PENINSULA, CALIFORNIA. 200–400mm zoom lens (in 400mm range), f/16 at 1/15 second, Fujichrome Velvia.

strong abstract, and I've come in close to eliminate sand and other unnecessary elements.

Third, the curls of bark on the trunk of a madrone tree (page 84) create a pattern that is textural in nature, but is also a composition of light and line. What attracted me was the smooth texture of the almost skinlike surface of the tree. The bark is peeling naturally in tissue-paper-like curls. Soft light again is necessary for this image to work.

and reducing the film's ability to record colors. The comparison of smooth shapes on a rough surface gives us a texture we can really sense with almost tactile enjoyment.

As Art mentioned, soft light was again necessary to make the frozen waterfall readable. You may be wondering how we can talk about soft light and contrast at the same time. It has to do with the film's sensitivity to light, and we discuss it in the next chapter.

MADRONE BARK, WASHINGTON. 55mm macro lens, f/16 at 1/2 second, Fujichrome Velvia.

FROZEN WATERFALL, YELLOWSTONE NATIONAL PARK, WYOMING. 200–400mm zoom lens (in 400mm range), f/11 at 1/15 second, Fujichrome 100.

READING THE LIGHT

Without light we would have no color. And without light, there would be no photography. In fact, the word *photography* derives from Greek roots meaning "writing with light."

Primitive man did not have the benefit of science to explain natural phenomena such as the rainbow. Nor did we, until Sir Isaac Newton's use of the prism separated white light into its component colors. Light is a form of electromagnetic energy, which, in the whole spectrum of frequencies, is only visible as colors in a very narrow band. Other frequencies, such as infrared, ultraviolet, gamma, and X-ray radiation, are invisible to our eyes.

Yet, despite our basic understanding of light, it is something we are apt to take for granted, like the rising and setting of the sun. But in photography, we can never take light for granted, and must learn to perceive its many nuances. As we see in the series of four images of the Twelve Apostles taken at different times of the day, the quality of the light creates a variety of colors and moods. It also models form, and the direction of light is crucial to how we perceive shapes and three-dimensional space.

AW I first photographed the seastacks on pages 86–87 off the southern coast of Australia early in the morning, resulting in the very pastel image. I came back later in the day and photographed the others, late afternoon (silhouettes), sunset (pinks and oranges), and just after sunset (very cool blues). By comparing all four, you can see how the shifting position of the sun has profound ramifications for the emotional impact of the image. I like the warmth of the sunset shot with the pinks and oranges, but I also like the cool, subtle early morning shot.

MH This series reminds me of the Rouen Cathedral series of the French impressionist Claude Monet. He always painted the facade of the cathedral from the same vantage point, but under different light conditions at different times of the day and year. The resulting comparisons are a symphony of color tapestries with varying vibrations and moods. The cathedral was not the point. It was the effect light had on its appearance.

Unlike the tourist who stood on the edge of the Grand Canyon, snapped his photo, and then said, "Okay, let's go, I've got it," we could stand in the same spot, every day, 365 days of the year, and have 365 different images. The subject will be the same. But it will not look the same because the lighting conditions will differ.

On film, light translates into color, and colors, as we saw in chapter 4, elicit emotional responses from us. Mood by itself can be the subject of the photo, as it is in these four images. But more important, mood is one emotional link the photographer shares with the viewer. Each of us can probably pick a favorite. It might be interesting to ask yourself why you like one more than another.

QUALITY OF LIGHT: TIME OF DAY

Even though daylight film is designed to be used outdoors under sunny conditions, full midday sunlight is usually the worst for photography. Its

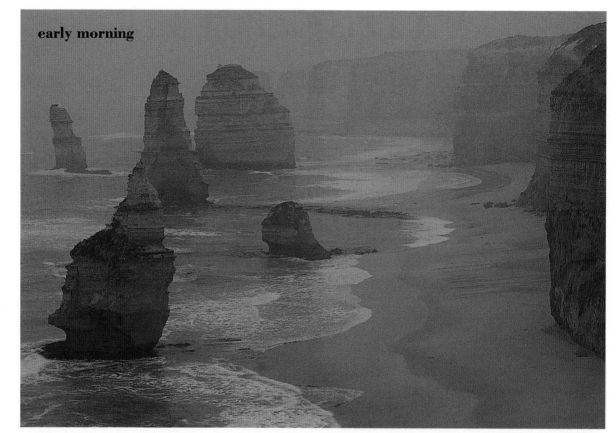

early morning

Twelve Apostles,
Victoria,
Australia.
80–200mm zoom
lens (in 200mm
range), f/16 at
1 second,
Fujichrome 50.

Twelve Apostles,
Victoria,
Australia.
80–200mm zoom
lens (in 200mm
range), f/16 at
1/15 second,
Fujichrome 50.

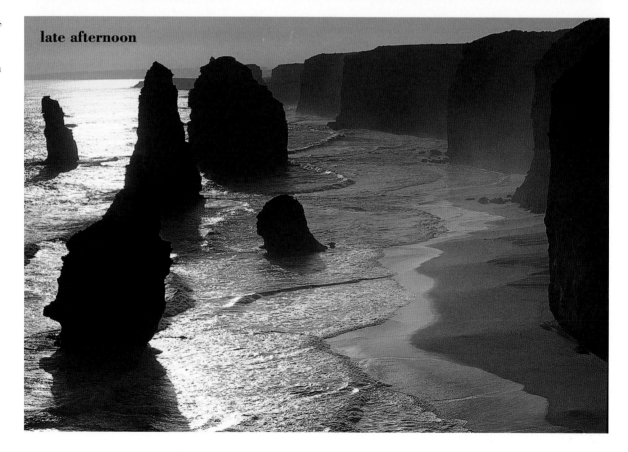

late afternoon

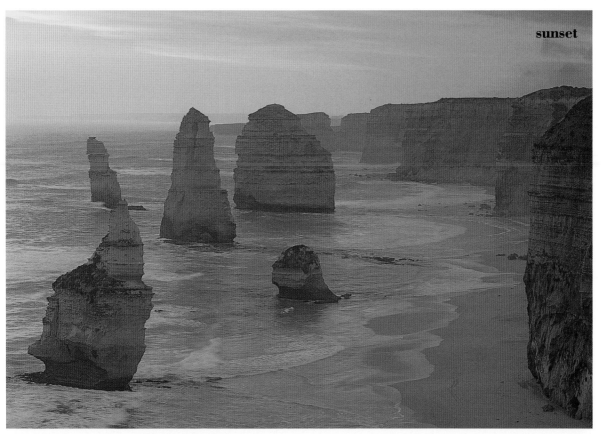

sunset

TWELVE APOSTLES,
VICTORIA,
AUSTRALIA.
80–200mm zoom
lens (in 200mm
range), f/16 at
1/8 second,
Fujichrome 50.

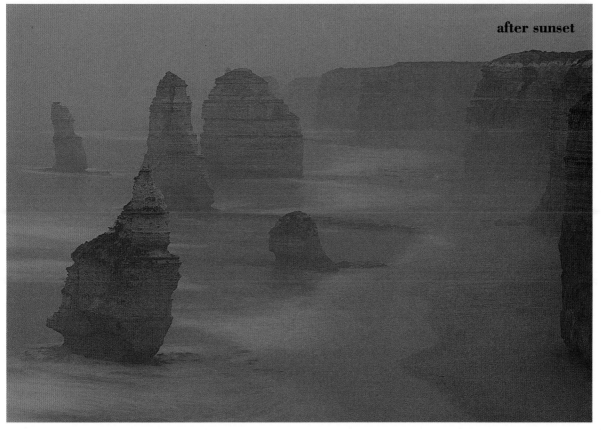

after sunset

TWELVE APOSTLES,
VICTORIA,
AUSTRALIA.
80–200mm zoom
lens (in 200mm
range), f/16 at
2 seconds,
Fujichrome 50.

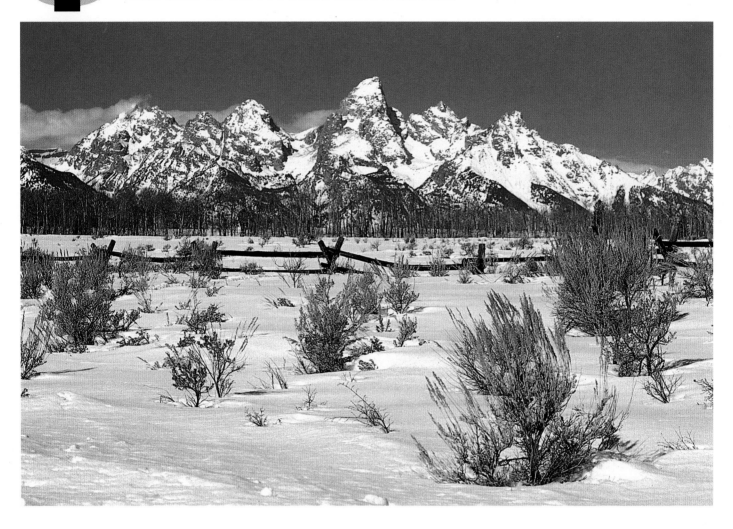

GRAND TETONS,
WYOMING.
20mm lens, f/22
at 1/60 second,
Fujichrome
Velvia.

direct overhead lighting produces flatness of form and washed-out colors.

Most professional photographers choose mornings or afternoons, when light moves toward the warmer end of the spectrum. But it is not just for warmth of color. Early and late in the day, the tonal range is less extreme, and the film can record more subtle gradations of tone. Color films usually respond better in lighting situations where the contrast is less extreme.

The problem arises with film. It is not nearly as sensitive as the human eye. In bright light, the eye can see all the tonal values from the brightest highlights to the darkest shadows because the iris automatically adjusts to the different amounts of light. Our brain also tells us what to expect. For example, a scarlet tanager registers the same color red in our mind, even though we might see it in sunlight or in shade.

Film, however, has a smaller parameter of sensitivity. Its response to tonal extremes varies, depending on the film. Color negative films are more sensitive and can handle a wider range of contrast. But color transparency film cannot. Since this is the film most commonly used for reproduction, it is important to understand its capabilities.

AW Many people have the idea that bright, sunny days are best for photographing landscapes. The sun can be an advantage, but as we saw with the Twelve Apostles, time of day can make a world of difference.

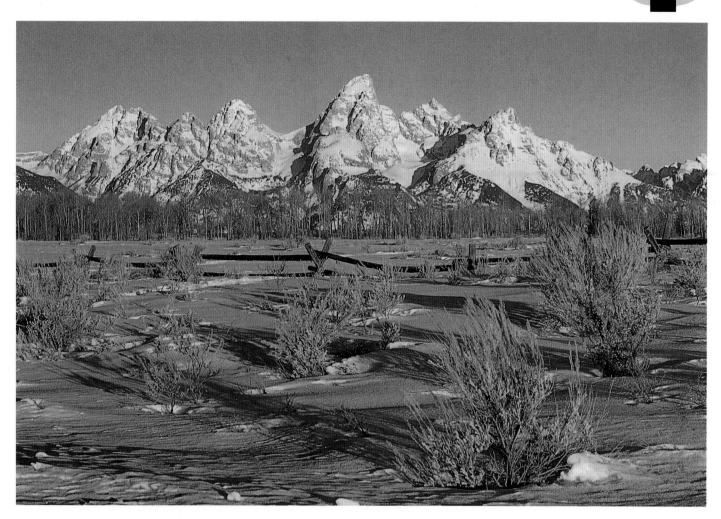

Here I photographed the Grand Tetons from the east at noon, and then again at sunrise. Clearly, the low angle of the sun makes a more appealing shot. Snow is very tricky for exposure, especially in bright sun. The light meter is weighted to read 18 percent gray and will actually try to make white snow 18 percent gray. With the low light and long shadows, exposure is easier, and the sagebrush in the foreground is more colorful under the low-angled light.

MH Once you become sensitive to light as a photographer, you rarely photograph a subject under midday lighting conditions, and this comparison clearly shows you why. Early morning and late afternoon provide more color in a landscape because the sun's rays pass through thicker layers of the atmosphere, which absorb the blue end of the spectrum, leaving us to see wavelengths at the warmer end of the color spectrum. This accounts for the "golden glow" one associates with late afternoon, then moving to the orange and red end of the spectrum as the sun sets on the horizon. (Sunrise is the same phenomenon in reverse.)

While this phenomenon gives additional warmth here to an otherwise cool, snow-covered winter landscape, the low angle of light also creates shadows that give the foreground texture and interest, and overall enhances the feeling of three-dimensional depth in the scene.

GRAND TETONS, WYOMING. 20mm lens, f/22 at 1/15 second, Fujichrome Velvia.

ABOVE RIGHT: GEMSBOK, SAMBURU NATIONAL PARK, KENYA.
200–400mm zoom lens (in 400mm range),
f/5.6 at 1/125 second, Fujichrome Velvia.

BELOW RIGHT: CLARET CUP CACTUS BLOSSOMS, ARIZONA.
50mm lens, f/16 at 1/15 second, Fujichrome 100.

OPPOSITE ABOVE: GEMSBOK, SAMBURU NATIONAL PARK, KENYA.
200–400mm zoom lens (in 400mm range),
f/5.6 at 1/30 second, Fujichrome Velvia.

DIRECT SUN VS. OVERCAST LIGHT

AW The sun was moving in and out of clouds, and these shots were taken a few minutes apart. In the first image, taken in full sunlight, the angle of the animal's head is casting a deep shadow and making it hard to see detail in the boldly marked face. The next image, when a cloud covered the sun, shows what happens when the shadows disappear. Now the animal's face is easy to read and you can even see the subtle catchlight in the eye. Even though the position of the animal in this image is not as strong as in the first, the overall impact is more pleasing.

MH Reduced-contrast lighting helps with this image, but not without some loss. For one thing, the gemsbok's form is not as distinct. Without highlight and shadow to define his form, the animal is not as separate from the landscape background as in the first image. I agree that the second is a more appealing portrait because of the facial detail, but I still like the warm, sunlit feeling of the first image. Again, this shows that there is no single "correct" way to portray something—photography is subjective.

On a bright day, lots of the blue wavelengths of light are bouncing about, which causes shadow areas to reflect some of this blue light. Even though there might be momentary cloud cover, which acts as a giant white diffuser, there is still a strong blue component to the quality of the light. The film sees it even if we don't. The difference in color between these two images is influenced by some reflected blue light reaching the film.

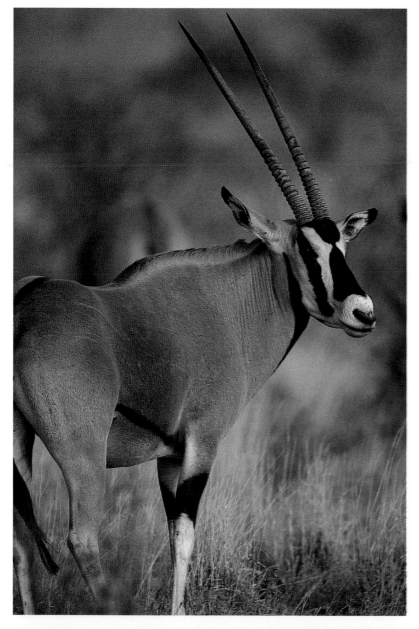

AW In the first exposure of the cactus image, bright sun has rendered this scene into a cluttered, broken-up image because of the lights and darks. This was photographed in the Chiricahua Mountains in Arizona on a clear, cloudless day. So I arranged my pack to cast a shadow over the area in the viewfinder. I was able to re-expose without the strong brights and darks, and the result is a much more satisfying image.

MH This is a beautiful example of how film responds to high-contrast and low-contrast lighting conditions. The most noticeable difference is in the color. The sunny version shows a warmer red with more of a yellow component, and the shadow version shows a more bluish red. But aside from that, the highlights and shadows are also noticeably different.

In the sunny version, the shadows have filled in and gone dark, with no readable detail. The cactus needles are the lightest values in the scene. The image has a lot of snap because of the contrast of darks and lights, and because Art exposed to keep the highlights from washing out, to let the shadows fill in, the image is publishable.

In the shadow version, the yellow stamens of the flowers are now the brightest area of the image. There is more detail in the shadow areas, and texture to the cactus needles.

Flower photographers soon learn to recognize the value of high overcast for intensifying color in a scene. Uniform, even, low-contrast light is infinitely preferable for saturating color. The red flowers appear more saturated in color than they do in the sunny version. Some photographers use a diffuser, such as a white umbrella, or a reflector to throw more light into the shadow areas, or even flash to fill in the shadows and reduce the high-contrast situation. Anything that works to create a more balanced lighting is worth trying when conditions are not ideal. One could also use a warming filter to keep the reds from going bluish, which is discussed in chapter 7 on creative options.

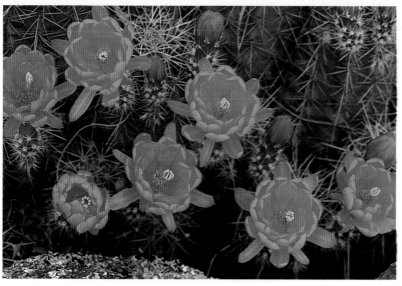

CLARET CUP CACTUS BLOSSOMS, ARIZONA. 50mm lens, f/16 at 1/4 second, Fujichrome 100.

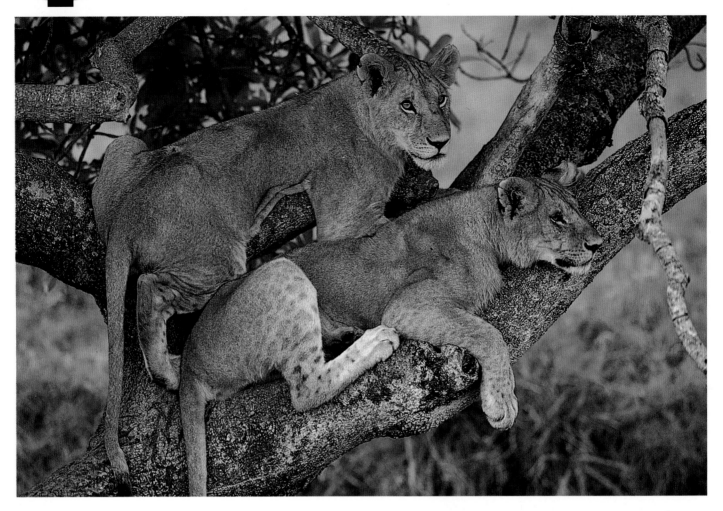

LION CUBS,
SERENGETI PLAIN,
KENYA.
200–400mm
zoom lens (in
200mm range),
f/5.6 at 1/60
second,
Fujichrome 100.

OVERCAST LIGHT

AW The shot of the lion cubs was taken after waiting for a couple of hours for the sun to disappear behind clouds. Reduced contrast was necessary to give me the result I wanted. In the forest scene from Honshu, the subtleties of the bark and lichens on the trees are illuminated with the same intensity as the leaves on the limbs surrounding them. Again, it's a very flat image and easy to expose for because there are no bright highlights or dark shadows.

In the maple trees covered with moss in the Olympic rain forest, again the subtleties of the browns, oranges, and greens are more vibrant under the flat lighting. The overcast acts like a huge white light that gives each color a fighting chance to shine. Had there been blue sky, the shadows would have taken on a bluish cast, and in direct sun, the contrast would have been more than the film could handle.

MH The subtleties of color in all these images would be impossible with bright sunlight. Overcast lighting enhances color. The diffusing effect of cloud cover filters out a lot of the blue and ultraviolet wavelengths in daylight. This allows other colors to appear more saturated.

In the trees of Honshu, I love that there is still a sense of depth, and this is partly achieved by the composition. The tapering limbs of the trees carry us back into the picture space, away from the front plane of the strong, vertical trunks. The change in scale of the textures, front to back, also enhances the deeper sense of space. The tiny leaves in the background contrast with the bolder pattern in the foreground.

In the Olympic rain forest image, I like the feeling of actually being in the forest. I can see, thanks to the low-contrast lighting, all the subtle textures and details, giving the scene a tactile quality, and a gentleness and intimacy that would be lost had it been photographed under sunny conditions.

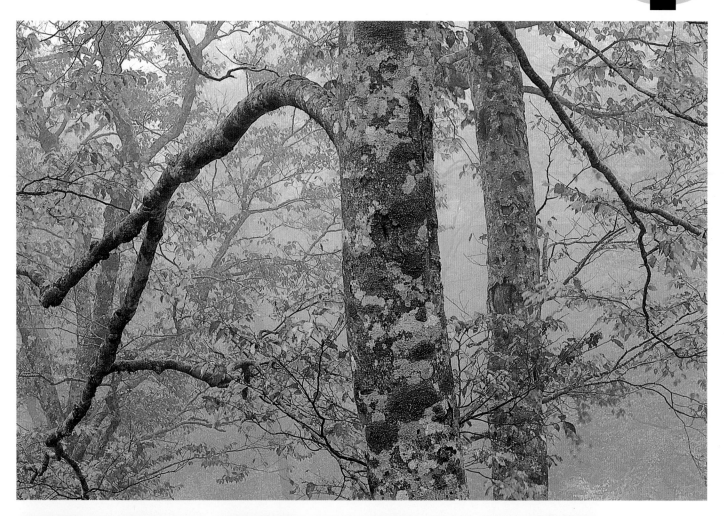

FALL MAPLE,
HONSHU, JAPAN.
20mm lens, f/22
at 2 seconds,
Fujichrome
Velvia.

MAPLE TREES,
OLYMPIC NATIONAL
PARK, WASHINGTON.
20mm lens, f/22
at 1 second,
Fujichrome
Velvia.

DIRECTION OF LIGHT

AW As with the Twelve Apostles, these two bristlecone pine trees, high in the White Mountains of California, look very different in different light. The direction of light greatly affects our perception of a subject. In the first, low-angle front lighting filtered through a polarizer gives the scene an otherworldly feel, emphasizing the starkness of where these trees have had to grow. In the second image, the late-afternoon sky, with sun hidden behind the weathered trunk, gives a more delicate feeling to the tree.

MH This is a good example how light affects emotional impact of a given image. The first is strong and stark, no doubt enhanced by the polarizer darkening the sky and cutting down the glare of the frontlighting on the tree trunk. The second is more ephemeral, with a pastel tonal quality. I like both images for different reasons. The first is bold, and the tree has not only color but texture to add to its character. The second, with the tree trunk now in the shade, emphasizes the outline and form. The shape of the tree reminds me of the famous Greek sculpture called the *Winged Victory (Nike) of Samothrace*, and to me, it evokes an eternal quality of the triumph of life over bleak and desolate surroundings. Both versions relate the power of the tree, and each creates a sense of place that goes beyond just a documentary photo.

BRISTLECONE PINES, WHITE MOUNTAINS, CALIFORNIA. 20mm lens, f/22 at 1/30 second, Fujichrome 50.

OPPOSITE: BRISTLECONE PINES, WHITE MOUNTAINS, CALIFORNIA. 20mm lens, f/16 at 1/15 second, Fujichrome 50.

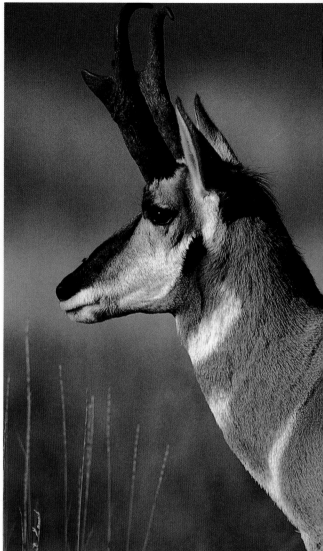

FRONTLIGHTING

AW What happens to a lot of people in the field is that they get so excited as they get close to an animal, they forget to look which way the sun is coming from. They will shoot from the direction of their approach, which may not necessarily be the best lighting. I analyze where the light is coming from first, then approach the animal from the direction I think will give me the best exposure. In this case, the first was shot completely backlit, and there is disconcerting shadow detail on the face. In the second, I've approached the animal with frontlight falling on it in order to give me better detail on the face.

MH Most photographers learn to keep the light falling on the subject, that is, coming from over their shoulder. Frontlighting does not give shadows, as does sidelighting. As a result, there is often less contrast to deal with, and thus less of a three-dimensional feel. If your goal is to flatten out the image into a two-dimensional design, frontlighting will enhance that. The bee-eater image is a perfect example.

ABOVE LEFT: PRONGHORN, NATIONAL BISON RANGE, MONTANA. 300mm 2.8 lens, f/5.6 at 1/60 second, Kodachrome 64.

ABOVE RIGHT: PRONGHORN, NATIONAL BISON RANGE, MONTANA. 300mm 2.8 lens, f/5.6 at 1/60 second, Kodachrome 64.

ARCTIC FOX,
BROOKS RANGE,
ALASKA.
300mm 2.8 lens,
f/5.6 at 1/60
second,
Kodachrome 64.

CARMINE BEE-
EATER, BOTSWANA.
800mm 5.6 lens,
f/5.6 at 1/60
second,
Fujichrome
Velvia.

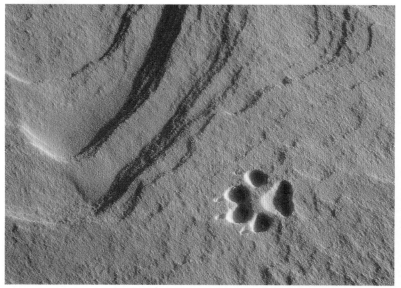

WOLF TRACK,
ELLESMERE ISLAND,
CANADA.
50mm lens, f/16
at 1/15 second,
Kodachrome 64.

SIDELIGHTING

AW Sidelighting, or using a low angle of light, enhances compositions. A very low angle of light was essential here to throw some shadow so that the track would separate out from the white snow. Rather than being bright white, the snow is almost neutral gray with shadows of each snow grain.

The second picture is an adolescent bald eagle at the nest. He's doing an early-morning stretch to dry off dew that has accumulated on his wings during the night. The ends of the wings are in shadow, and the front is bathed in warm soft light. The tree behind is cast in shadow, which gives an eerie effect. Light highlights the eye and beak.

MH Sidelighting, more than any other, throws relief into the landscape or subject. In the picture of the wolf track, I like the ephemeral quality and mystery evoked by this gentle, shadowy impression. Wolves are elusive and hard to see. Tracks may be the only sign of their presence. To me, this single track evokes all the solitude of a wilderness remote and expansive enough to support a population of wolves.

In the shot of the eagle, the low angle and direction of the light creates a drama to this picture that would be lost with frontlighting. Because of the darks and lights, and strong contrast, we feel the powerful bird infused with a sense of mystery and drama.

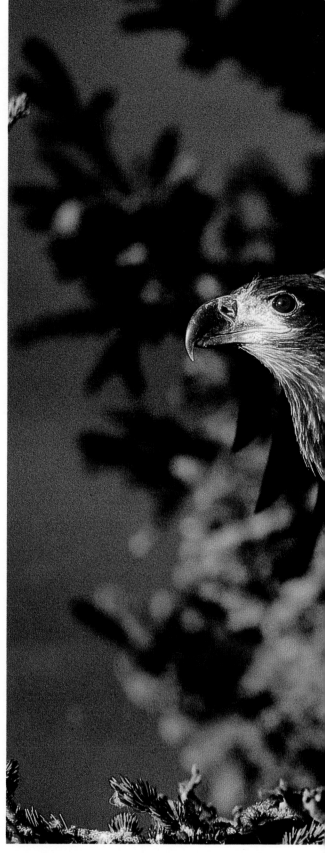

IMMATURE BALD EAGLE AT NEST, ADMIRALTY ISLAND, ALASKA.
800mm 5.6 lens, f/5.6 at 1/60 second, Fujichrome 100.

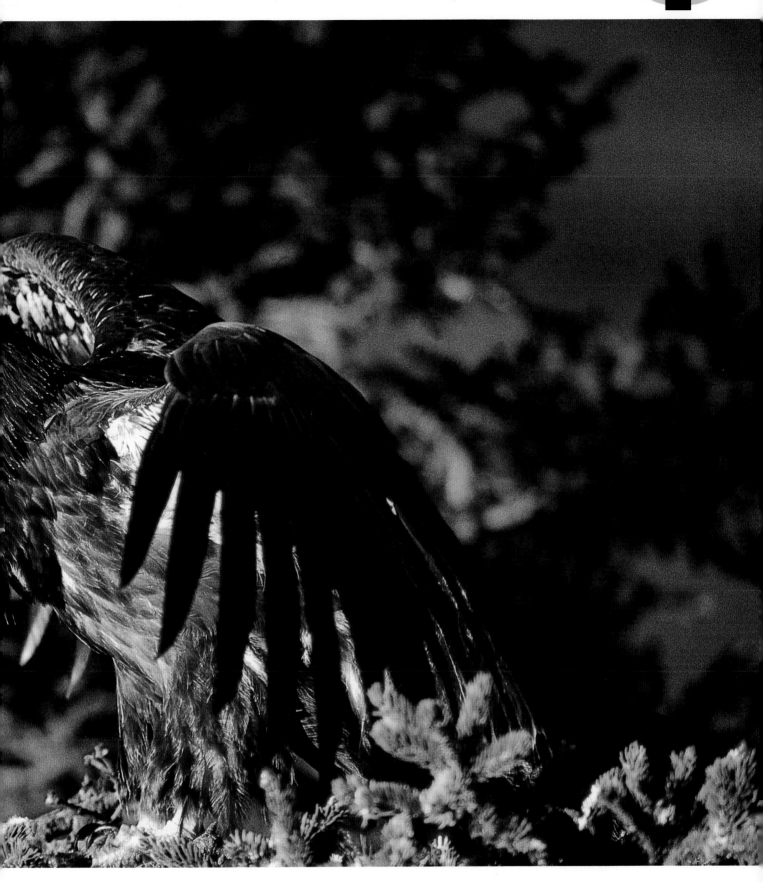

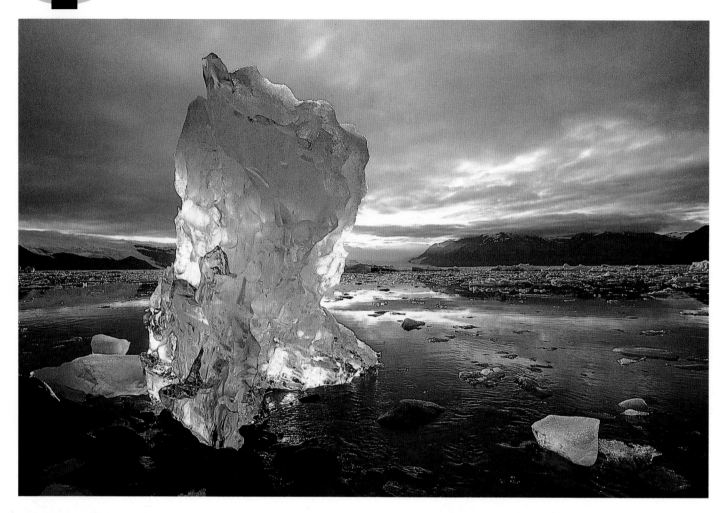

STRANDED ICEBERG,
ICY BAY, ALASKA.
20mm lens, f/22
at 1/15 second,
Fujichrome 100.

OPPOSITE ABOVE:
ALASKA RANGE,
DENALI NATIONAL
PARK, ALASKA.
135mm lens,
f/5.6, 1/125
second,
Fujichrome 100.

OPPOSITE BELOW:
DALL SHEEP,
DENALI NATIONAL
PARK, ALASKA.
200–400mm
zoom lens (in
200mm range),
f/5.6 at 1/125
second,
Kodachrome 64.

BACKLIGHTING

AW When you are in the field, lighting conditions can be constantly changing, and different situations present themselves. Reflected light is not something you might go out to shoot, but when it occurs, you should be aware of it. The same is true of backlighting. It can dramatically change a subject you have been photographing with frontlighting.

When I change my position, the iceberg and the Dall sheep on a ridge have become entirely different images. I created silhouettes as I moved around to the other side and created a more dramatic scene. The backlit iceberg was fairly easy, as gray sky and water gave me an even overall exposure. With the Dall sheep, I used the blue sky as a gray card, set my exposure, and then reframed and shot the sheep.

MH Backlighting is usually the best way to create two-dimensional form. Silhouettes have no detail, only shapes. The character of

the shape becomes more important, as a symbol and as a compositional element. Before I left the magazine, I had been collecting a series of silhouette images for a portfolio. It was going to be a game, without captions until the very end, for the readers to test their skills at identifying animals and birds just from their shape.

With the iceberg, however, the backlighting does just the opposite because it's a translucent object and needs light from behind to show off its three-dimensional form. Without backlighting, the iceberg would be like a silhouette, flat and two-dimensional.

When shooting backlit subjects, you may encounter the problem of lens flare. This happens when light entering the lens causes internal reflections off the lens elements. It can easily be avoided by shading the front lens element. At the magazine, we tried to select images without lens flare because we felt it was unnatural—not something you would see with the human eye—and it interjected the camera's presence between you and the subject.

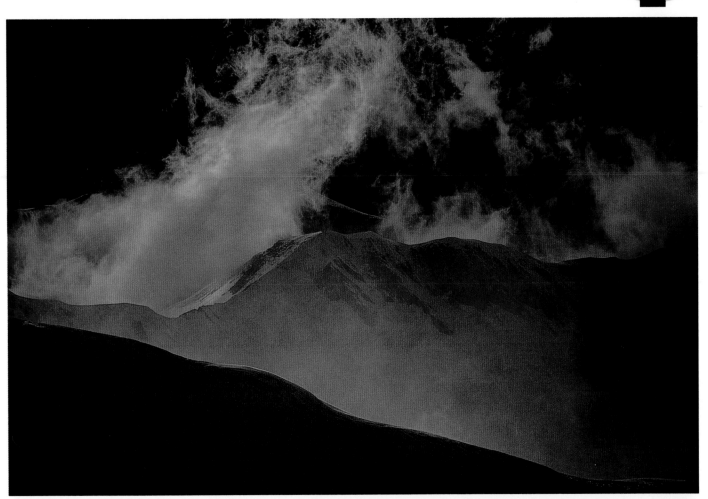

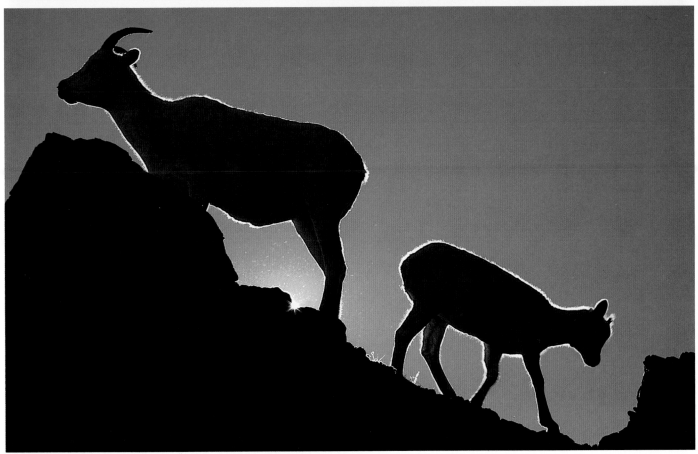

LYNX, MONTANA. 300mm 2.8 lens, f/8 at 1/125 second, Kodachrome 64.

REFLECTED LIGHT

AW The Adélie penguins were shot in noon-day light. I was working with penguins in the shade, and the light reflecting off adjacent ice and snow is acting like a giant reflector and lighting up the shadow area. Otherwise, I wouldn't have been able to get as much detail in this image. The slot-canyon image was also taken in bright, contrasty light a few feet away. This is a good thing to remember when in the field. In otherwise impossible lighting conditions, you can often look around and find something that is being lit indirectly and get very usable images that way.

With the lynx, he was sitting on very bright snow. Rather than trying to shoot the whole animal with too much bright snow in the frame, I chose to come in on his face (with a 300mm lens), which was softly illuminated by the reflected light off the snow.

MH Being able to shoot outdoors at noon with bright snow is the mark of a seasoned professional. An assignment photographer may not have the luxury of waiting for ideal light conditions. Art has resourcefully taken advantage of a difficult situation. Snow, sand, or any bright surface will reflect enough light into a shaded area to make a soft, delicate illumination. For portraits, this is often the most flattering light, which is why studio photographers bounce the flash off another light-colored surface. In this way, there are no harsh shadows or directional light to pick up lines and blemishes on the skin's surface.

Here, in these three images by Art, the softness of the reflected light allows the film to record detail since it is not dealing with a high-contrast situation. In the lynx portrait, Art's tight cropping has conveniently removed the bright snow that would have been distracting to our eye, interfering with our enjoyment of the picture.

OPPOSITE ABOVE: ADÉLIE PENGUINS, PAULETTE ISLAND, ANTARCTIC PENINSULA. 500mm 2.8 lens, f/5.6 at 1/125, Fujichrome 100.

OPPOSITE BELOW: SLOT CANYON, ARIZONA. 20mm lens, f/16 at 4 seconds, Fujichrome Velvia.

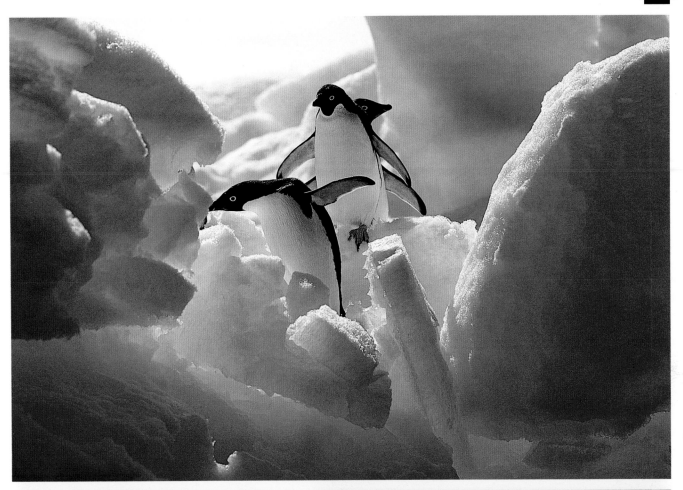

LEOPARD, SAMBURU
NATIONAL PARK,
KENYA. 800mm
5.6 lens, f/5.6 at
1/60 second,
Fujichrome 100.

ICEBERG, ANTARCTIC
PENINSULA.
560mm lens
arrangement
(200–400mm
zoom lens in
400mm range
with 1.4 extender,
400 x 1.4 = 560),
f/5.6 at 1/60
second,
Fujichrome 100.

SPOTLIGHTING

AW As with reflected light and backlighting, spotlighting is an unusual occurrence that when encountered should be taken advantage of. In this case, you expose for the highlights, as I did with the swans. The other swans in the background can go gray, but the swan in the spotlight must not be overexposed, as it would have been had I exposed for the swans in the shadows.

Again, with the leopard, I exposed for the brightest part of the animal. I aimed the camera on the ground that was in the same intense sunlight as the leopard. I took a reading off the ground, then reframed and shot the leopard.

In the iceberg shot, the area being lit was so small, it was hard to meter off the scene itself. To expose for the highlights, I panned the camera to a brighter area, took a reading in bright sun, and reframed with that reading.

In the aerial of the Arctic National Wildlife Refuge, I exposed for the gray area of the clouds above where the light is coming through. That was what I figured the middle gray of the scene to be, but I still bracketed to be safe. Since I couldn't be sure the meter was accurately reading such

a contrasty scene, I took several frames, some slightly underexposed, some slightly over, to be sure I got the correct exposure.

MH Spotlighting is dramatic and draws the eye immediately to the subject, just as a spotlight would on an actor in a theatre production. It creates an intimacy, too, by drawing our attention into the picture space. This is perhaps most noticeable with the swan, but also with the iceberg. It is as if we are looking with binoculars, zeroing in and ignoring the larger surroundings.

WHOOPER SWANS, HOKKAIDO, JAPAN. 200–400mm zoom lens (in 400mm range), f/5.6 at 1/125 second, Fujichrome

ARCTIC PLAIN, ALASKA. 135mm lens, f/2.8 at 1/60 second, Fujichrome 100.

HIMALAYA RANGE,
TIBET. 50mm lens,
f/16 at 1/125
second,
Kodachrome 64.

FINDING THE
18 PERCENT GRAY

AW No matter what the light conditions are, you need to know what your cam-era's built-in light meter is telling you. Most cameras have an averaging meter. It reads the scene, computes light values, and takes the average. In most cases, it will try to render the scene a neutral, or 18 percent, gray. In the first shot, I have taken exactly what my camera light meter was reading, and what is happening here is that I am underexposing the image. The light meter is being fooled by the brightness of the snow, and it is calculated to read that snow as 18 percent gray. What I do then is open up the exposure by one f-stop or decrease the shutter speed by one.

What I normally do is find an area in the scene that is 18 percent gray. If you notice, at the bottom of the frame are some gray rocks. And indeed, the rock I was standing on was completely gray, so I filled the frame with the rock at my feet, took my exposure reading off that, then reframed the shot using the same shutter speed and f-stop determined by the rock. By doing this,

HIMALAYA RANGE, TIBET. 50mm lens, f/11.5 at 1/60 second, Kodachrome 64.

the white snow remains white. I do not carry a gray card with me in the field, as some photographers do, for metering. Instead, I find something in the scene to reproduce 18 percent gray.

As with previous images, this first shot of sun behind a tree in Africa was taken using the camera's meter reading. Here, I panned the camera to the neutral sky to the left of the sun, took a new reading off that, and reshot the same image using the new reading. The sun is properly exposed and the tree silhouetted.

MH Once you understand what the light meter is telling you, you can control lighting and color to suit your expressive needs. Silhouettes are subjective. Sometimes the slight overexposure to render foreground detail creates an ethereal, sun-infused effect. Underexposure leads to generally unreproducible images. As you can see with the tree images, in the darker version it is difficult to read the delicacy of the branches.

The lighter version has a better color balance, too. Technically, you could reproduce either image, but the darker one borders on being too dense and would be a challenge to the color separators.

SUN SETTING BEHIND ACACIA TREE, BOTSWANA. 800mm 5.6 lens, f/16 at 1/125 second, Fujichrome Velvia.

SUN SETTING BEHIND ACACIA TREE, BOTSWANA. 800mm 5.6 lens, f/16 at 1/30 second, Fujichrome Velvia.

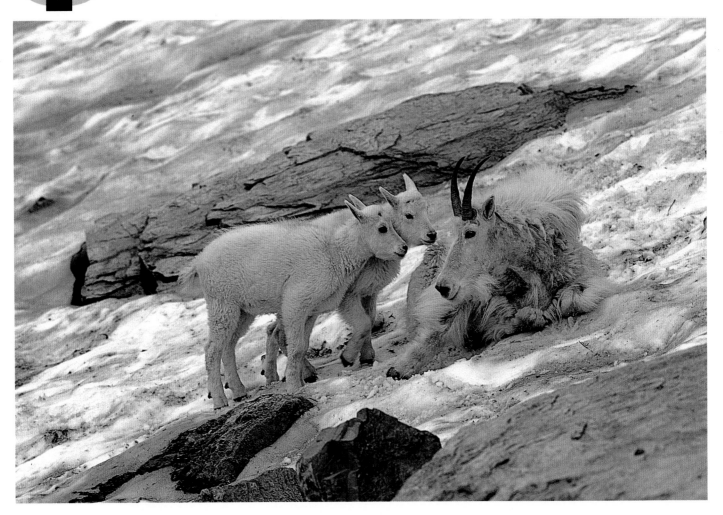

MOUNTAIN GOATS, GLACIER NATIONAL PARK, MONTANA. 200–400 zoom lens (in 200mm range), f/11 at 1/60 second, Fujichrome Velvia.

OPPOSITE: HORNED PUFFIN, SAINT GEORGE ISLAND, ALASKA. 800mm 5.6 lens, f/8 at 1/60 second, Kodachrome 64.

AW With the goats, the exposure was easy to get because essentially the whole image is 18 percent gray, or close enough. Using the gray rocks in the foreground for my reading, I reframed the shot, knowing the mountain goats will show up whiter, which is exactly what I wanted. With the puffin, the bird is high contrast, black-and-white. In any light this is a tough exposure. Again, I took my reading off the gray rock and kept the same exposure for the bird.

MH A painter once told me he could paint any landscape with only one tube of colored paint and a tube each of black and white. For that matter, you don't even need a tube of color. Any subject, landscape or otherwise, can be reduced to its pure tonal values, white for the highlights, black for the shadows, and the rest in intermediate shades of gray. When trying to judge exposure, it helps to think in terms of black, white, and gray.

If you can find the middle tone in whatever you are trying to shoot, the other values, the lights and darks, will fall into balance, whether the lighting is bright or flat. A lot of gray cards occur naturally out in the field; you just have to look for them. Green grass, brown dirt, your own faded jeans will all work, as long as they are metered in the same light as the subject you want to photograph. In a pinch, some photographers will expose for the palm of their hand and open up one stop or a stop and a half.

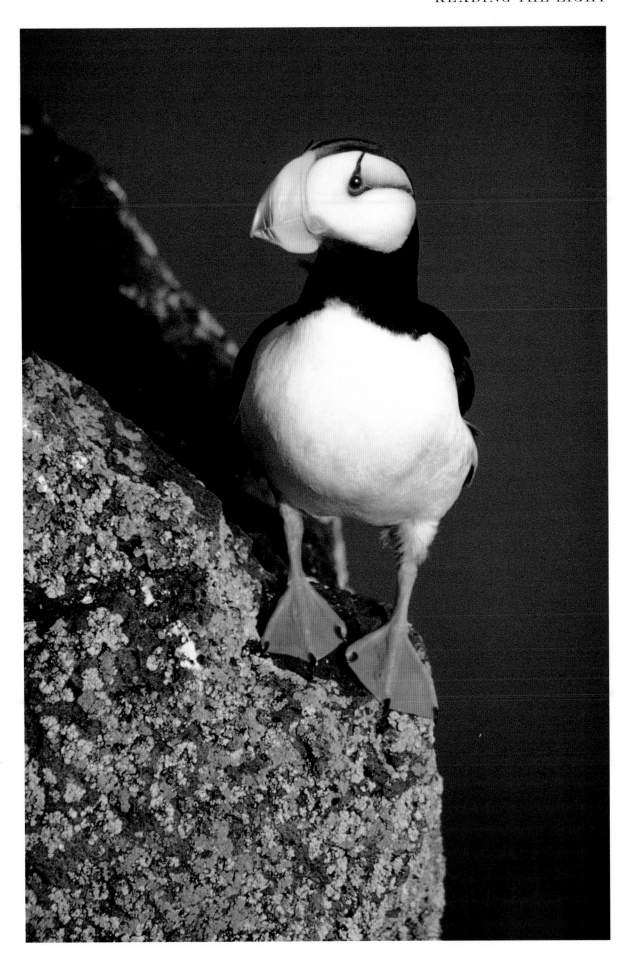

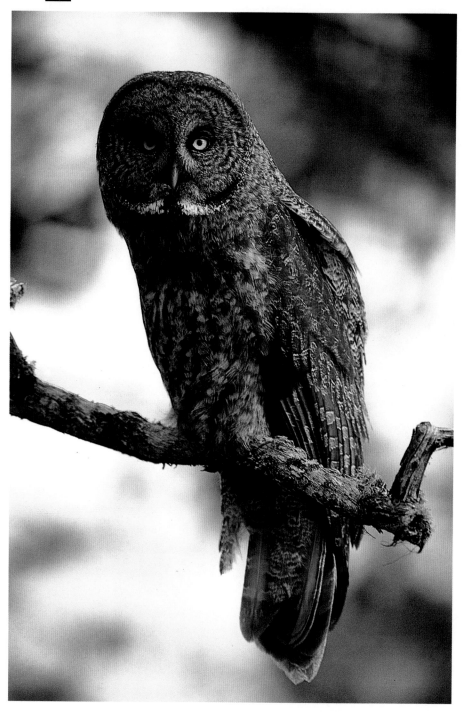

GREAT GRAY OWL, OREGON. 800mm 5.6 lens, f/5.6 at 1/60 second,
Fujichrome 100.

AW In the first image, the owl is against the pale background of an overcast sky, causing it to show up as a silhouette. If I had exposed for the owl, the sky would have washed out even more. So in the second image, I found a better position where the background behind the owl was darker. I could expose for the lighter owl and let the background go darker, if necessary. I normally prefer to put a light subject against a dark background, as light areas tend to come forward and dark areas recede.

MH As you are beginning to see, understanding light and what the light meter of the camera is telling you are crucial to getting good images. The lighting is a soft overcast, but in the first image, the light background has weighted the meter reading toward underexposing the bird, which in reality is probably very close to 18 percent gray. By recomposing with a darker background, the meter will read the scene as 18 percent gray, and the owl will stand out as lighter in tone. Generally, portraits need to be clear, and the expression on the face of the animal readable. The eyes are the most lively aspect of the face and are usually the first thing one looks for when studying a portrait, whether of an animal or a human being. But I still like the first image because of its mystery. It connotes "owl" more to me than the evenly lit version. Owls are spooky. They are silent fliers, and we encounter them usually at dusk, when visibility is poor. Being able to see only one of the bird's eyes reinforces that eerie quality. Also, with the face in shadow, the yellow eye peers brightly and intensely at us. The eyes in the more classic portrait do not have that haunting quality. If I were to publish this image, I would crop in tighter, to minimize the disturbing light areas in the background.

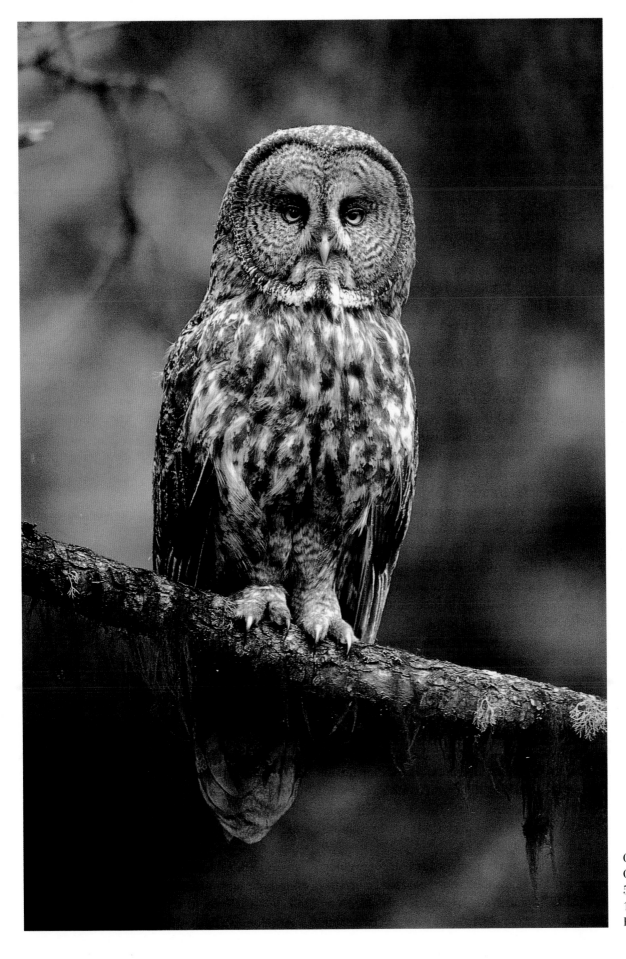

GREAT GRAY OWL,
OREGON. 800mm
5.6 lens, f/5.6 at
1/60 second,
Fujichrome 100.

7 CREATIVE OPTIONS

The camera enables us to see and do things creatively that are beyond the capability of the human eye. It expands our range of seeing and gives us new options. Fast shutter speeds can freeze a moment in time that is too quick for the eye to see, and slow shutter speeds allow us to capture motion in a way we cannot experience. The iris of our eye adjusts automatically to different levels of light. We can see everything in a scene instantly in focus. A camera lens, however, sees the world differently, depending on whether its aperture is small or large. The aperture affects the depth-of-field, or the area that is in focus at any given time. The nature of lenses is such that small apertures have greater depth-of-field, while larger apertures have a much shallower depth-of-field.

With a camera, we can take advantage of this. We can leave some things in focus and intentionally throw others out of focus. This is selective focus, one of the creative tools a photographer can use. If you look again at the screech owl comparisons at the beginning of chapter 3, you will see selective focus at work. Other creative options at the nature photographer's disposal are color films, various filters, and flash. These are the equivalent of the artist's palette, the color medium with which he can work. Using filters to alter the available light, you can bias the way the film will record color, thus imposing your own color preferences over those of the film or of nature.

Daylight films themselves vary in their color rendition. For years, the fine-grained Kodachrome and Ektachrome transparency emulsions were the industry standard. Kodachrome is a film with good contrast that renders colors somewhat more warmly than Ektachrome, recording shadows and highlights well to give the final image crispness or "punch."

In recent years, Kodachrome and Ektachrome have received some stiff competition from the new Fujichrome films, which give a warmer rendition of colors that some editors like and others don't. Ektachromes, which used to be bluish and better for rendering greens than Kodachrome, have undergone changes to make them more competitive with Fuji. The new Ektachromes are more neutral in color, and warmer than the old.

Photographers need to shoot their own film comparisons to assess what qualities these different films have, especially under different available light conditions. Fujichromes are beautifully rich in color under overcast lighting, but feel slightly overexposed under bright sunlight. The rendition of colors in all these films differs slightly from the color we see with the naked eye. And color preference is a subjective thing. Kodachrome skies are a cooler gray-blue than Fujichrome, which are more azure colored. Actual sky blue is somewhere in between the two.

Art uses three basic filters for nature photography, to correct or balance light conditions that are less than desirable. He doesn't use the colored filters for strange or surreal effects, but to return color to a more natural tone. The 81A warming filter cuts down on the bluish cast of shaded subjects on sunny days, the graduated neutral-density filter balances high-contrast lighting, and a polarizer cuts glare and reflections that can interfere with the way film records color.

And finally, flash offers a means of expanding opportunities when light conditions aren't ideal.

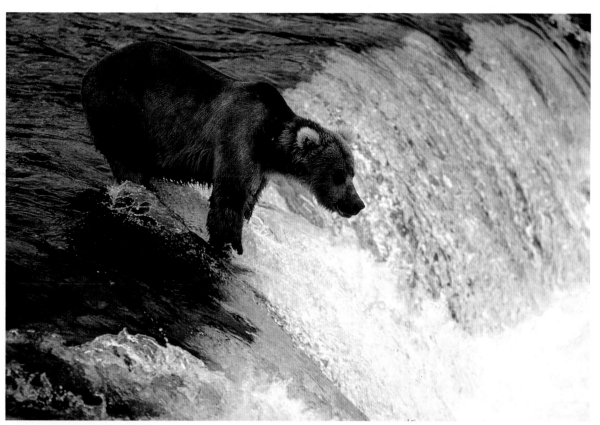

BROWN BEAR,
KATMAI NATIONAL
PARK, ALASKA.
200–400mm zoom
lens (in 200mm
range), f/5.6 at
1/60 second,
Fujichrome 100.

BROWN BEAR,
KATMAI NATIONAL
PARK, ALASKA.
200–400mm zoom
lens (in 200mm
range), f/22 at
1/4 second,
Fujichrome 100.

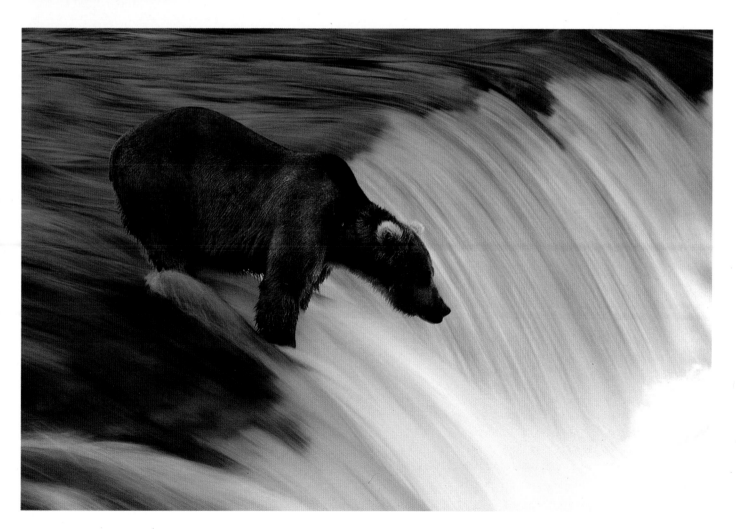

The use of flash in nature photography has not been thoroughly exploited. A great deal of nocturnal activity in the animal world is still undocumented and offers great potential for pioneering photographers. Fill-flash, used to fill in dark shadows in high-contrast situations, is another technique beginning to be used more and more in the field. As nature photographers become more sophisticated and creative with flash technology, they will be able to shoot more under lighting conditions previously considered undesirable or marginal.

USING SHUTTER SPEED TO ISOLATE SUBJECT

AW In the photos of the bear on the previous page, I shot the same animal in the same spot with two different exposures, the first at 1/125 and the second at 1/8 of a second. After about twenty minutes of observing this bear trying to catch salmon, I realized it wasn't going to be successful. I wanted to photograph it in an interesting way, so I tried to think of what else I could do. I decided to make the water a more important part of the composition. By shooting at 1/8 of a second, the water's motion is blurred, setting the bear off against it.

MH What makes the second image successful for me is that the water's motion is more apparent. Freezing motion at a fast shutter speed is not always desirable. It can end up making water look hard and brittle, more like liquid glass. Ironically, the slower shutter speed creates a stronger impression of water and the power of the waterfall, giving us a sense of the challenge this bear faces trying to catch fish under these conditions. The more literal first image does not make as strong an impression as the second image.

AW In the first image of the monkey flowers with the waterfall, the waterfall itself is, again, somewhat frozen at a shutter speed of 1/60 of a second. To my eye, it is not the most attractive effect. In the second frame, I have used a slower shutter speed of 1/4 second, and I feel it

complements the overall soft, pastel quality of the image to have the waterfall less defined.

MH What is appealing here is the difference of textures. The slower shutter speed renders the stream silkier and smoother, making a softer contrast to the tapestry of vegetation. Having sharpness in the foreground brings out the flowers crisply, and with the waterfall more of a textural contrast, it recedes better into the back of the picture space. Both images are certainly publishable, but the first photograph isn't as elegant as the second.

MONKEY FLOWERS AND STREAM, MOUNT RAINIER NATIONAL PARK, WASHINGTON. 20mm lens, f/5.6 at 1/60 second, Kodachrome 64.

MONKEY
FLOWERS AND
STREAM,
MOUNT RAINIER
NATIONAL PARK,
WASHINGTON.
20mm lens,
f/22 at 1/4
second,
Kodachrome
64.

WAVE WASHING
ONTO SHORE, ARCTIC
COAST, ALASKA.
20mm lens,
f/16 at 1 second,
Fujichrome 100.

SHUTTER SPEED:
SUBJECT MOVING, CAMERA
STATIONARY

AW A lot of times when you are outside, the lighting conditions do not permit you to photograph a sharp image. In those situations, if you try to photograph a running animal or flying bird, and the light only permits a fastest shutter speed of 1/60, then you are always going to have a slightly out-of-focus animal that will forever look like a mistake.

With the mallards, it was a heavily overcast day late in the afternoon. The fastest shutter speed I could attain was 1/30, yet all these mallards were busy swimming around and there was no way I could get a sharp shot. Rather than try, I put the camera on one full second and took a correspondingly small f-stop (f/16), then let the birds paint their images across the plane of the film. The resulting image is more artistic, to my eye—an impressionistic view of mallards. I'm making the best of a bad situation, and I'm making the image work. Often, the photos I am most pleased with are where I've pushed the limits with camera, and I'm usually pleasantly surprised by the results.

MH We once ran a cover of daisies that were blowing in the wind, and it was controversial. Uniformly, though, photographers liked it and congratulated us for daring to use it. People tend to think that only sharply focused images can be published. But how better to illustrate the concept of wind than with something moving? At times it is fun to challenge preconceptions, which is why we chose the daisy cover. What made the picture work was that one daisy in the whole field was still sharp.

Sometimes, you can't successfully demonstrate a concept such as motion without showing blurred movement. A Formula One race car would not look fast if it were shot at 1/500 of a second. The sensation of a blizzard is more apparent with the slow shutter speed showing the snow as streaks, instead of flakes. Too many blurred images used all at once would be hard to look at, but used sparingly, they have impact and make for an artistic change of pace.

MALLARDS ON LAKE,
BRITISH COLUMBIA,
CANADA.
20mm lens, f/16
at 1 second,
Fujichrome 100.

BAMBOO IN
SNOWFALL,
HONSHU, JAPAN.
200–400mm zoom
lens (in 400mm
range), f/11 at
1/30 second,
Fujichrome 50.

WILDEBEEST,
SERENGETI PLAIN,
KENYA.
200–400mm zoom
lens (in 400mm
range), f/11 at
1/2 second,
Kodachrome 64.

SHUTTER SPEED: PANNING CAMERA WITH MOVING SUBJECT

AW In all three of these images of running animals in Africa, wildebeest, zebra, and impala, the animals were fast and there wasn't enough light to stop the motion. With the longer exposure, perhaps as slow as a 1/2 second, I panned the camera sideways with the motion of the animal.

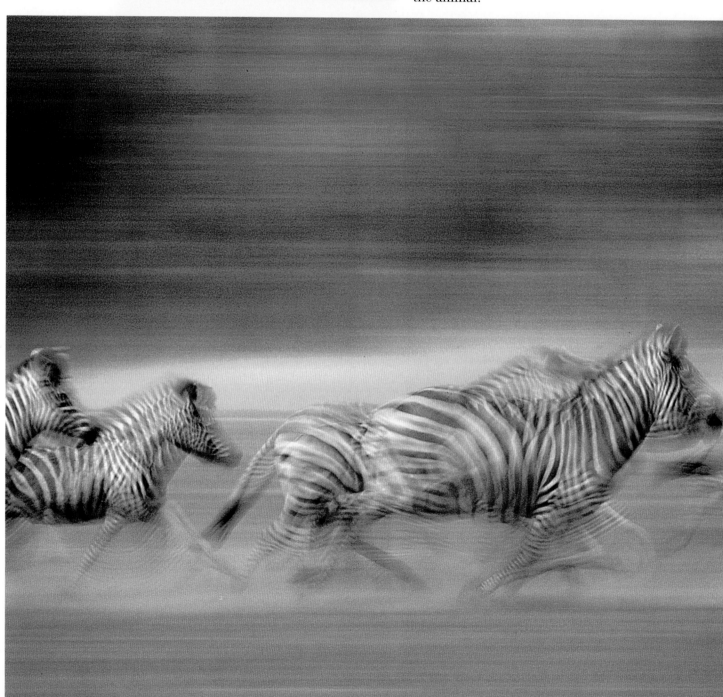

IMPALAS, BOTSWANA. 200–400mm zoom lens (in 400mm range), f/16 at 1/8 second, Fujichrome Velvia.

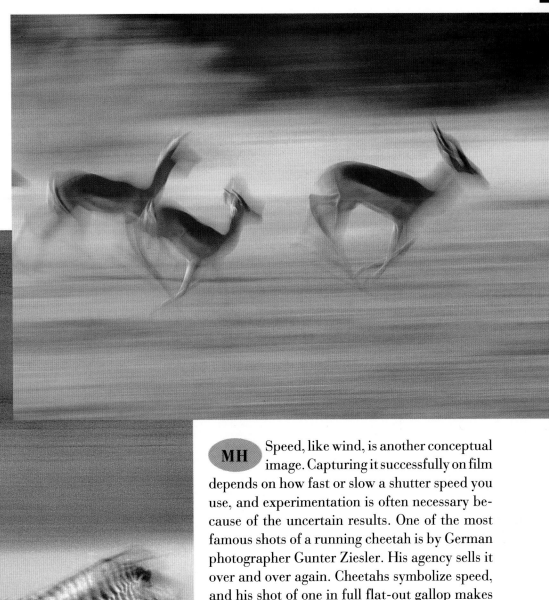

MH Speed, like wind, is another conceptual image. Capturing it successfully on film depends on how fast or slow a shutter speed you use, and experimentation is often necessary because of the uncertain results. One of the most famous shots of a running cheetah is by German photographer Gunter Ziesler. His agency sells it over and over again. Cheetahs symbolize speed, and his shot of one in full flat-out gallop makes a powerful statement.

ZEBRAS, BOTSWANA. 200–400mm zoom lens (in 400mm range), f/11 at 1/8 second, Fujichrome Velvia.

AW Sometimes when animals are moving, you have enough light to stop the action with a fast exposure. Swimming whales or porpoises need bright, sunny conditions. With the impalas and the eagle, both extremely fast animals, I used 1/500 of a second, plus panning, to stop the action. The elephant was in low light, but as a larger and slower animal, 1/250 stopped the action of both the water and the animal.

MH At other times, it is interesting to see the action clearly, and to let the imagination fill in the consequences of the frozen movement. Will the eagle catch the fish? The power of the roaring river that the elephant is trying to cross looks more imposing frozen, in this case, than if it were blurred. This is the opposite of our brown bear at Katmai Falls.

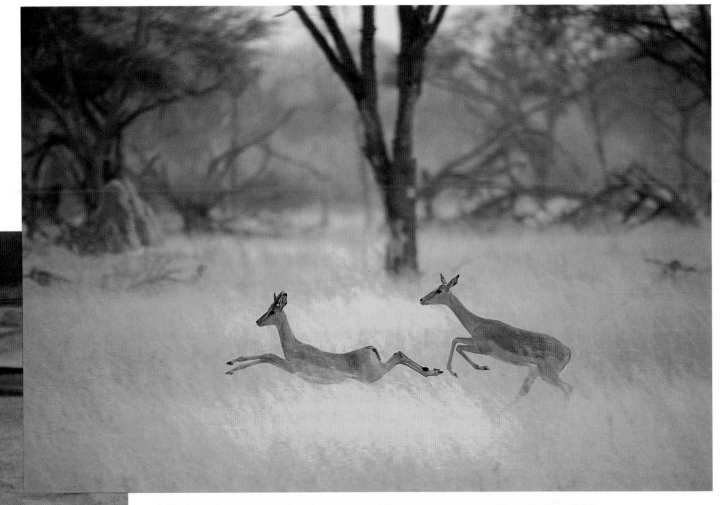

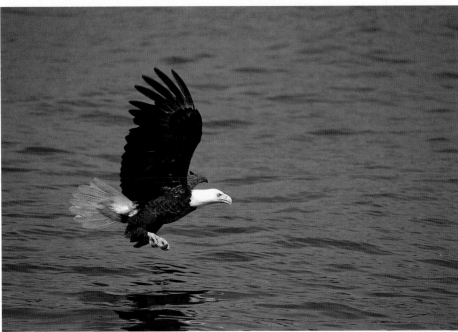

ABOVE: IMPALAS, BOTSWANA. 200–400mm zoom lens (in 400mm range), f/4.5 at 1/500 second, Fujichrome Velvia.

LEFT: BALD EAGLE, ALASKA. 800mm 5.6 lens, f/5.6 at 1/500 second, Fujichrome 100.

ELEPHANT CROSSING SAMBURU RIVER, SAMBURU NATIONAL PARK, KENYA. 200–400mm zoom lens (in 400mm range), f/4.5 at 1/250 second, Fujichrome Velvia.

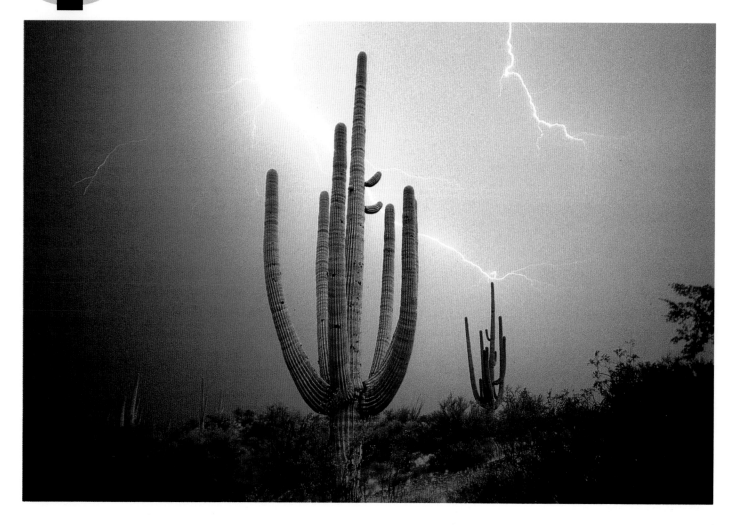

LIGHTNING ABOVE
SAGUARO CACTUS,
SONORAN DESERT,
ARIZONA.
20mm lens, f/5.6
at bulb setting,
Kodachrome 64.

SLOW SHUTTER SPEED: TO CAPTURE UNUSUAL EVENTS

AW This was taken during a lightning storm over the Sonoran Desert in Arizona—not highly recommended. I had the camera on a tripod and allowed the shutter to remain open with the camera set on bulb and using a locking cable release. As the lightning flashes occurred, one behind the cactus and one over my shoulder, moments apart, it created an even exposure of light bathing the whole scene. Leaving the shutter open is not as critical as how many flashes and how far apart they occur. I left the shutter open long enough to get the first flash behind the cactus, and I would have been happy with that. But the second flash went off before I could react. The result was lucky, as I ended up with front- and backlighting in the scene.

I have found, over the years, that some of the most dramatic shots I have taken were under the most stringent, uncomfortable atmospheric conditions—snowstorms, windstorms, rainstorms, lightning storms.

MH This is an example of the camera being able to record something that is too fast for the human eye to capture properly. Fast shutter speeds enable us to savor at a later time and at our own pace such moments as leaping animals and hovering hummingbirds. Here, a longer exposure allows the film to record the entire path of the lightning bolt or even several at a time.

Art's lightning image is an example of a situation where I would not want to be standing in the photographer's shoes. Just looking at this picture makes me feel as if my hair is bristling with electricity. Some years ago, we received a series of lightning images taken by a young man whose job was as a summer fire warden in the Southwest. He spent weeks as a lookout in a fire tower

and was able to get some remarkable shots, which we ran as a portfolio. It took real daring to do it, and the results were breathtakingly beautiful.

Another time, we ran an essay of the aurora borealis by a Japanese photographer, again images made possible by long time exposures. Natural phenomena such as these can only be appreciated through the camera's technology and the photographer's skill.

AW Photographing star trails is similar to that of lightning, or of waterfalls, only with a very long exposure. What I will do is put the shutter on bulb, use a locking cable release, open the widest aperture (f/2.8 on most of my lenses), and focus on infinity. Prior to that I will have determined that there will be no moon so I can be sure the sky will remain dark.

In the case of this mountain, Tramserku, in the Himalayas, I framed the shot of the mountain just the way I wanted it before it got dark. As the sun set and direct light left the mountain, a warm glow appeared in the sunset sky. The glow still illuminated the mountain with a very soft light.

In fact, the light was so subdued it required a four-second exposure. Three seconds into the exposure I put the lens cap over the lens to stop exposing the mountain. Then, when it was completely black, I removed the lens cap and exposed for six hours as the stars came out and moved across the night sky.

The reason I did it this way, in one exposure, is that, unless you have a pin-registered camera, you cannot effectively take a double exposure without slightly moving the film. Moving the film would cause the star trails to come out of the mountain, making it look unreal. By doing one exposure, even though it was interrupted by the lens cap, I didn't move the film.

MH You don't get to make many mistakes in a situation such as this one. Again, the camera and the photographer give us an experience we ourselves cannot see. When Art submitted this photograph to the magazine, it was so unusual that we immediately decided to use it for either a cover or a table-of-contents opener. It ultimately ran in January 1991 as the opener.

STAR TRAILS ABOVE MOUNT TRAMSERKU, HIMALAYAS, NEPAL. 200–400mm zoom lens (in 400mm range), f/4.5 for 6 hours, Kodachrome 64.

RIGHT: ORGAN PIPE CACTUS, ARIZONA. 55mm macro lens, f/2.8 at 1/125 second, Fujichrome Velvia.

FAR RIGHT: ORGAN PIPE CACTUS, ARIZONA. 55mm macro lens, f/22 at 1 second, Fujichrome Velvia.

ORGAN PIPE CACTUS, ARIZONA. 55mm macro lens, f/8 at 1/8 second, Fujichrome Velvia.

DEPTH-OF-FIELD: STOPPING DOWN TO IMPROVE COMPOSITION

AW The first of these was taken with an aperture of 2.8, with a shallow depth-of-field. The second, taken at f/8, shows how the middleground cacti start to come into focus, and at f/22, third shot, foreground, middle, and background are all three in focus.

MH This is an example where sharpness of focus is mandatory, not only for publishability, but in order to make the strongest statement. When the eye must follow elaborate or fine detail through the depth of the picture space, it is jarring to have foreground or background blurred. The out-of-focus elements become disturbing. Our normal expectation is to see everything in clear detail, except for those things too close for our eye to focus on. If you have to sacrifice one over the other, go for foreground sharpness because of the eye's need to travel into the picture space without a distracting obstacle.

AW In both these images, I used maximum depth-of-field to insure that each image was sharp throughout. In this case, it was f/22.

MH I can't imagine either of these with out-of-focus elements. The crisp wildflowers in the foreground jump out at us, and yet, at the same time, we are drawn into the rest of the field by the quantity of similar flowers. Without all these elements in focus, the impression of abundance would be lost.

In the Death Valley image, we need the crisp focus in order to savor the contrast of textures and lines, and the sense that this desert goes on forever. Again, the absence of a horizon accentuates the timeless quality of this landscape.

ABOVE LEFT: SPRING MEADOW, MOUNT RAINIER NATIONAL PARK, WASHINGTON. 20mm lens, f/22 at 1/2 second, Fujichrome Velvia.

ABOVE RIGHT: SAND DUNES, DEATH VALLEY, CALIFORNIA. 80–200mm zoom lens (at 80mm range), f/22 at 1 second, Fujichrome Velvia.

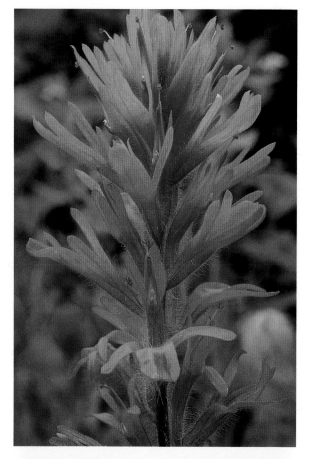

ABOVE: INDIAN
PAINTBRUSH, BANFF
NATIONAL PARK,
ALBERTA, CANADA.
55mm macro lens,
f/22 at 1 second,
Fujichrome
Velvia.

BELOW: INDIAN
PAINTBRUSH, BANFF
NATIONAL PARK,
ALBERTA, CANADA.
55mm macro lens,
f/8 at 1/8 second,
Fujichrome
Velvia.

OPPOSITE ABOVE:
WALRUSES, ROUND
ISLAND, ALASKA.
300mm 2.8 lens,
f/11 at 1/15
second,
Kodachrome 64.

OPPOSITE BELOW:
WALRUSES, ROUND
ISLAND, ALASKA.
300mm 2.8 lens,
f/11 at 1/15
second,
Fujichrome 100.

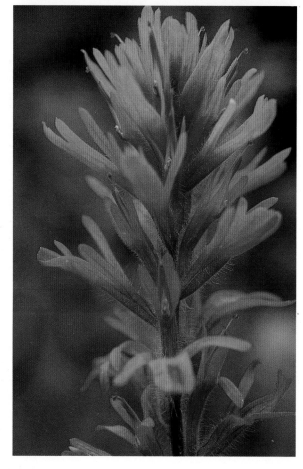

DEPTH-OF-FIELD: OPENING UP TO IMPROVE COMPOSITION

AW Here we have two shots of Indian paintbrush in the Canadian Rockies. The first was taken at f/22. When photographing flowers, many people tend to use maximum depth-of-field to make sure all the elements of the flower are in focus. They fail to utilize their depth-of-field preview button and to really scrutinize the image in the viewfinder to make sure that what they are ultimately shooting is not going to be distracting. When they get their film back, they are disappointed to find light spots or clutter they hadn't noticed in the viewfinder. Here, having determined the background was too busy, I opened to aperture f/8, rather than 22, and diffused the backdrop so it recedes behind the flower.

MH Now we have the opposite problem, where we do not desire to have everything in the frame in crisp focus. This is one of the major differences between the human eye and the camera. The camera has the ability to change relative focus, keeping some things sharp and others more diffuse. True, we could hold something close to our eye and look out farther beyond it. The effect would be an out-of-focus blur in the foreground and the distant background in focus. But the eye can't concentrate on both at the same time. Our focus shifts from one to the other.

The selective-focus capability of the camera lens can be used to isolate a focused subject against an out-of-focus background. This is what you are most likely to achieve using long telephoto lenses. Because a fast shutter speed is needed for stability, the lenses are used nearly wide open, at very shallow depths-of-field.

COLOR AS A FUNCTION OF FILM TYPES

AW For years professional photographers had no alternative to using Kodachrome 25 or 64. Ektachrome films didn't have the archival longevity—that is, their emulsions did

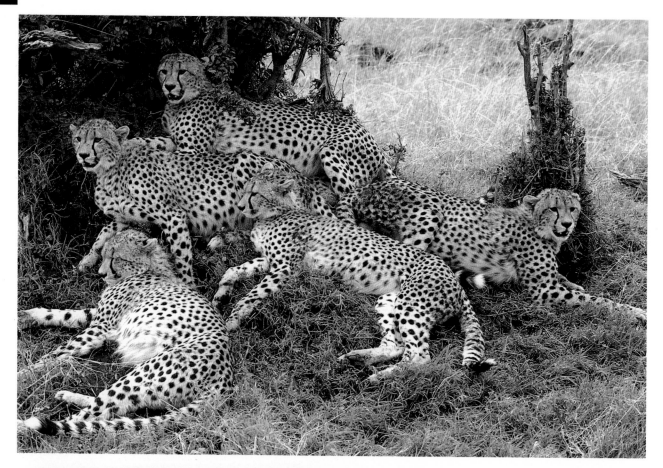

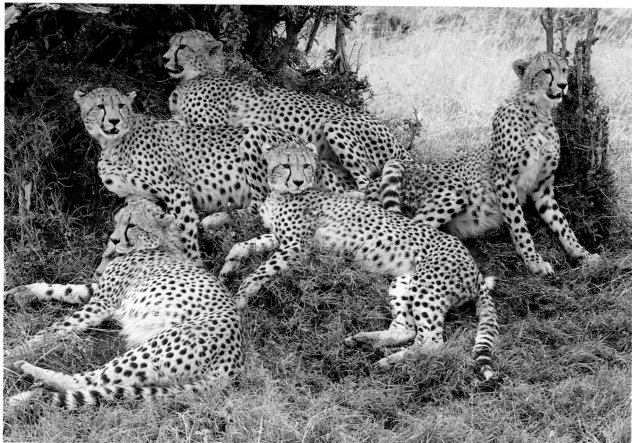

CHEETAH SIBLINGS, MARA RIVER, MASAI MARA NATIONAL PARK, KENYA. 200–400mm zoom lens (in 200mm range), f/11 at 1/60 second, Fujichrome 100.

GREAT HORNED OWL, POINT LOBOS, CALIFORNIA.
200–400mm zoom lens (in 400mm range), f/4.5 at
1/15 second, Kodachrome 64.

OPPOSITE ABOVE: CHEETAH siblings, MARA RIVER, MASAI MARA
NATIONAL PARK, KENYA. 200–400mm zoom lens (in
200mm range), f/11 at 1/30 second, Kodachrome 64.

GREAT HORNED OWL,
POINT LOBOS,
CALIFORNIA.
200–400mm zoom
lens (in 400mm
range), f/5.6 at
1/15 second,
Fujichrome 100.

not remain stable and the colors would shift after a certain amount of time. Enter the little green box. Fujichrome emulsions provided more color saturation and brilliance compared to the subtler tones of Kodachrome.

MH There used to be an editorial bias toward Kodachrome, but that is changing as more and more professionals switch to Fuji. They like the brighter color, fine grain, and good detail. Truthful color rendition is probably still somewhere in between the two. There hasn't been a color film manufactured that captures color as we see it. Photographers need to become familiar with the color characteristics of whatever films they use under the various lighting conditions they will encounter.

The human eye can differentiate some 9 to 10 million different hues. I doubt that any of our current color films can capture anywhere near that number, and the film companies do not say in their technical specifications how many colors films can record.

In the four-color printing process that is universally used today in color reproduction, printers claim that an infinite number of colors can be faithfully reproduced. But if you compare an original painting with its four- or even six-color reproduction, they do not look the same. Since the reproduction of the artwork has been made from a photograph of the painting, one can't be sure where the deficiency lies, in the film's recording of color or in the printing inks.

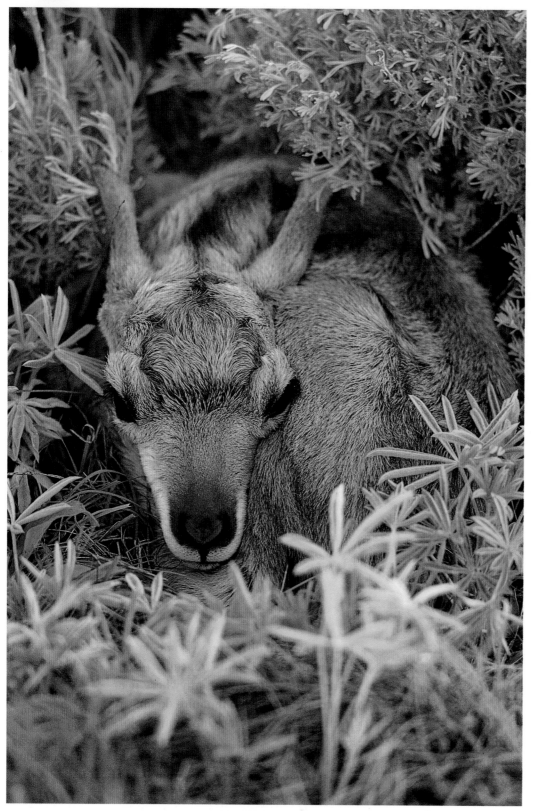

PRONGHORN FAWN, RED ROCKS NATIONAL WILDLIFE REFUGE, MONTANA.
55mm macro lens, f/8 at 1/30 second, Kodachrome 64.

OPPOSITE: PRONGHORN FAWN, RED ROCKS NATIONAL WILDLIFE REFUGE, MONTANA.
55mm macro lens, f/8 at 1/30 second with 81A filter, Kodachrome 64.

USING FILTERS: 81A WARMING

AW Basically, I use an 81A warming filter more than anything. When you have a blue-sky day and are shooting in shadows, people aren't aware that shadows are actually reflecting blue from the sky. It's like a huge blue light reflecting blue down on everything. Viscerally we respond more to warm colors. They are more pleasing to the eye. To counter the blue effect, I will use the 81A to warm up the colors and try to return them to colors as we prefer them.

MH Fortunately, the printing process is very sophisticated today, thanks to the introduction of laser scanners for making color separations. By tweaking the red, blue, yellow, or black colors, which create the four-color process, a scanner operator can reduce the bluish cast or beef up the yellow and the red to add warmth. However, it is always better to have the right color balance in the original transparency, since that is what an editor sees. At the magazine, we were painstaking in our monitoring of the color separations and in making the necessary color corrections. Not all publications maintain tight quality control, and this is an area where many things can and do go awry.

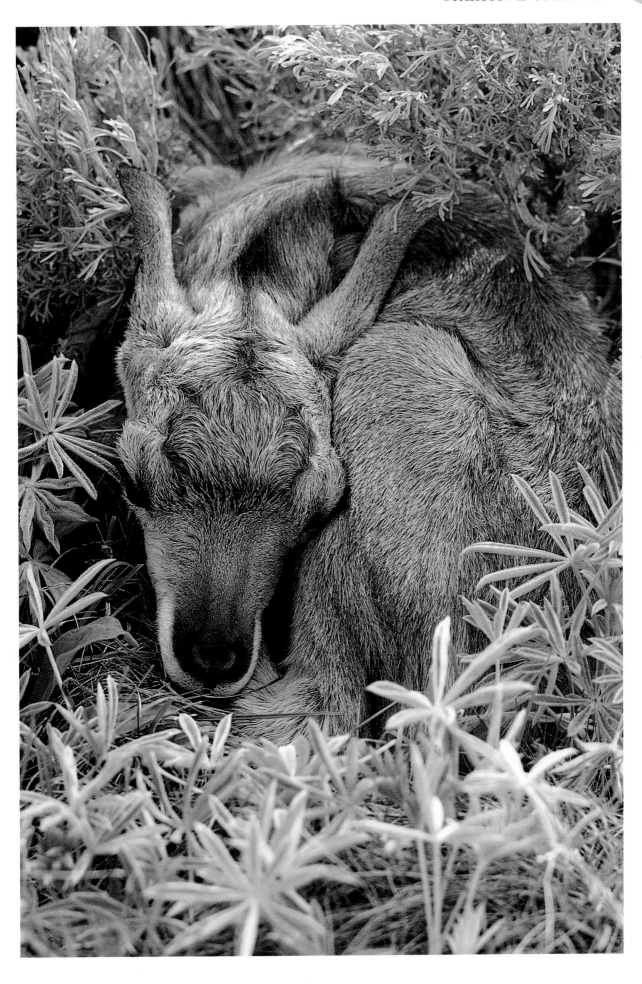

GRAND TETONS,
WYOMING.
80–200mm zoom
lens (in 80mm
range), f/22 at
1/8 second,
Fujichrome 100.

GRAND TETONS,
WYOMING.
80–200mm zoom
lens (in 80mm
range), f/22 at
1/30 second,
Fujichrome 100.

FILTERS: GRADUATED NEUTRAL-DENSITY FILTER TO BALANCE CONTRAST

AW One of the most difficult scenes to handle out of doors is bright light, when you have bright highlights and dark shadow areas. In the first image, I have exposed for the shadow. In the second, I exposed for the mountain peaks, and in the third, I have used a graduated neutral-density filter to darken the bright peaks and sky and bring the exposure values more in line with each other. The Grand Tetons in early-morning light is one of those tricky situations.

The old homestead is in the mountain's shadow, clearly two f-stops darker than the sunlit mountains above (or two exposure values). In the second shot, the shadowed areas are too dense when I expose for the mountains. The graduated filter can be moved up and down and is gradually diffuse. It is a great aid for outdoor photography, making an otherwise unattainable photograph possible.

MH By balancing the extremes of contrast in this scene, we end up with a publishable image. In the first, the mountains look washed out. In the second, the foreground is too dark to read detail. The final version looks natural, the way we would actually see it.

The eye can compensate automatically for the different light levels and read instantaneously the details of either the bright or shaded areas without any problem. The problem is the film. It is less sensitive than the eye, so in high-contrast light, the film cannot handle a great range of exposure values. The neutral-density filter helps by decreasing the difference between highlights and shadows.

GRAND TETONS, WYOMING. 80–200mm zoom lens (in 80mm range), f/22 at 1/8 second with a graduated neutral-density filter, Fujichrome 100.

DEVIL'S MARBLE WITH GHOST GUM TREE, NORTHERN TERRITORY, AUSTRALIA. 20mm lens, f/8 at 1/8 second with circular polarizer, Fujichrome Velvia.

STARFISH IN TIDE POOL, WASHINGTON COAST. 55mm macro lens, f/16 at 1/8 second, Fujichrome Velvia.

FILTERS: POLARIZER

AW The white ghost gum tree and boulder were photographed in late-afternoon light with and without a polarizing filter. I used a 20mm wide-angle lens. The larger image is taken with the filter. It darkens the sky behind the boulder, making the boulder stand out more, and it also lightens the tree.

Using the telephoto lens eliminates the darkening you get with a wide-angle, as you can see with these next two shots of Mt. Ama Dablam. I prefer the second image over the first in that the polarizer darkens the sky and sets the lighted mountain off better.

In the tide-pool shot, I used my 55mm macro lens first without the filter, and then with the polarizer. By carefully positioning myself at 90 degrees to the direction of the sun, and rotating the polarizer, I can remove the surface reflection of the water and get more detail and color out of what is below the surface.

ABOVE: DEVIL'S MARBLE WITH GHOST GUM TREE, NORTHERN TERRITORY, AUSTRALIA. 20mm lens, f/11 at 1/15 second, Fujichrome Velvia.

With the dolphins (see page 136), I again used the 55mm and polarizer, and I was lucky to have a calm, glassy surface on the sea. Also, without Ektachrome 400 film, I would not have been able to capture this. I needed the extra shutter speeds to stop the action of these fast swimmers. Since the polarizer cuts out a stop and a half of light, I wouldn't have been successful with slower films.

AMA DABLAM, HIMALAYA RANGE, NEPAL. 300mm 2.8 lens, f/5.6 at 1/8 second with polarizer, Kodachrome 64.

MH Personally, I think polarizers create a false sky color, and at the magazine I shied away from slides that had deep blue polarized skies. But Art is right that they do often enhance the drama of a normal lighting situation. Both images of Mt. Ama Dablam would be publishable. In his two images of the tree and rock, using a polarizer helps to reduce the glare off the rock and tree trunk. As a result, the true color of the subject is recorded on film.

The drawback of using a wide-angle lens with a polarizer is that the polarizer is most effective at a 90-degree angle to the sun, and a wide-angle

ABOVE: AMA DABLAM, HIMALAYA RANGE, NEPAL. 300mm 2.8 lens, f/8 at 1/15 second, Kodachrome 64.

STARFISH IN TIDE POOL, WASHINGTON COAST. 55mm macro lens, f/11 at 1/4 second with polarizer, Fujichrome Velvia.

lens encompasses about 140 degrees, depending on the focal length. This results in an uneven tone in the sky. A polarizer also diminishes the amount of light reaching the film, reducing exposures by a stop or a stop and a half.

Generally, light waves radiate in all directions. But when they are reflected from a shiny surface, such as water, in the case of Art's tide-pool shot, or shiny leaves, they are reflected directionally, cause a glare, and diminish apparent color. A polarizing filter can be rotated to cancel the light waves causing the glare (sometimes referred to as "specular" reflection because light is reflected back as in a mirror).

CONTROLLED LIGHTING: FLASH AND FILL-FLASH

AW Sometimes it is necessary or desirable to use flash in the field, even during daylight hours. The first image is a northern pygmy owl peeking out of its nest hole in a ponderosa pine in eastern Washington. The hole was in the shade, so there was limited light, giving a fairly shallow depth-of-field and a bluish cast. Since the animal was stationary within the tree, I was able to use flash and warm up the colors to a more natural hue. Had he been moving around, flash would also have enabled me to stop the action of his movement, maintaining crisp focus.

MH The color is definitely more pleasing in the second image. The increased depth-of-field also makes it a more publishable shot over the first because of the crisper focus. An annoying element of flash photography of animal faces is that sometimes you see a double catchlight in the eyes, which is the reflection of the double flash units. It looks unnatural.

COMMON DOLPHINS, SEA OF CORTÉS, BAJA CALIFORNIA, MEXICO. 55mm macro lens, f/5.6 at 1/125 second with polarizer, Ektachrome 400X.

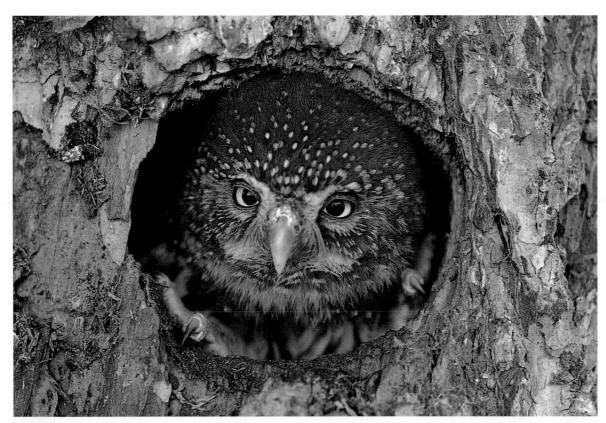

NORTHERN PYGMY OWL IN PONDEROSA PINE, EASTERN WASHINGTON. 80–200mm zoom lens (in 80mm range), f/5.6 at 1/15 second, Fujichrome Velvia.

BELOW: NORTHERN PYGMY OWL IN PONDEROSA PINE, EASTERN WASHINGTON. 80–200mm zoom lens (in 80mm range), f/11 at 1/60 second with flash, Fujichrome Velvia.

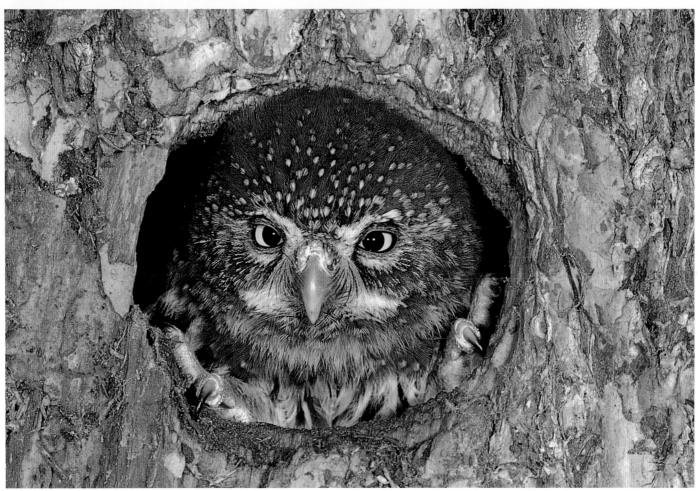

LONG-EARED OWLETS, EASTERN WASHINGTON. 50mm lens, f/5.6 at 1/60 second, Kodachrome 64.

LONG-EARED OWLETS, EASTERN WASHINGTON. 50mm lens, f/16 at 1/15 second with flash, Kodachrome 64.

AW The first shot is taken with available light at 1/60 of a second at f/5.6, making for a shallow depth-of-field. The owl farthest away is out of focus. So I decided to use flash to increase the depth-of-field and use a longer exposure to still allow natural daylight to register a sense of place.

In the second exposure, f/16 at 1/15 of a second, the flash illuminated the owls and the shutter remained open long enough for the background trees and foliage to have a presence. In the third, 1/60 at f/16 created the illusion of a nighttime shot, more in keeping with a person's expectation of seeing owls at night.

MH This comparison is interesting in that it shows you how color is a function of the light source. In the first image, under the low-light conditions, because of the surrounding forest of green, the reflected light has a greenish cast, and the film records it. Using flash, which is more color balanced to white light, we can see more of the truer color of the young owls.

I personally like the middle image best because again, owls connote a certain spooky feeling, and the backgrounds' being slightly present creates more of that feeling for me than the all-dark, nightlike background. In all fairness, though, all three images are publishable, and it is merely a question of personal taste.

LONG-EARED OWLETS, EASTERN WASHINGTON. 50mm lens, f/16 at 1/60 second with flash, Kodachrome 64.

AW At times when the sun is out, the angle prevents you from shooting without a shadow, such as in tree situations as with the lemur. Half its face was in shade, and the background was bright. I didn't want him to end up a silhouette. So by using the flash to fill in the harsh shadow area, I could render more even lighting to the overall scene. In order for the brilliant iridescent colors of the golden-breasted starling to render truly on the film, I used fill-flash.

MH The use of fill-in flash in daylight is expanding the range of opportunities for nature photographers, enabling them to shoot under harsh lighting conditions, as Art did with the lemur, or to give a catchlight to the eye, render true color, and otherwise balance uneven lighting conditions. Already photographers are shooting subjects at dusk, using the rich sky color as background, and lighting subjects in the foreground with flash. When used subtly, the lighting has an eerie quality that gives the final image more of a sense of mystery and drama.

GOLDEN-BREASTED STARLING, KENYA. 200–400mm zoom lens (in 400mm range), f/8 at 1/60 second with fill-in flash, Fujichrome Velvia.

SIFAKA LEMUR,
MADAGASCAR.
200–400mm
zoom lens (in
400mm range),
f/11 at 1/60
second with
fill-in flash,
Fujichrome
Velvia.

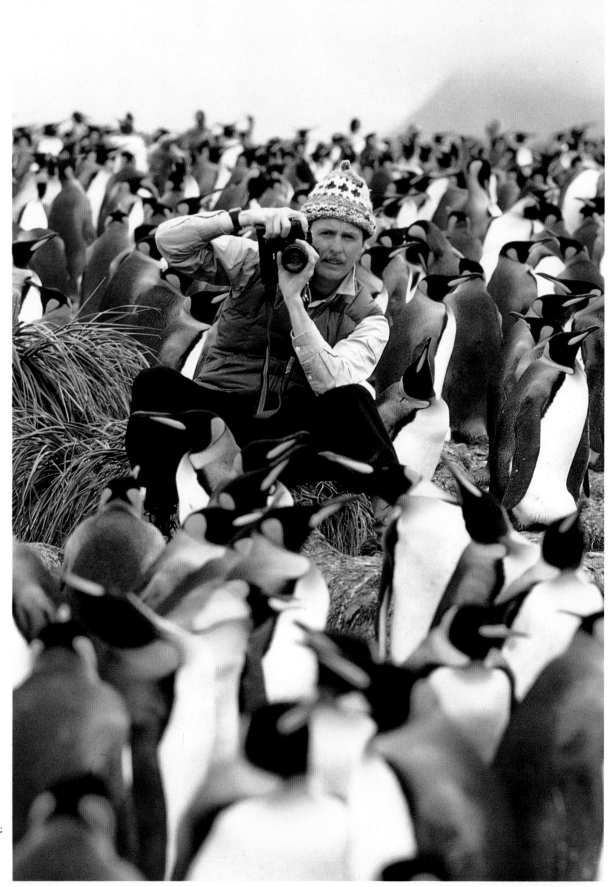

ART WOLFE IN KING
PENGUIN ROOKERY,
SOUTH GEORGIA
ISLAND.

IN THE FIELD WITH ART WOLFE

When I first decided that I wanted to try to make a living from photography, the biggest challenge to me was what could I photograph and how could I market the results. The obvious solution seemed to take pretty pictures of landscapes and get them onto the walls of the outdoor-recreation stores in Seattle.

I spent a small fortune that first year making prints, and for the next year, I concentrated on marketing my prints through one store only, Recreational Equipment Inc. A friend was writing a book on Indian baskets of the Pacific Northwest, so I offered to do the photography. Then the Army Corps of Engineers, who knew of my work from REI, called me to bid on a project that meant spending six months photographing every living creature in a valley that was to be dammed. I told them I'd do it for ten thousand dollars, and the next thing I knew, I had work for six months.

My next goal was to get published in magazines. I realized this meant coming up with story/photo packages, so I had to come up with an idea. I decided on something close to home—the Olympic Mountains. Over a succession of weekends during the summer, I trekked through the Olympics photographing the animals of the high meadows, the flowers, as well as panoramic landscapes. I was able to sell a story on the high, open ridges of the northeastern Olympics to *Pacific Search* magazine.

The importance of a regional magazine is not to be discounted. It is usually easier to break in on a local level where the competition isn't as stiff.

From there, I decided to broaden my horizons, still within mountain habitats, and to cover the Rockies. From there I tackled the Oregon coast and the desert Southwest. All along, I kept looking for story possibilities and trying to get variety for each subject. If it was an animal, I planned for different seasons and habitats. Depth of coverage was my goal whenever possible.

Now when I go on an extended trip, I generally pack three camera bodies, two of which I will use, and one that will serve as a backup in case one of the others breaks down. I'll take my 20mm wide-angle, a 60mm macro, an 80–200mm zoom, my 200–400mm zoom, or else a 300mm-f/2.8 telephoto with a 1.4 tele-extender. If I am feeling really ambitious, I will haul along my 800mm, but only when I think there is a potential to photograph bears, birds of prey, or any other animal that is difficult to approach.

For stability, I carry a sturdy tripod and ball head. My film preferences are Fujichrome 50 and Kodachrome 64. I find these the best for my needs, for both wildlife and landscapes.

ANIMALS: HUMAN INTEREST

AW In taking an animal portrait, the first thing I look for is eye contact. A ranger came up to me once in Yellowstone National Park and asked me not to get too close to elk that were lying down in a snowstorm. He said, besides, if they look at you, it's not a good shot. I asked him why. He said, "It's obvious that they see you and it looks very unnatural." I thanked him for the advice. A lot of people agree that eye contact means you are interfering with the animal's natural behavior.

But for me, the images I remember most are

GRAY WOLF, MONTANA. 200–400mm zoom lens (in 400mm range), f/5.6 at 1/30 second, Ektachrome 400X.

where there was a visual connection with the animal the moment I took the picture. It's true that if you view man as completely foreign to the environment, then we are intruders. But we didn't land here from outer space. I happen to think we are part of the whole system. Certainly, we are different from animals, but to look at man as foreign to nature is erroneous in my mind. If we considered ourselves an integral part of the environment, then perhaps we'd be more respectful of wildlife and nature and not constantly abuse and destroy it for our own benefit.

What I try to do is capture the personality of the animal or a momentary glance toward the camera. I hope that whoever views my work may subsequently experience the same sense of immediacy and intimacy that I did when I clicked the shutter. I feel my most successful shots have captured that awareness. It doesn't mean that their eyes are necessarily looking right at you, but that I have captured some glance or look that gives an insight into that animal's behavior. We read people and animals by the looks in their eyes.

Whenever I've been able to capture an animal's expression that appears human, I have had great response from viewers. We tend to anthropomorphize a lot of animals, and some of my most successful photos as a wildlife photographer are ones that people can identify with. The two young lions yawning appear to be laughing, and it is hard not to smile when looking at them. No less true is the grooming of the snow monkeys, where the monkey being groomed has its eyes closed and we tend to interpret this in human terms, as if this were a blissful moment. I have found that images which tend to evoke an emotional response are more successful, whether they are of a beautiful mountain at sunrise or an animal interacting with another.

MH As an editor, I was always interested in finding wildlife pictures that communicated something more than a mere portrait—interactions, behavior, animals not looking at the photographer. I wanted the sense that the animals were unconcerned and uninhibited by the

LION CUBS, MARA
RIVER, MASAI
MARA NATIONAL
PARK, KENYA.
200–400mm
zoom lens (in
400mm range),
f/4.5 at 1/125,
Fujichrome
Velvia.

SNOW MONKEYS,
HONSHU, JAPAN.
200–400mm
zoom lens (in
200mm range),
f/5.6 at 1/60
second,
Fujichrome
Velvia.

OLIVE BABOON,
MARA RIVER,
KENYA.
200–400mm
zoom lens
(in 400mm
range), f/5.6 at
1/25 second,
Fujichrome 100.

GRIZZLY BEAR, DENALI NATIONAL PARK, ALASKA. 200–400mm zoom lens (in 400mm range), f/4.5 at 1/125 second, Kodachrome 64.

presence of a human being, that they were behaving normally.

The confrontational wild-animal portrait, where you are staring into the eyes, was not something we looked for at *Audubon*. But there is, obviously, a place for it. *National Wildlife* magazine, for example, prefers just such images for their front and back covers. I have noticed that poster companies also choose photographs where the animal is looking at the viewer.

Portrait painters believe that the eyes are the "windows of the soul" and reveal the character of a person. In animals, we can only guess what they are thinking, and I am sure this is a big part of the head-on portrait appeal.

AW This grizzly in Denali National Park is sitting on its haunches and stretching its hind foot—hardly the posture of a fierce predator, nor typical of what we might expect. I love it because it looks more like Yogi Bear relaxing.

The olive baboon in Kenya has caught its lip on a tooth, yet it looks as if it is scowling or threatening, partly because its eyes are obscured in the shadow of the forehead. This type of expression has a broad range of application for either commercial advertising or editorial use.

MH As I mentioned with the previous example, it is refreshing to see an animal doing something while unaware of being watched or photographed. And the unexpected pose can be anthropomorphic, and therefore humorous.

Scientists generally cringe at the notion of imparting human attributes to animal behavior. I personally like thinking that animals have an intelligence and an inner life all their own. Until science can figure out for certain what animals are thinking, and what motivates their behavior, we are free to interpret their expressions any way we please.

Editorial use of images such as these tends to be more literal. At *Audubon*, photographs were mostly used to illustrate stories, so we rarely could use a humorous or "cute" photo. Instead, we used cartoons to inject humor, and they bore no relation to the text on the pages.

Commercial or advertising use tends to opt for the human qualities animals portray. This gives the commercial message humor in a non-threatening way. Showing people doing funny things might offend some market sectors, whereas an animal doing the same thing will not.

ANIMALS—GETTING CLOSE: TECHNIQUES IN THE FIELD

AW I have found over the years that it is necessary to get close to an animal, despite the fact that many of us use very long lenses. Even with an 800mm lens, you still have to be in fairly close proximity to the subject to fill the frame and get a pleasing portrait. In other instances this is not the desired effect, the environment is equally important, and backing off or keeping your distance is necessary.

I have found that when I approach such animals as goats, sheep, and elk, if I am in the open, without making an attempt to sneak up on them, I have greater success. With Dall sheep, guanacos, or mountain goats, animals that live in mountainous terrain, I will approach from below, giving them free access to escape up and away, which is their normal means of fleeing danger. By not blocking their escape routes, I can usually get closer because the animals tend to be more comfortable.

The photo of guanacos was taken in Torres del Paine National Park in southern Chile. They are clearly looking down at me, as I have approached them from below, but with a relative degree of comfort and safety. I was able to get many different shots of them, framing in with longer lenses, and as long as I remained below them, they didn't flee. In the case of the Dall sheep, I am again shooting from below. The mother is so relaxed she is lying down with her back to me, and the young one is monitoring my movement.

RIGHT: Guanacos, Torres del Paine National Park, Chile. 300mm 2.8 lens, f/8 at 1/60 second, Kodachrome 64.

BELOW: Dall sheep, Denali National Park, Alaska. 200–400mm zoom lens (in 400mm range), f/11 at 1/60 second, Fujichrome Velvia.

MH One of our concerns at *Audubon* was harassment of wildlife in the pursuit of photography. We were hearing more and more stories about photographers pushing a wild animal to get that close-up portrait, sometimes interfering with its resting, feeding, or nursing behavior. Though we worried that just a few nature photographers were giving the whole field a black eye, we were concerned that the field was

getting so competitive that this kind of behavior indicated a dangerous trend.

We also felt a responsibility, as one of the nation's major showcases for wildlife photography, not to promote or condone such behavior. We avoided using close-up portraits of dangerous animals for fear that it would perpetuate the notion they are approachable. Such a published portrait tacitly encourages photographers to take unnecessary risks to get the "marketable" shot.

We went so far as to query several of our writers about doing an article on the whole question of ethics in nature photography. But we faced a dilemma: if we couldn't cite specific examples of unethical behavior in the field and name names, we wouldn't have had a credible article. If, however, we dealt with the facts and named names, we ran the risk of being sued for libel.

MOOSE COW, DENALI NATIONAL PARK, ALASKA. 300mm 2.8 lens, f/8 at 1/60 second, Kodachrome 64.

AW The moose in Denali National Park allowed me to get within thirty feet, as I was not trying to conceal my approach. When I am photographing deer or moose in a forest, I don't sneak around and crouch behind trees and bushes. As a result, they tend to allow me to get closer. If I crouch low to the ground, I am emulating what they construe to be a predatory animal, and it makes them far more nervous than if I am out in the open. With owls, birds of prey, and bears, I avoid direct eye contact. It seems to be a challenge to the animal.

In the case of the harbor seal, I sat quietly on a rock along the water's edge. They are naturally curious animals. I remained perfectly still as it came up, closer and closer, and I was able to get good shots with a 400mm lens. I let the animal come to me. In all cases, I used a tripod.

With owls, if I am looking for them in forested nesting territory, I'll carefully avoid looking directly into their eyes once I locate them. Instead, I will set up the camera where I think I have a clear view of the bird, put my lens on the tripod, get my head behind the viewfinder, and then pan the lens toward the sitting owl, avoiding direct

eye contact with the bird at all times. With bears, getting too close and having direct eye contact can put an end to one's career, since they interpret eye contact as a challenge.

MH Indeed, it has ended careers on two occasions. In October 1986, when William Tesinsky was killed trying to photograph a sow grizzly in Yellowstone National Park, we assigned one of our contributing editors to investigate the events that led to his death. Tesinsky, a skilled outdoorsman, lived in nearby Great Falls, Montana. He was an auto mechanic with dreams of becoming a professional nature photographer. His friends later said he would do almost anything to get a picture. A board of inquiry concluded that Tesinsky had provoked the attack by surprising the feeding bear and approaching too close. She attacked in self-defense. Nevertheless, she was "destroyed."

About six months later, Chuck Gibbs, another avid amateur photographer and ursophile, approached too close to a sow grizzly and her three cubs in Glacier National Park and was killed. This time the bear was not shot.

HARBOR SEAL,
MONTEREY BAY,
CALIFORNIA.
200–400mm
zoom lens (in
400mm range),
f/5.6 at 1/25
second,
Fujichrome
Velvia.

LEOPARD, SAMBURU NATIONAL PARK, KENYA. 800mm 5.6 lens, f/5.6 at 1/30 second, Fujichrome 100.

AW In the case of the leopard in a tree, I am using an 800mm telephoto lens from a vehicle. You are not allowed to leave your car, but since most animals in African parks are used to vehicles, it functions beautifully as a blind, allowing you to get much closer than you could, or would want to, on foot. Had I gotten out, this leopard would more than likely have fled. He is watching us intently, but is undisturbed.

In the case of the elk, I spotted the animal from a great distance, and seeing that he was heading in my direction, I remained stationary. He actually walked to within twenty-five feet of me and allowed me to take his picture with a 200–400mm zoom lens. When you allow the animal to move toward you, you usually end up with better shots than if you were to circle around and cut off its path.

MH I once gave an assignment to a conscientious photographer to document wildlife on the prairies. It took him two years to complete because we discovered we needed shots of nesting birdlife, and it carried over into the following spring. He called me when he got back, very upset. The nest he had found and photo-

graphed had been predated the next day. When he went back to check, no chicks could be found. He thought it had been well-enough concealed, but he figured his human scent may have led a raccoon or possum or snake to the site. He vowed never again to let himself make the same mistake.

The signs always say, "Take only pictures, leave only footprints." But sometimes even the intrusion of taking photographs can cause environmental damage.

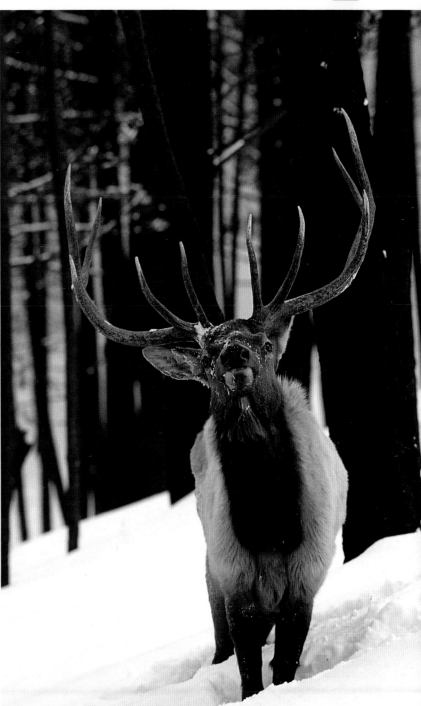

BULL ELK, YELLOWSTONE NATIONAL PARK, WYOMING. 200–400mm zoom lens (in 400mm range), f/11 at 1/60 second, Fujichrome 100.

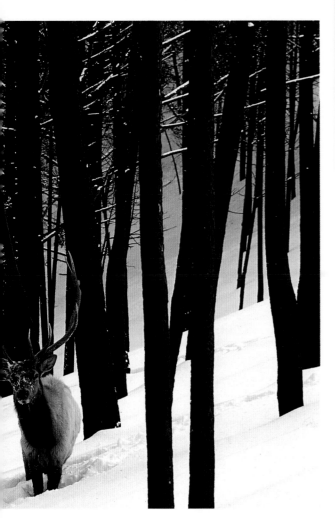

BULL ELK, YELLOWSTONE NATIONAL PARK, WYOMING. 200–400mm zoom lens (in 200mm range), f/11 at 1/60 second, Fujichrome 100.

BLACK-TAILED DEER,
MONTEREY,
CALIFORNIA.
200–400mm zoom
lens (in 200mm
range),
f/5.6 at 1/60
second,
Fujichrome Velvia.

THE DECISIVE MOMENT

AW When working in the field, I have found photography to be more of an organic experience. The longer I stay with an animal, the more in tune I am with its movement and its behavior, and as I am putting film through the camera, it usually isn't until the second, third, or fourth roll that I really begin to get into the position of getting what I was initially after.

In the case of a black-tailed deer moving through the windswept cypress trees on the Monterey Peninsula, I watched from afar as it walked toward these trees, knowing that if it remained on its course, I would get a visual relationship between the graphic trees and the deer itself. I moved in a direction parallel to the deer's movement, and as it started to get into position, I kept hoping it would go through the trees precisely where it did.

I was already planning in advance to arrive ahead of the deer. I nailed down the correct exposure, focused, and then waited for the precise moment when the deer would walk over the limb and became one with the tree, and that is when I clicked away. Of all the shots in the sequence, I knew the image on the top of page 155 would be the one I'd want to use.

MH Henri Cartier-Bresson coined the expression "the decisive moment" to characterize the precise instant when the photographer catches the subject and defines a whole world or character in the click of the shutter.

Nowadays, cameras have motor drives, which make it much easier to capture fleeting moments and are especially useful in wildlife photography. Autofocus lenses also increase your likelihood of success with a moving subject. But even with all the automatic assists, you still need to be alert to the potential, and ready with your exposure and framing. The eye and the mind are still the most important creative tools we have.

Most wildlife photography is unpredictable. But experience, judgment, and quick reflexes can make the most of this unpredictability. Some knowledge of an animal's behavior also increases the chance of success. If you know, for example, that male storks carry sticks for building the nest to the female as part of their courtship ritual, you can set yourself up ahead of time with lighting and composition prearranged and be ready for the opportune moment.

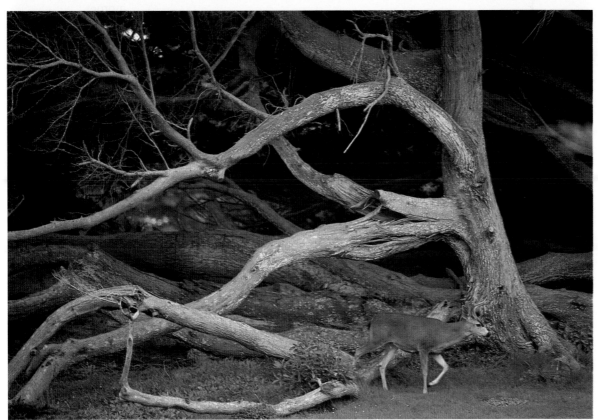

ABOVE: BLACK-
TAILED DEER,
MONTEREY,
CALIFORNIA.
200–400mm
zoom lens
(in 200mm range),
f/5.6 at 1/60
second,
Fujichrome Velvia.

LEFT: BLACK-TAILED
DEER, MONTEREY,
CALIFORNIA.
200–400mm zoom
lens (in 200mm
range), f/5.6
at 1/60 second,
Fujichrome Velvia.

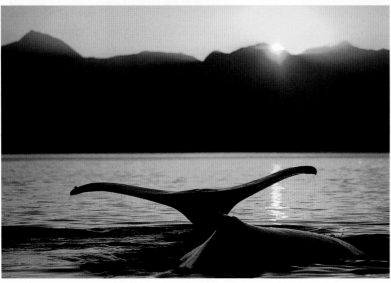

ABOVE: MOUNTAIN LION, ARIZONA.
200–400mm zoom lens (in 400mm range), f/4.5 at
1/8 second, Fujichrome 100

LEFT: HUMPBACK WHALE, ALASKA. 80–200mm
zoom lens (in 80mm range), f/2.8 at 1/125 second,
Fujichrome 100.

OPPOSITE ABOVE: COLUMBIA BLACK-TAILED DEER, OLYMPIC
NATIONAL PARK, WASHINGTON. 300mm 2.8 lens, f/4.5 at
1/60 second, Kodachrome 64.

OPPOSITE BELOW: COLUMBIA BLACK-TAILED DEER, OLYMPIC
MOUNTAINS, WASHINGTON. 300mm 2.8 lens, f/5.6 at
1/250 second, Kodachrome 64.

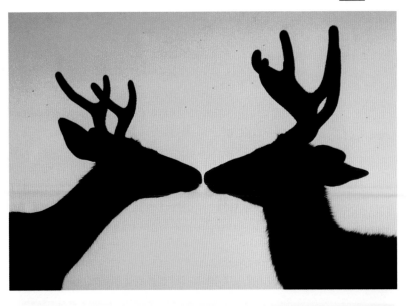

AW When I am photographing a particular animal, a moment sometimes arises, often a split second, that is absolutely critical, where you either get the shot or you don't. In the case of the two bucks silhouetted against the sunrise in the Olympic Mountains, they were moving through, browsing, and at a certain point they both looked up, walked toward each other, and touched noses. Then it was over, in a matter of seconds, and they never came together again. It was certainly a question of being in the right place at the right time, and recognizing that the moment was fleeting and capturing it.

It was crucial in the case of the humpback whale surfacing as the last ray of sun was disappearing behind the Fairweather Range in southeast Alaska. The tail is only on the surface for a split second. I had to act fast.

With the mountain lion, it was early morning. The lighting conditions were bad, and I was forced to use slow shutter speeds. Fortunately, a crow landed in a nearby tree and distracted the lion just long enough for me to get this shot using 1/8 of a second.

MH Photographs of this nature were precisely what we always looked for and hoped to find—the serendipitous moment in nature.

Still photographs, I believe, will not be replaced by video. Frozen in time by the camera, the moments can be enjoyed again and again. Some are so memorable, they become iconographic, such as Jim Brandenburg's widely published photo of the white wolf leaping onto an ice pan. The wolf is leaping away from us into the picture space. Suspended in midair for eternity, he becomes a metaphor for all biological life on our planet, pursuing his survival, taking risks, not knowing his fate. It is a haunting image.

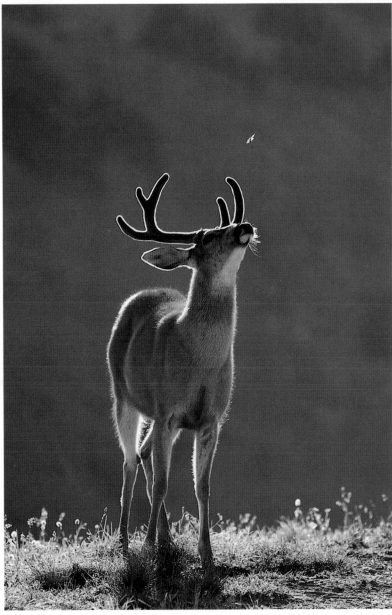

CHANGING ATMOSPHERIC CONDITIONS

RIGHT: NATIVES, MADAGASCAR. 20mm lens, f/2.8 at 1/30 second, Fujichrome Velvia.

COMMON ZEBRAS IN RAINSTORM, SERENGETI PLAIN, KENYA. 200–400mm zoom lens (in 400mm range), f/5.6 at 1/30 second, Fujichrome Velvia.

Not long ago, I found myself in an incredible lighting situation in Madagascar without anything apparent to shoot. This is a photographer's worst nightmare. We were driving in a remote area and could see a storm approaching. It was dark up ahead, but still light where we were. The landscape was glowing, but everywhere I looked, it was flat, flat country. I yelled, "Stop the car, stop the car, stop the car." There wasn't even time to grab the tripod, which for me is like going out without pants on. I don't do it very often. My companions asked me if I wanted my tripod, but I was already running and yelled, "There's no time."

I had on a wide-angle lens, which allowed me to shoot at 1/30 of a second. So I ran across this field until I saw these two men walking. There was no time for communication, and I knew they didn't understand English. The rain was already hitting my face, and I knew it would be a deluge any minute. The men turned out to be twins, both six feet five inches. Most Malagasys are shorter than me.

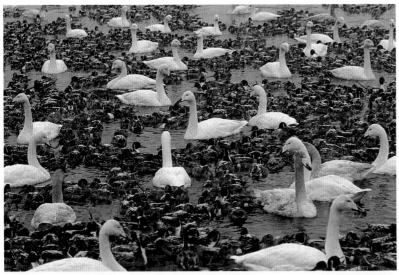

WHOOPER SWANS AND PINTAILS, HOKKAIDO, JAPAN. 80–200mm zoom lens (in 80mm range), f/11 at 1/30 second, Fujichrome 100.

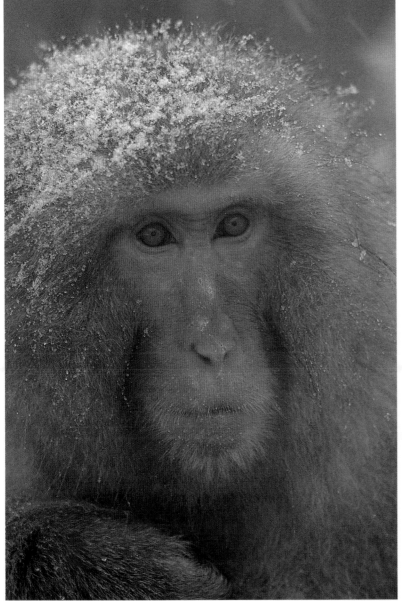

SNOW MONKEY, HONSHU, JAPAN. 200–400mm zoom lens (in 400mm range), f/4.5 at 1/30 second, Fujichrome 100.

Here were these two enormous beanpoles in rags. There wasn't even time to be afraid of them. I just put my hand on their chests and said, "Stand there." I started shooting with the wide angle, left and right. They just stood there looking at me, and then it was over. It started raining, and I put my coat over my camera and ran back to the car. It was one of the best shots of people I've ever done.

The hardest thing is driving through an environment and letting go of it, saying there is nothing here I can shoot. You can be in the best landscape; if the light is awful, then you go home empty-handed.

AW The texture of snow on the monkey's long fur gives this portrait a sense of place and justifies its name. Snow, like fog, diffuses detail and enables you to paint a more impressionistic interpretation with a camera. The zebras in the Serengeti were photographed during one of the heaviest rainstorms I've ever experienced.

MH All these images have the quality of atmosphere, which can inform us, without words, about that particular animal's world. Some of the most interesting images are the unexpected. Seeing animals under adverse weather conditions causes us to appreciate that life is not always easy for them either. Even though snow monkeys are adapted to snow, we need to be reminded that they survive, without complaining, in such inclement conditions. The expected photos of zebras show them in sun-washed, grassy savannas, not in the middle of a torrential downpour.

For a short while, we ran a feature in the magazine to showcase unexpected or unusual moments like these, calling it "One Picture...," the implication being that it "was worth a thousand words." The format was a double-page spread — horizontal, like our wraparound cover—that couldn't be ruined by the gutter's split down the middle. Within those constraints, we just couldn't find enough images to sustain it. But it was one of the most fun to look for. *Natural History* magazine has a similar feature in a vertical format called "Natural Moment."

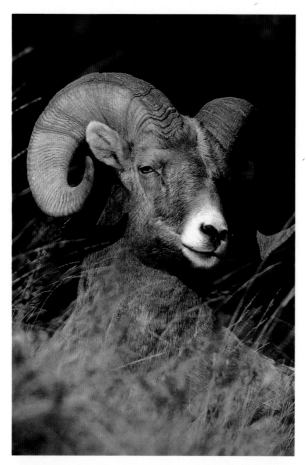

ABOVE: BIGHORN
SHEEP, MONTANA.
300mm 2.8 lens,
f/8 at 1/125
second,
Kodachrome 64.

BELOW: BIGHORN
SHEEP, MONTANA.
300mm 2.8 lens,
f/11 at 1/125
second,
Kodachrome 64.

OPPOSITE ABOVE:
SNOWY OWLETS,
ARCTIC TUNDRA,
ALASKA.
200–400mm zoom
lens (in 400mm
range), f/11 at
1/30 second,
Fujichrome 100.

OPPOSITE BELOW:
SNOWY OWLETS,
ARCTIC TUNDRA,
ALASKA.
200–400mm zoom
lens (in 400mm
range), f/11 at
1/30 second,
Fujichrome 100.

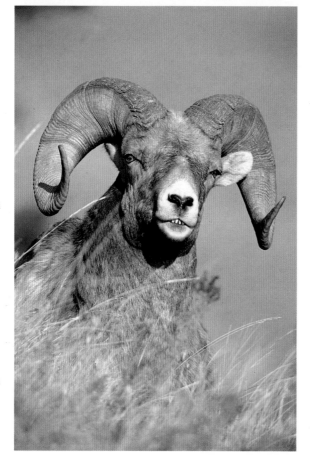

CHANGING YOUR POSITION: MAKING THE MOST OF IT

AW When I am teaching my classes, I like to have my students take a particular subject and photograph it in a variety of ways, from different angles and in different light, with a variety of lenses. It trains the eye and familiarizes the brain with that subject matter, sensitizes them to what their lenses will do, what different times of day will do—a very worthwhile exercise to go through to try to make a new statement.

The bighorn sheep was shot on a hillside in a bison range. Same animal, same lighting. I just moved fifteen feet in one direction. The first backdrop is dark juniper trees, the second is a hillside of the same grass—two completely different statements with very little effort on my part. In the snowy owls and flowers on the tundra, I first raised the camera to shoot down on them, then lowered myself down to shoot up at them with the overcast sky behind.

MH We used the owls for a cover of *Audubon*, only it was a slightly different version of the first. What I loved about that image then, and still do, is the unusual perspective—ground and eye level to the young owls. The minute I saw it, I knew it was a cover. One is immediately put into their world because of the vantage point. And the juxtaposition of fledglings and flowers summed up, for us, the whole story of high-arctic summers, where a profusion of life blossoms forth in a short period of time, and where breeding birds must raise their young on the ground because there are no trees.

Editors need variety. In illustrating a story, the final mix of images used may come from one source or many. Putting together words and text in a story is tricky. You try to keep the visual emphasis consistent with the story line. Pairings or groupings of photos become important considerations in longer articles, and just as in pictorial composition, the whole look of a two-page spread is composed of balancing color, subject, space, and line.

Being able to deliver variety on a story makes for a good assignment photographer. Even though we rarely gave assignments on wildlife subjects

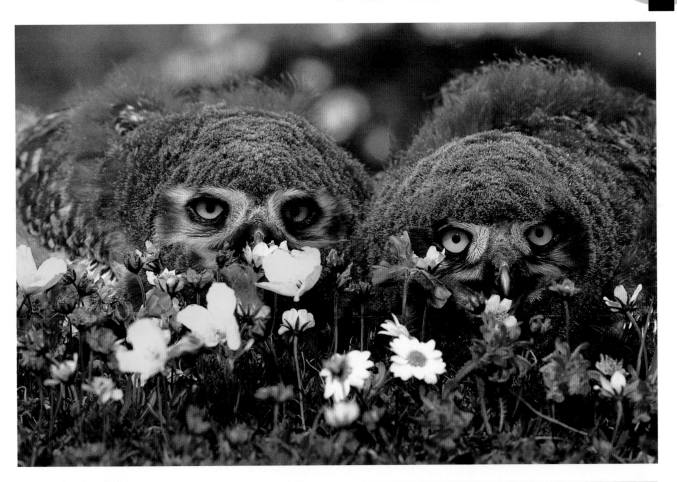

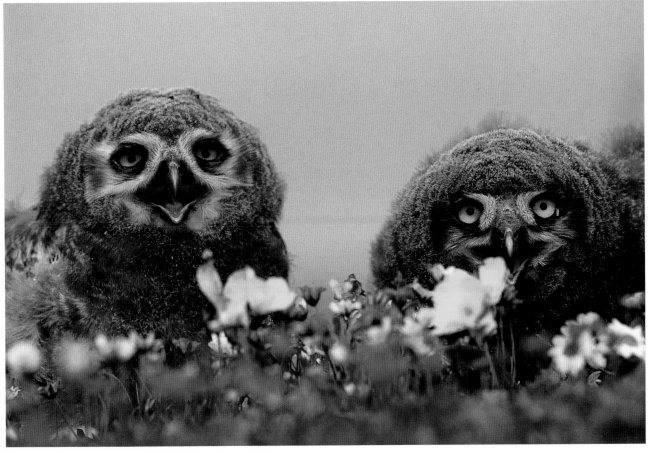

ABOVE: MEDITERRANEAN PINES AND CYPRESSES, TUSCANY, ITALY.
200–400mm zoom lens (in 400mm range), f/11 at 1/15 second,
Fujichrome Velvia.

OPPOSITE ABOVE: MEDITERRANEAN PINES AND CYPRESSES, TUSCANY, ITALY.
200–400mm zoom lens (in 400mm range), f/11 at 1/15 second,
Fujichrome Velvia.

OPPOSITE BELOW: MEDITERRANEAN PINES AND CYPRESSES, TUSCANY, ITALY.
20mm lens, f/11 at 1 second, Fujichrome Velvia.

because of the unpredictability of nature, we did give out assignments for stories concerning people or specific events.

For the photographer, assignments for any publication are stressful because you have to produce, no matter what the conditions are, within the constraints of a limited period of time. Photographers who can give an editor visual variety, whether on an assignment or by pulling from stock, will get called on again and again.

AW Often, if you have a very good subject in good light, it would be silly, in terms of your investment to get yourself into this situation, to approach the subject from only one point of view. I have often shot a subject from one angle and then walked to the opposite side and shot from that angle and changed again. This enables me to market the same basic subject in different markets without a fear that the use will overlap and the same two images will appear simultaneously.

MH If you are planning to market your photography, you need to be versatile and offer a variety of perspectives, as well as of subject matter. Composing an image is not always just simply taking what you think is the best possible shot of something. Professionals think about down-the-road usage. This is because sometimes an image must provide space for type to be overlaid or dropped out, as in a photo used for a cover, or perhaps a calendar will require a specific format.

Being able to think "in the round"—how a subject will look from all angles—is a valuable skill and can even lead you to discover new, creative approaches.

Richard Frank

AT THE LIGHT TABLE WITH MARTHA HILL

Picture editors, whether they work for a magazine, stock agency, book publisher, calendar, poster or greeting-card publisher (known as paper products), have one thing foremost in mind—how an image is ultimately going to be used, or to phrase it another way, who the audience will be. Photographs appropriate for commercial use may not be suitable for editorial and vice versa. An image of battling, bloody pit bulls might be acceptable to the audience of a European magazine, but will engender thousands of outraged letters in an American publication. Likewise, a naked baby might look fine illustrating a diaper ad, and inappropriate on the cover of *Audubon*.

In publishing, picture editors generally perform a variety of functions similar to those of word editors. First, they assess all photo submissions, whether solicited or unsolicited, for appropriateness to their publication. They know what stories are currently in inventory, what has previously run, and what may be coming in on assignment. How a particular story or proposal fits into the overall mix of stories is just one of several considerations.

If the photo submission does not meet the standards of previously published material, it is returned. Then there is the task of finding illustrations for those word stories that do not come in with photos. A decision must then be made whether pictures can be gathered from known sources or whether a photographer needs to be assigned.

When it comes time to edit a story or submission, all the images are laid out on the light table. Each is carefully examined with a four-power loupe, adequate magnification for 35mm slides. Projecting slides is not recommended for several reasons. First, the light and heat can cause fading in the film's color dyes. Second, the mechanism can scratch the film, and third, critical focus of the image is not easy to assess, even though it is enlarged on the screen or wall.

The selection process begins. No images with technical flaws should even be on the light table, unless there is a strong reason to consider them. Slides that are not critically sharp may be unsuitable for enlargement in four-color reproduction.

A 35mm slide, blown up vertically to full-page size, is enlarged about 800 percent (a double-page spread represents a 1,700 percent enlargement). Any fuzziness is therefore magnified, and because offset lithographic printing depends on a dot-screen process to reproduce imagery, the unsharp edges will read more as dots than as lines. Some softer focus images can be used, but they almost always have to be small.

Once the images have been culled for their technical qualities, i.e., proper color saturation (exposure), sharpness, and good composition, then other considerations such as artistry, emotional impact, uniqueness, and storytelling qualities come into play, along with how an image may end up being used (cover, table of contents, inside editorial use). In most cases, I made a preliminary edit and returned the outtakes to the photographer.

Art directors need to have the flexibility of

horizontals as well as verticals. Laying out the text and pictures requires cropping, moving, pairing, resizing—all to fit the page grid of that particular publication. In magazines, some pages share space with ads. Some pictures require breathing space around them. These are some of the magazine's concerns of which the photographer might not be aware.

If you look closely at a publication, you can discover its style of using pictures with words. *National Geographic*, for instance, has a smaller page format than most, which makes it hard to cram lots of text and pictures together and still do the pictures justice. So they will run some double-page spreads (across two pages) and use columns of type that are dropped out (white type on a dark background). They will set captions with italic type to show that the information is different from that contained in the article, and generally, they try to keep the pages from looking cramped or cluttered.

Audubon was larger in format, and we had the ability to really showcase the photography. Rarely would we drop type out of an image. Photos had white space around them for breathing room, and type was kept simple and in clean blocks for readability. Double-page spreads were reserved for images that had artistic merit or had great visual impact in larger size. But you couldn't do a lot of them. Too many would dilute their power; visual variety is what makes a magazine's pages come alive.

SUBMITTING YOUR WORK

A photographer should never be shy about approaching a publication, assuming he has done his homework, read back issues of the magazine, and ascertained what style and needs they have for their particular audience. If your work is good, and appropriate for that publication, there should be no hesitation to send it in with a brief cover letter stating why you think the magazine should consider it. Editors need as many reliable sources as they can find and usually want the best and newest material available.

They also want to see submissions that are tightly edited; if you include weak images, the impression you leave is that you don't know how to tell good from bad. Your picture judgment will be forever suspect. I once received a large cardboard box in our usual stack of unsolicited submissions. It worried me. Was it all stuffing, or was it full of yellow boxes? I should have sent it back unopened, but instead, I took a quick look to see what subjects there might be.

To my dismay, there were hundreds of frames of the same subject—a coyote pouncing on a mouse. They went back with a terse note. Later, when I instituted the checkoff rejection slip, one of the categories was "material needs editing." This work should be done by the photographer. The only editing a picture editor is supposed to do is that related to magazine stories when the time comes to lay out the story.

It is not always easy to edit your own work. But if you aren't ruthless in editing yourself, you can be sure an editor will be. A photographer once came to see me with a story idea. We looked at the images, but I didn't keep any. Unable to contain his curiosity, he asked me why I hadn't. I told him many of the pictures weren't good enough, and there certainly weren't enough good ones for a story. He said, "But I spent weeks, mostly in the pouring rain, trying to get those shots."

An editor has none of the emotional ties to the work that the photographer has, which can cloud his objectivity. The quality of the photographs is all that matters.

At times, however, you might be forced to forgo technical perfection if a subject is unusual enough. When we did a story on the recovery of the Eastern coyote in New England, we could not find good images. Rather than use a portrait of an easy-to-find *Western* coyote, we ended up using a grainy image on high-speed film of genuine Eastern coyotes. In this instance, authenticity counted more than quality.

If your work is rejected, it doesn't necessarily mean it wasn't good. It may simply be similar to something they already have or have coming in. If, however, you haven't done your homework and send material similar to something recently published, that editor will think you don't read the magazine or don't care, and your material will most definitely be rejected. If they have just done a story on lemmings, the last thing they want to see is your lemming pictures, no matter

how fabulous they may be. Market research is crucial to success.

I was having a problem with photographers who sent unsuitable material, and I needed a way to discourage them. The issue was brought to a head by a submission of roses photographed in a yard with children and picket fences. I had returned them with our standard rejection form, which was so polite and bland, it didn't do the job. A couple of months later, I'd receive another batch of similar material. By the third submission, I was getting irritated.

At the time, our rejection slip read, "Thank you for submitting your material to *Audubon*. We are sorry that it does not meet our needs at this time." Not exactly enlightening if you want to know *why* your material was returned.

I polled various photographers to see how they would feel if they received a form rejection slip that itemized reasons for the return. All felt it would be helpful and constructive. We devised the following form. The categories represented the most common failings I saw. In seven years of using it, only one photographer complained.

REJECTION FORM SAMPLE

Thank you for submitting your material to *Audubon*. We are returning your material enclosed herewith for one of the following reasons:

____ **Terms of delivery memo too restrictive**

____ **Unacceptable format** (__prints ___dupes ___boxes)

____ **Material needs editing, too many images**

 ____ **Currently overstocked**

 ___ try resubmitting same material in ____ months

 ___ try submitting new material in ____ months

 ____ **Too similar to material on hand or recently published**

____ **Inappropriate subject matter**

 ___ study magazine, then query or submit different subject

____ **Quality of material does not meet our standards**

 ___ works shows promise—try again

 ___ based on submission, we cannot be encouraging

 ___ technical quality good, concept too ordinary for us

When submitting material, please remember:

 1. to include sufficient postage to ensure the safe return of your photographs

 2. we are not responsible for unsolicited material

 3. seasonal material should be submitted at least
 six months ahead

No. Slides _____ Date _____ Reviewed by _____

Additional comments: _____

Every year, there are many more serious nature photographers trying to market their work to the same limited number of nature-oriented publications. When I started as picture editor, in 1978, unsolicited submissions amounted to a few envelopes a week. Six years later, submissions would pile up so fast, we had to stack them on the floor. We were literally inundated. I asked Kay Zakariasen, photo editor of *Natural History* magazine, if she had experienced a similar increase of submissions in her office. She had not. Her problem was just the opposite. Because her publication was so scientifically oriented, her picture needs were somewhat esoteric. She often had to cast a very broad net to find enough of the right images to illustrate their stories.

If there is a strategy to submitting or showing your work, it depends on the individual editor. It is usually best to call or write and ask for submissions guidelines. Some editors do not like to see people in person. They feel uncomfortable and pressured looking at material with the photographers present. Others may need flexibility in making appointments. If a sudden deadline arises, they may need to reschedule. People who took little of my time and got right to the point were appreciated.

Sending the same material to several clients at once can be dangerous. Simultaneous submissions, as they are called, can backfire on the photographer. More than once, we had to pull an image or story that was already separated and ready to publish because someone discovered it had just appeared in another publication.

It is the photographer's responsibility to let an editor know if the same image is under consideration elsewhere, as he is the only one who knows what material is where. Errors of this nature can cost the publication a lot of money, and editors are not likely to forgive and forget. Such mistakes can cost the photographer any future business with the publications that were burned.

Editors need photographers, and photographers need editors. As in any other business rela-tionship, there is a mutual dependency between buyer and seller. Personalities do, of course, enter into the equation. Some people are easier to work with than others, and they are the ones an editor is more apt to call. This is especially true where assignments are concerned.

TELLING A STORY VISUALLY

Telling a story in pictures is much like telling one with words. All good reporters learn to answer the questions, "Who, What, Where, When, Why?" A picture story should visually answer the same questions. More and more magazines are looking for picture story packages, something they can put in to liven up the editorial pages. It is easier to buy a completed package than to research material from different sources.

In order to help you understand what a picture story might consist of, I pulled a series of polar bear photographs from Art's files. I wanted to see if a story could be developed from what he had randomly gathered. I pulled images that I liked, or that I thought made a point, and limited myself to one page of twenty, knowing that most published stories would end up using half that number or less. The red dots indicate my final edit for the story.

WHO Polar bears. Since all the images were taken from the same area—Churchill, Manitoba—but consisted of many different individuals, the story could not be about one bear. It would therefore have to be more general—about polar bears, bears in Churchill, or some aspect of bear behavior.

I've picked a theme called "Awaiting Freeze-up" to build a story around. Normally, this would be done by the photographer submitting the story package. Let's assume we are going to do the story just with pictures and captions, no text.

A

POLAR BEAR(S)
CHURCHILL, MANITOBA, CN
COPYRIGHT ART WOLFE 1090

B

POLAR BEARS
CHURCHILL, MANITOBA, CN
COPYRIGHT ART WOLFE 1090

C

POLAR BEAR(S)
CHURCHILL, MANITOBA, CN
COPYRIGHT ART WOLFE 1090

262

D

© ART WOLFE

264

NOV 83P8 31

E

259

POLAR BEAR(S)
CHURCHILL, MANITOBA, CN
COPYRIGHT ART WOLFE 1090

F

© Art Wolfe

256

ADULT POLAR BEAR ON ICE
CHURCHILL, MANITOBA, CAN.
COPYRIGHT ART WOLFE 1183

G

ART WOLFE ©

POLAR BEAR CUBS AT PLAY,
HUDSON BAY, MANITOBA,
CANADA
Copyright Art Wolfe 1183

H

© ART WOLFE

NOV 83P5 28

I

ART WOLFE ©

© Art Wolfe

POLAR BEAR
HUNTING

J

POLAR BEAR(S)
CHURCHILL, MANITOBA, CN
COPYRIGHT ART WOLFE 1090

K

"FLOP"

260

POLAR BEAR(S)
CHURCHILL, MANITOBA, CN
COPYRIGHT ART WOLFE 1090

L

ART WOLFE ©

© Art Wolfe

POLAR BEAR(S)
CHURCHILL, MANITOBA
CANADA
Copyright Art Wolfe

M

ART WOLFE ©
DUMP BEAR

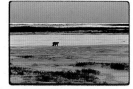

258

NOV 83P8 26

N

POLAR BEAR CUB
MANITOBA
COPYRIGHT ART WOLFE

O

© Art Wolfe

263

POLAR BEAR
MANITOBA

NOV 83P7 11

P

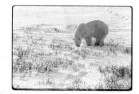

POLAR BEARS
CHURCHILL, MANITOBA, CN
COPYRIGHT ART WOLFE 1090

Q

POLAR BEAR(S)
CHURCHILL, MANITOBA, CN
COPYRIGHT ART WOLFE 1090

R

POLAR BEARS
CHURCHILL, MANITOBA, CN
COPYRIGHT ART WOLFE 1090

S

261

POLAR BEARS
CHURCHILL, MANITOBA, CN
COPYRIGHT ART WOLFE 1090

T

ART WOLFE ©

POLAR BEARS
AND PEOPLE
DON'T MIX

257

NOV 83P5 91

F

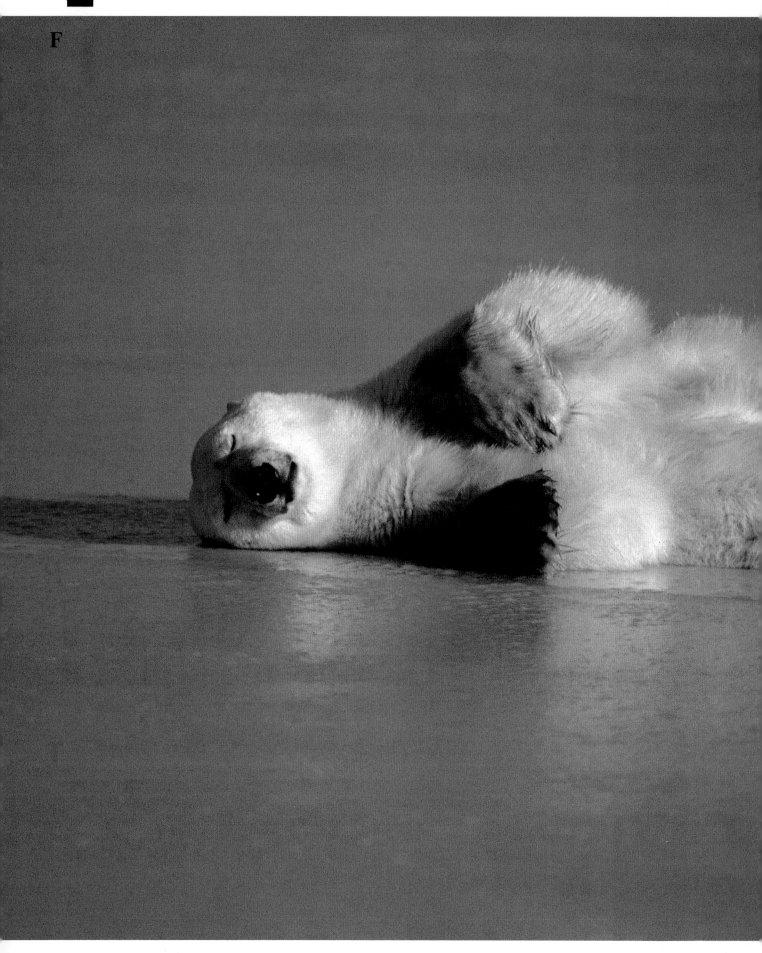

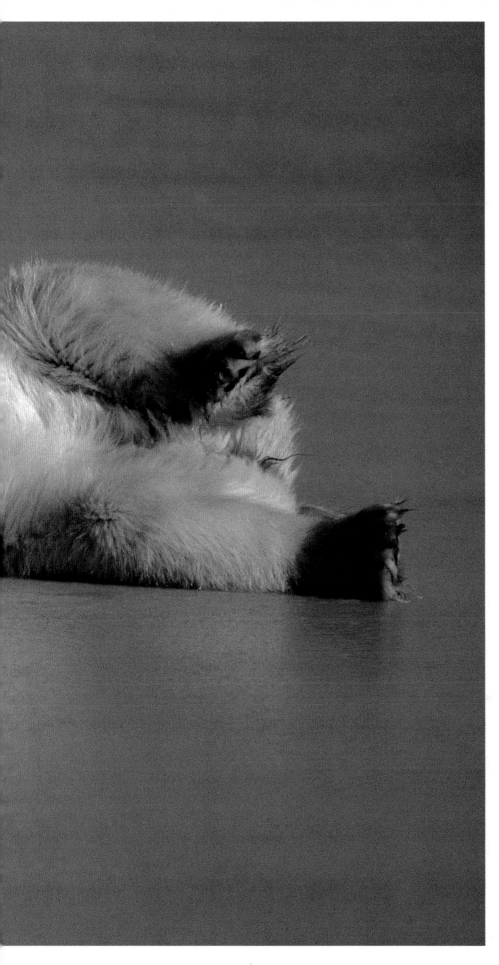

Opening Spread

WHAT In telling a story, one must have an opening, whether it is with words or images. The idea is to pique the reader's interest. Depending on whether the opener was to be a two-page horizontal or a one-page vertical, I would select either the two adult bears fighting—"S" (cropped to a vertical)—or "F"—the bear lying down on the ice in beautiful light (horizontal). Both images make you ask, "What are these bears doing?"

The reason I would not use the two bears playing as my horizontal choice is that the action falls in the center of the frame. It would fall into the split of the gutters and be harder to read, thus losing its impact.

We can blow up the shot of the bear lying down to a full double-page, nothing essential is lost in the gutters, and we have plenty of solid color areas in the frame we can use for dropping out a title and caption text at the bottom.

WHERE Churchill, Manitoba. It is one of the few places in the world where bears gather in great numbers. Here, the one image we don't have is an aerial view, or map, showing Cape Churchill, essentially an east-west coastline seventy miles long. Without either, we could rely on a few images to capture the flavor of Churchill.

As we amplify the Churchill part of the story, where bears interact with the townspeople, we begin to answer part of the "Why" of our story. Although garbage is not the reason bears congregate, the dump brought hungry bears into contact with people and gave Churchill its early notoriety. We could have a spread made up of a group of images—the garbage shot, the sign shot for a color spot, and the shot of the bears with tundra buggies.

Second Spread

Our letter to the editor would include relevant caption information to explain what is going on, such as:

"M": Originally, the garbage dump attracted bears close to the town, creating a dangerous situation for the residents, day or night.

"T": Even today, after the dump has long since closed, bears are still a threat. There is a nine P.M. curfew for children during the six-week period when bears are in the area.

"E": One local resident turned bear-watching into a tourist industry. He designed the "tundra buggy," a special bus with huge tires that elevate tourists above bear level so they can safely view and photograph out the windows. Today, he has six buggies and some competition.

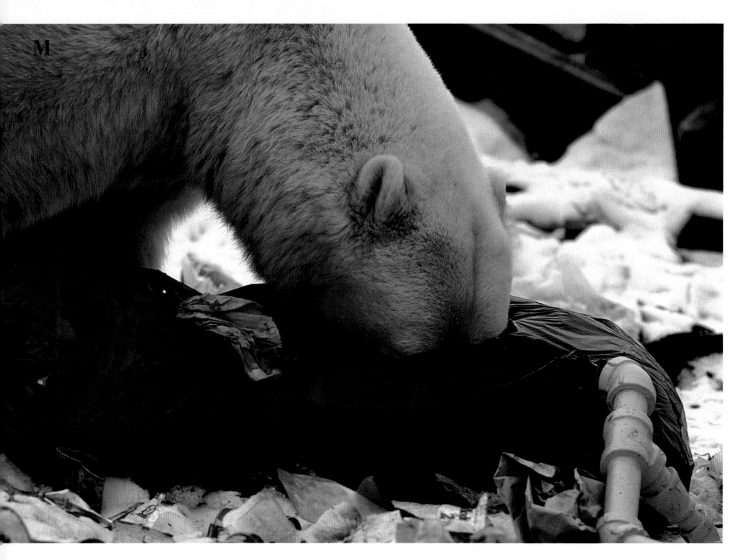

E

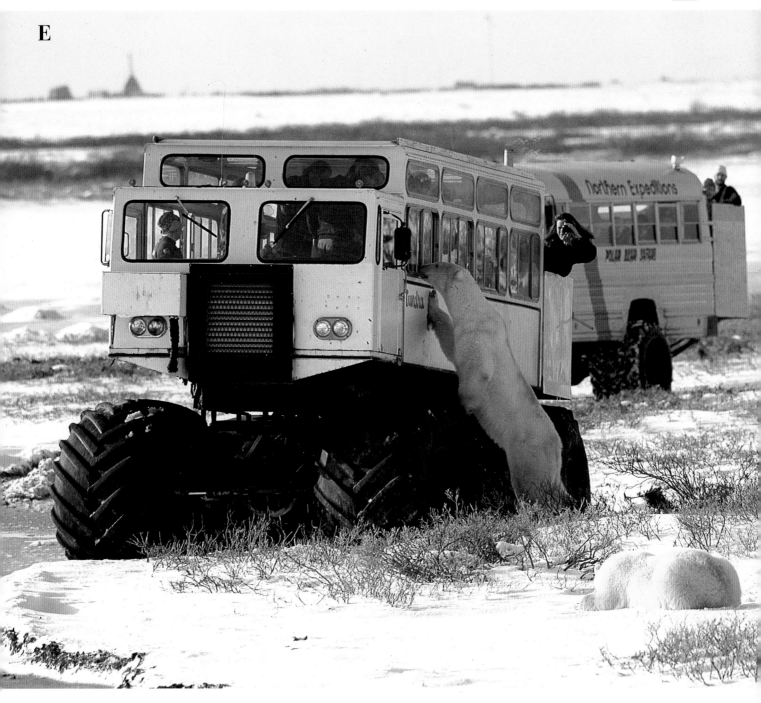

For our layout, we could put the bear with his nose in garbage lower left and pair it with the sign at the upper right of the left-hand side of the spread. On the right page, we could then use the tundra buggy image as large as possible, cropping in on the right. We could probably have white space on this spread for captions.

WHEN The fall. Arctic blasts coming out of the northwest cause ice to form first along this shoreline. This is precisely why bears flock here in numbers. They have spent the summer months denning or otherwise trying to stay cool. With no sea ice on Hudson Bay, there are no seals, so all the bears are fasting. By fall, they are hungry, eager to get out on the ice to hunt. They congregate along the shoreline to await freeze-up.

Here we could use a spread of bear activities, using a single adult, a shot of the adult males play-fighting, and a close-up of the sleeping bear. We have now led into the "**WHY?**"

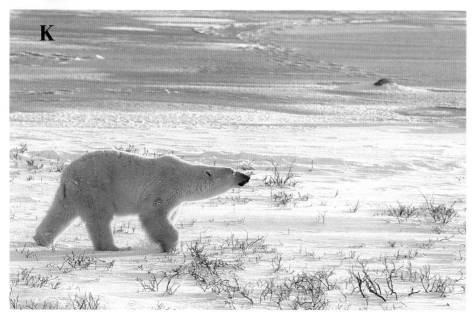

K

Third Spread

"K": I chose the shot of the single bear prowling the shoreline to underscore their normally solitary existence, and to convey their restlessness to get out on the ice.

"S": Awaiting freeze-up, the males, rather than avoiding each other, will often spar and play, sometimes even older animals with younger ones. They are channeling normal aggression into harmless contests of strength that may later prove useful during the mating season when males do battle in earnest.

"C": The close-up of the sleeping bear gives a change of perspective, and highlights another activity of the waiting bears. Hungry, they conserve energy by sleeping.

Our layout for this spread would have, at the top, the horizontal of the solo bear, flopped so the bear walks toward the center and cropped down from the top to fit. Then, below, we would run the shot of the playing bears as large as possible. On the right page, we would use the portrait of the sleeping bear as a full-page vertical. Our captions might be dropped out of the images, if we end up with no white space.

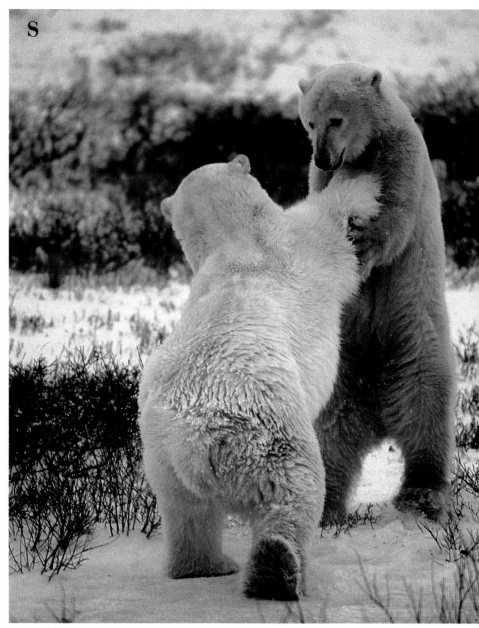

S

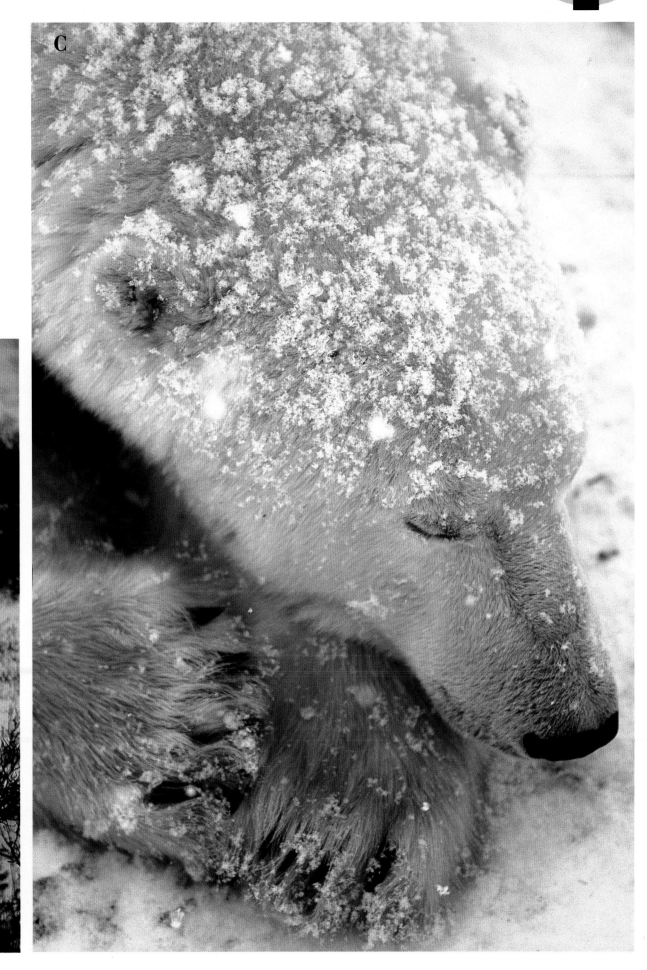

C

O

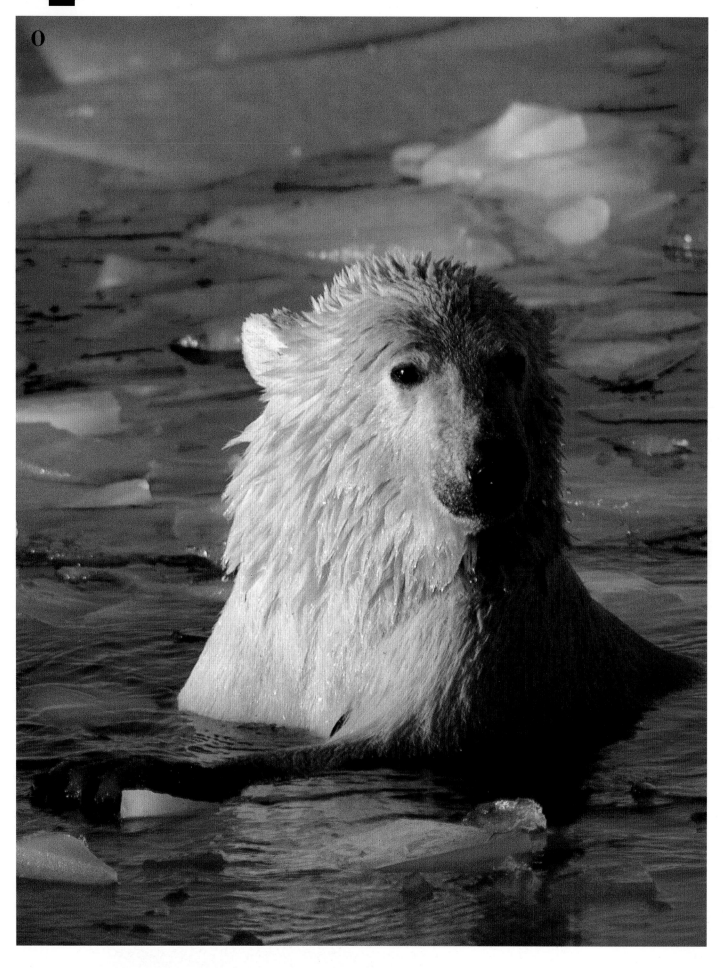

Closing Spread

Our photo story, however, needs a closing, just as we needed an opening. For our last spread, I would select the shot of the bear in the water, before the bay has frozen, on the left page, cropped to a vertical so we could blow it up to a full page. On the right, we could have white space at the top for more captions, and run the footprints across the bottom two-thirds, slightly cropped. The idea for pairing these two is that, one day, there may be lots of bears, but once the ice freezes, they disappear overnight. They return to their solitary lives for the winter, avoiding each other until the spring mating season.

So, with a few pictures and the right captions, we have pulled together a possible story package to market to magazines. Basically, the essential elements have been met—we have a subject, it does something interesting, and we have some colorful details to flesh out the story. I may not have selected some of your favorite images here, nor some of mine. We had to keep to our story line. You may want to try and create your own photo story using alternate images.

When studying the selection, notice the variety of perspectives—close-ups, telephoto, and wide-angle views. This is important to give the story a visual dynamism. Pictures taken from the same perspective often aren't as lively when viewed as a group, unless, of course, the purpose of your theme is the single vantage point.

We used single-perspective picture stories in the magazine with some success. One was a portfolio of a single tree from the same vantage point taken over the four seasons of the year. Two other portfolios entitled "Daybreak: Everglades" and "Daybreak: Yellowstone" offered variety in the form of the different animal life that could be observed at a single time of day in one location.

Another portfolio, one of my favorites, was a series of tight close-ups of one of nature photography's oldest clichés—the dew-covered spiderweb. The photographer had gotten in very close with a macro lens and extension tubes. Each image offered a slightly different twist—a true "theme and variations"—and a fresh look at an old standard.

D

ETHICAL CONSIDERATIONS

At *Audubon*, our goal was to inspire the members to protect and preserve wildlife and habitat from the local to the national level. Whenever possible, we used photographs of animals taken in the wild. In my second year as picture editor, I learned a hard lesson. We published a stunning shot of a great gray owl swooping down on a mouse in the January 1980 issue.

Throughout the whole process of separating and color-proofing the image, neither the editor, art director, nor I noticed the mouse was, in fact, a South African gerbil. It was embarrassing when one of our eagle-eyed readers pointed out that gerbils have a furred tail. Normal prey for this owl, a white-footed mouse, has a bare tail. We found out later that the photographer had been trapping mice to bait the owl, but had run out before he had the picture he wanted. So he went to a pet store and bought some gerbils.

Eliot Porter, considered the grandfather of large-format nature photography, came to a rather extreme point of view in his later years, prompted by a guilty conscience. No tampering with nature was acceptable to him, not even removing or rearranging a leaf. He "found" his photographs in nature. If the composition wasn't right, he moved to another location.

In a speech Porter made in 1986, when he was given *Audubon* magazine's Hal Borland Award, he confessed to having cut down a tree, years ago, to get the photographs he wanted of nesting warblers. The nest was in the top of a tall spruce in Maine. Since he had a view camera and a triple flash unit, climbing a tree was impractical. He resorted to sawing off, from the bottom of the tree, one foot per day, until the nest was at tripod level. Fortunately, nesting warblers are tenacious.

Manipulation of nature has been going on for years, since the early days of Hollywood to today's television nature specials. In film, footage can be cleverly edited to make you think events are taking place concurrently. It is common practice now for photographers to rent tame animals for portrait and habitat photography. Shots of captive animals are usable, but only if they do not convey false information. At the magazine, we needed to know if portraits were taken under controlled conditions. It could make a difference in how we captioned them.

A photographer once sent me a series of images showing a confrontation between a bobcat and a wolverine. He thought this unusual circumstance was worthy of a portfolio. I suspected such a confrontation would be unlikely in the wild, as wolverines are not only extremely rare, but are carrion eaters, and bobcats are not. I called him to verify the photographic conditions. When he told me he had set up the situation with rented animals, I explained the magazine's need for authenticity. Our credibility was something we guarded zealously.

In 1981, *Geo* magazine ran a story on giant pandas. The photographer claimed to have taken the photographs in the wild. *Geo* presented the portfolio as a rare coup. It later came out that the pandas were captive. *Geo* printed the following two months later: "We apologize to our readers for not discovering this deception sooner. It has cost a well-established photographer his job, and it will serve to make us more vigilant in the future. Embarrassing though this message is, there is no substitute in journalism for candor."

We are caught in a philosophical bind. On the one hand, photography is a documentary medium. We expect what it records to be the truth. On the other hand, artistic license gives the individual the right to interpret reality as he sees it.

How do we know when manipulation tampers with truth? It is not always so easy to detect. An example is a photo I first saw used commercially in national magazines as an ad for an underwater watch. Now the photo is marketed as a wildlife greeting card. It is of a sperm whale underwater, in silhouette, with a scuba diver touching its lower jaw. The implication was that divers wearing this watch would have remarkable wild experiences. In fact, the whale was dead, harpooned by whalers. As far as I know, it has not yet been used editorially.

Manipulating nature isn't the only problem we need to address. There are technical manipulations of images, too. Some involve the sandwiching of two images together to look like one finished frame. Others may be double exposures, such as an animal silhouetted in front of a large sun or moon, preshot with a telephoto, rewound,

and then put through the camera a second time when the right animal situation arises. These are better suited to the commercial and advertising markets than to editorial. Magazines with editorial integrity deal in facts and truth. This applies to pictures as well as words.

Computers have ushered in a new frontier of manipulation with machines, such as the Scitex, electronic imaging that can digitize photographs into tiny pixels. These digitized images can then be recombined, pieces taken out, parts moved, other pieces inserted, and then massaged to look like one believable whole. A few years ago, the *National Geographic* ran a cover of two pyramids. Word got out that the pyramids had been moved closer together by "Scitexing." There was a hue and cry in the publishing field. Wasn't that tampering with reality?

The camera's ability to document, to witness and record events, has always given photography a unique power over other forms of art. This is truth. Now, suddenly, technology can manipulate that truth. If pieces of one image can be lifted and inserted into another, the final image is not truth, or even necessarily reality. Done well, most people will never notice.

In the field of nature photography, harassment of wildlife is perhaps the ethical issue of most concern today. In Denali National Park, professional photographers are strictly regulated by a permit system, and access is controlled to reduce the risk of dangerous encounters between photographers and animals. In the previous chapter, we mentioned the two photographers killed by grizzlies when trying to get too close. Even though both attacks were deemed self-defense on the part of the bears, one of the animals was "destroyed." Other parks and wildlife management areas may be forced to control access, as much to protect wildlife as to protect careless photographers.

We have all become conditioned to a sophisticated level of nature photography, made possible by powerful telephoto lenses, motor drives, and publications such as *Audubon, National Geographic, Natural History, National* and *International Wildlife, Smithsonian,* and the books, posters, calendars, and greeting cards featuring wildlife. Also, television's omnipresent nature programs have brought into our living rooms intimate details of many animals' lives.

No doubt this has all contributed to the feeling that closeness is desirable. We seem to expect it to translate into benign interactions when we encounter animals in the wild. My brother once watched in disbelief as a man jumped out of his car in Yellowstone, pushed his little children right up next to two grizzly cubs, and took a picture with his Instamatic. He never gave a thought to the sow grizzly and the potential danger to his children.

Nature photographers are, I think, more aware and sensitive than most to the fragility of the beauty that inspires their work. I doubt they want to be responsible for wildlife harassment and habitat destruction. But competition in the field is intensifying, and more photographers are out there trying to get bigger and better images, more frame-filling portraits, and pushing the animals too hard. If the growing trend toward wildlife harassment doesn't self-regulate, then access may eventually be denied to all photographers.

James Balog recently caused quite a stir with his portfolio of vanishing species taken in man-made interior settings. His point was that the romance of wild animals in pristine wilderness is no longer valid. If so, is this portfolio the vision we want for the twenty-first century?

AFTERWORD

T HIS BOOK WAS NEVER intended to be definitive or all-inclusive. We merely wanted to bring to light some aspects of photography that are rarely discussed but that underlie the act of photography in a fundamental way.

Eliot Porter once described his fanatical pursuit of bird photography in some notes he published in *Audubon* magazine in 1972: "Simply recording a bird's image on film was not enough. The entire picture area was vitally important. Every element in it must contribute to the unity of the image if the picture is to merit consideration as art."

Why should we care to elevate bird photography or any photography to consideration as art? For the simple reason that art is the creative expression of human response to the world in which we all live.

Anything and everything can be the subject of art. It is how the artist expresses his ideas that determines his success or failure in communicating them to a larger audience. By expressing a personal vision, he can change the way we think and feel about what we see. This is what all great photography aspires to.

BIBLIOGRAPHY

ON ART

Arnheim, Rudolf. *Art and Visual Perception: A Psychology of the Creative Eye.* Berkeley: University of California Press, 1974.

———. *The Power of the Center.* Berkeley: University of California Press, 1988.

Canaday, John. *What Is Art?* New York: Alfred A. Knopf, 1980.

Clark, Kenneth. *Looking at Pictures.* Boston: Beacon Press, 1960.

Friend, David. *Composition: A Painter's Guide to Basic Problems and Solutions.* New York: Watson-Guptill, 1975.

Itten, Johannes. *The Elements of Color.* New York: Van Nostrand Reinhold, 1970.

ON PHOTOGRAPHY

Doeffinger, Derek. *The Art of Seeing.* Eastman Kodak, Rochester: Kodak Workshop Series, 1984.

Eastman Kodak. *The Joy of Photography.* New York: Addison-Wesley, 1979.

Feininger, Andreas. *Photographic Seeing.* Englewood Cliffs, NJ: Prentice Hall, 1973.

———. *Principles of Composition in Photography.* New York: Amphoto, 1973.

Newhall, Beaumont. *The History of Photography.* New York: Museum of Modern Art, 1982.

ON THE PHYSICS OF LIGHT AND COLOR

Evans, Ralph M. *An Introduction to Color.* New York: John Wiley & Sons, 1965.

Gregory, R. L. *Eye and Brain: The Psychology of Seeing.* New York: McGraw-Hill, 1978.

Hedgecoe, John. *The Art of Color Photography.* New York: Fireside/Simon & Schuster, 1989.

Helman, Hal. *The Art and Science of Color.* New York: McGraw-Hill, 1967.

Minnaert, M. *The Nature of Light and Color in the Open Air.* New York: Dover, 1954.

ON PHOTOGRAPHIC TECHNIQUE

Caulfield, Patricia. *Capturing the Landscape with Your Camera.* New York: Amphoto, Watson-Guptill, 1987.

Fitzharris, Tim. *The Audubon Society Guide to Nature Photography.* Boston: Little, Brown & Co., 1990.

Patterson, Freeman. *Photography for the Joy of It.* Toronto: Van Nostrand Reinhold, 1977.

———. *Photography of Natural Things.* Toronto: Van Nostrand Reinhold, 1982.

Peterson, Bryan F. *Learning to See Creatively.* New York: Amphoto, Watson-Guptill, 1988.

Shaw, John. *The Nature Photographer's Complete Guide to Professional Field Techniques.* New York: Amphoto, Watson-Guptill, 1984.

INDEX